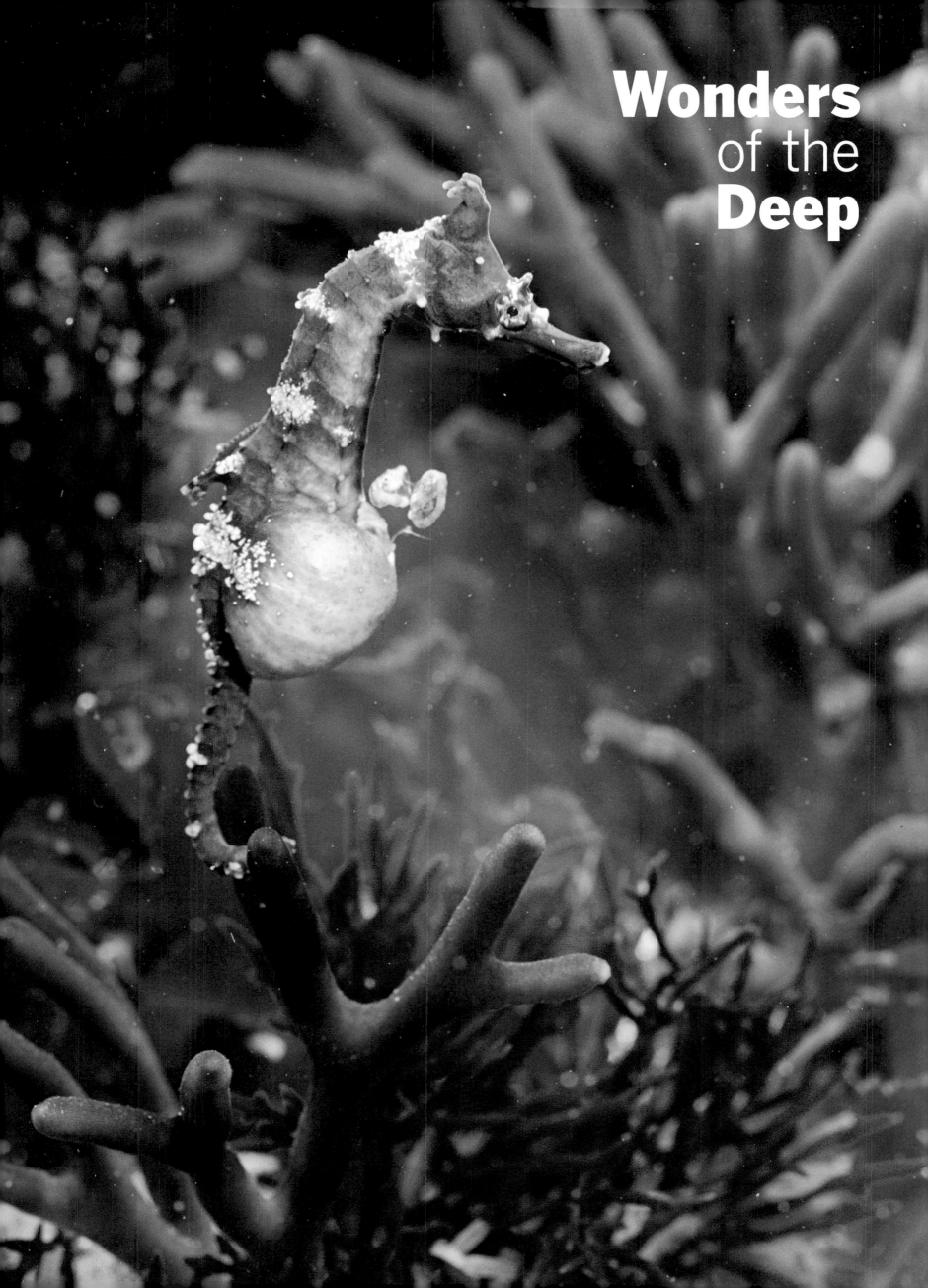

Wonders
of the
Deep

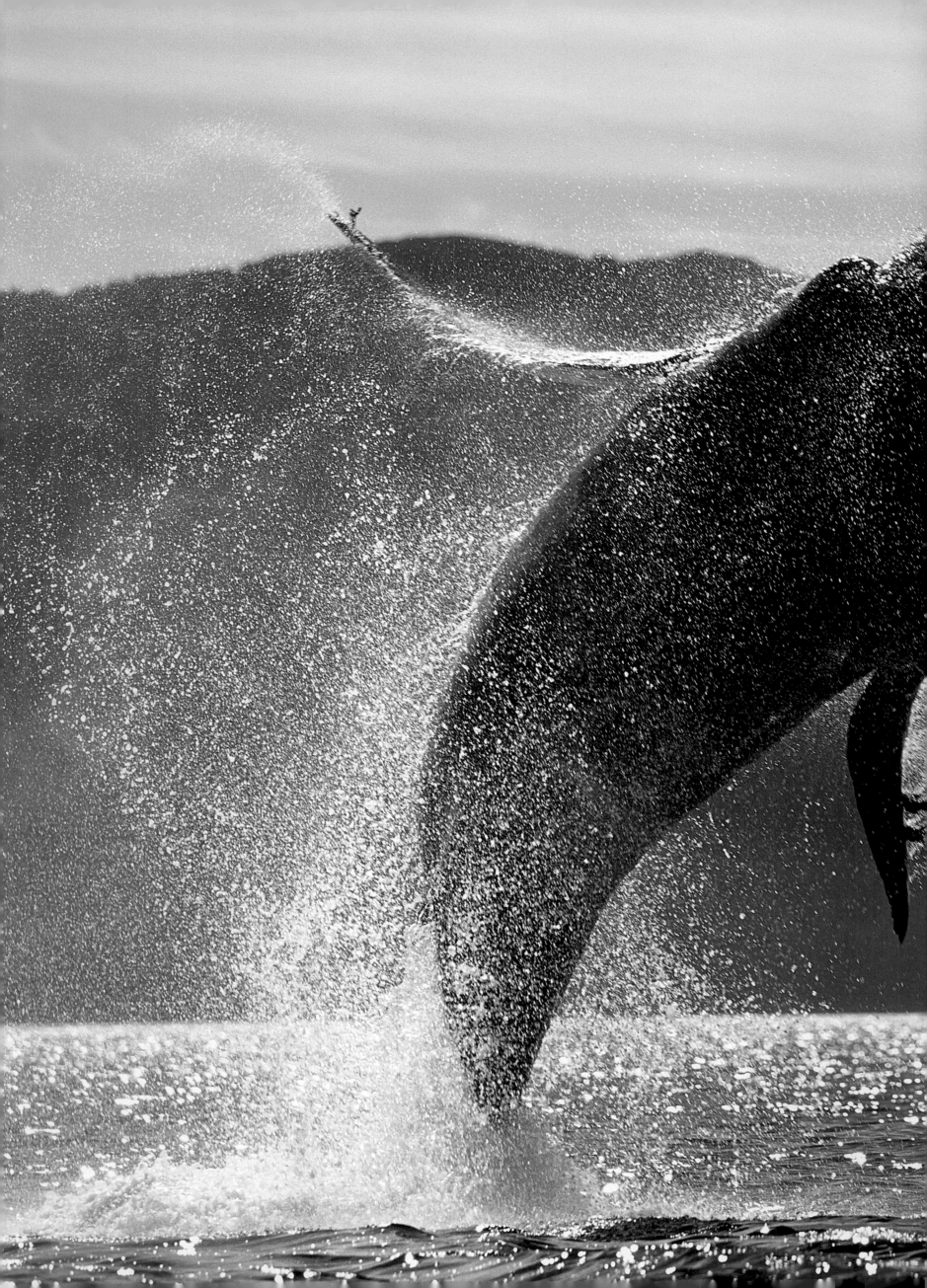

Wonders
of the
Deep

THE ASTONISHING SPLENDOR OF THE SEVEN SEAS

Contents

LIFE BOOKS
Managing Editor Robert Sullivan
Director of Photography Barbara Baker Burrows
Creative Director Mimi Park
Deputy Picture Editor Christina Lieberman
Copy Chief Barbara Gogan
Copy Editor Parlan McGaw
Writer-Reporters Michelle DuPré (Chief),
Marilyn Fu, Amy Lennard-Goehner
Photo Associate Sarah Cates
Editorial Associate Courtney Mifsud
Consulting Picture Editors Mimi Murphy (Rome),
Tala Skari (Paris)

Editorial Director Stephen Koepp
Editorial Operations Director Michael Q. Bullerdick

EDITORIAL OPERATIONS
Richard K. Prue (Director), Brian Fellows
(Manager), Keith Aurelio, Charlotte Coco,
Tracey Eure, Kevin Hart, Mert Kerimoglu,
Rosalie Khan, Patricia Koh, Marco Lau,
Brian Mai, Po Fung Ng, Rudi Papiri,
Robert Pizaro, Barry Pribula, Clara Renauro,
Katy Saunders, Hia Tan, Vaune Trachtman

TIME HOME ENTERTAINMENT
President Richard Fraiman
Vice President, Business Development & Strategy
Steven Sandonato
Executive Director, Marketing Services Carol Pittard
Executive Director, Retail & Special Sales Tom Mifsud
Executive Publishing Director Joy Butts
Director, Bookazine Development & Marketing Laura Adam
Finance Director Glenn Buonocore
Associate Publishing Director Megan Pearlman
Assistant General Counsel Helen Wan
Assistant Director, Special Sales Ilene Schreider
Book Production Manager Suzanne Janso
Design & Prepress Manager Anne-Michelle Gallero
Brand Manager Roshni Patel
Associate Prepress Manager Alex Voznesenskiy

Special thanks: Christine Austin, Katherine Barnet,
Jeremy Biloon, Stephanie Braga, Jim Childs,
Susan Chodakiewicz, Rose Cirrincione, Lauren
Hall Clark, Jacqueline Fitzgerald, Christine
Font, Jenna Goldberg, Hillary Hirsch, Amy
Mangus, Robert Marasco, Kimberly Marshall,
Amy Migliaccio, Nina Mistry, Dave Rozzelle,
Adriana Tierno, Vanessa Wu

ISBN 10: 1-60320-229-3
ISBN 13: 978-1-60320-229-9
Library of Congress Control Number: 2012938918

"LIFE" is a registered trademark of Time Inc.

We welcome your comments and suggestions about LIFE Books.
Please write to us at: LIFE Books, Attention: Book Editors,
PO Box 11016
Des Moines, IA 50336-1016

If you would like to order any of our hardcover Collector's Edition
books, please call us at 1-800-327-6388.
(Monday through Friday, 7:00 a.m.—8:00 p.m. or
Saturday, 7:00 a.m.— 6:00 p.m. Central Time).

ENDPAPERS: An aerial view of the coral reef off the Capricorn Islands, Australia. Photograph by Mitsuaki Iwago/Minden
PAGE 1: A male common Japanese seahorse releasing hatchlings out of its brood pouch. Photograph by Shinji Kusano/Nature Production/Minden
PAGES 2-3: A humpback whale breaches in Alaska's Frederick Sound. Photograph by Paul Souders/WorldFoto
THESE PAGES: The jellyfish *Ptychogastria polaris* in the Arctic Ocean. Photograph © Kevin Raskoff/DeepSeaPhotography.com

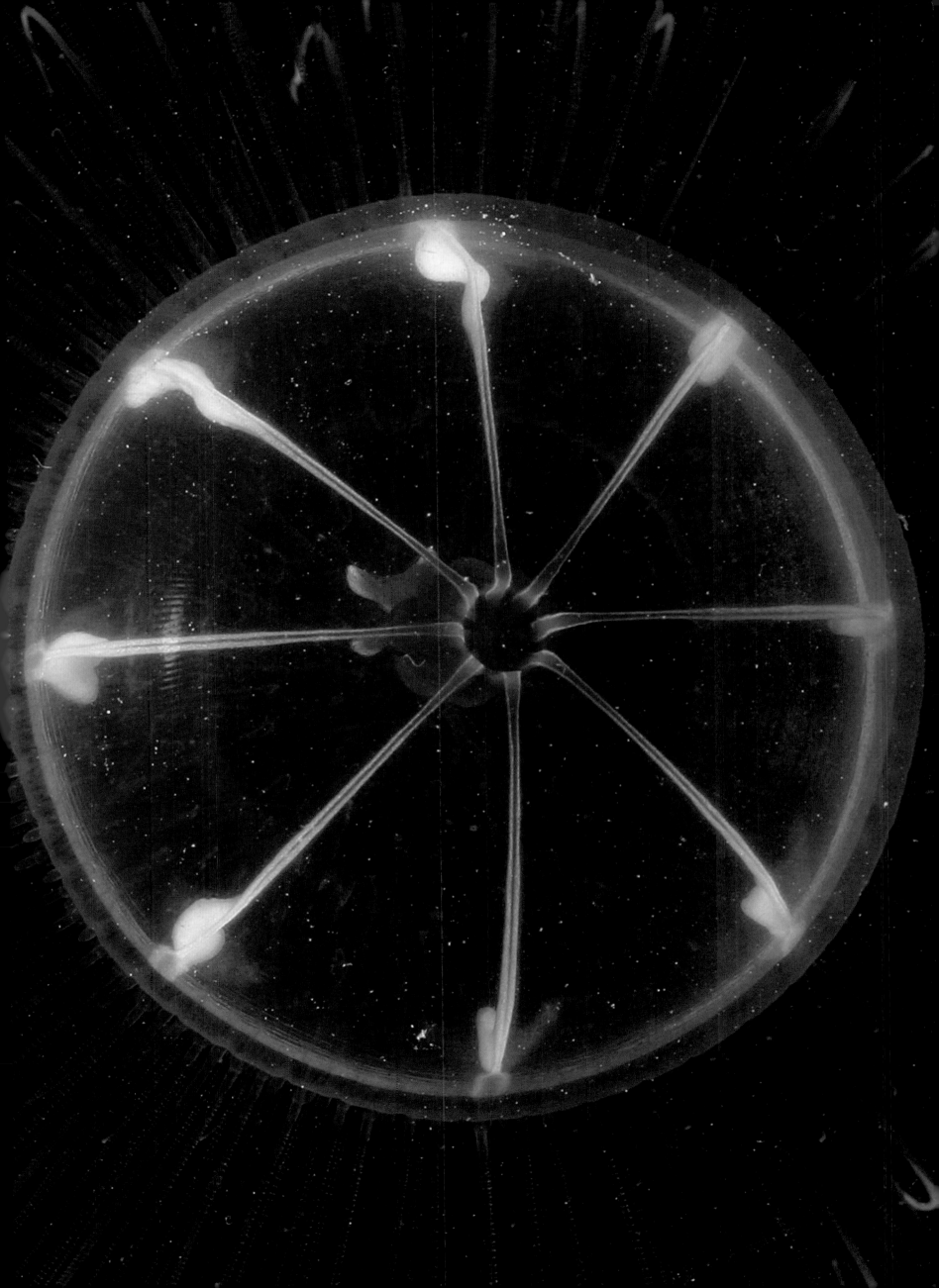

Their World Beneath the Waves

"The sea is everything. It covers seven-tenths of the terrestrial globe. Its breath is pure and life-giving. It is an immense desert place where man is never lonely, for he senses the weaving of Creation on every hand. It is the physical embodiment of a supernatural existence . . . For the sea is itself nothing but love and emotion. It is the Living Infinite, as one of your poets has said. Nature manifests herself in it, with her three kingdoms: mineral, vegetable, and animal. The ocean is the vast reservoir of Nature."

—JULES VERNE
TWENTY THOUSAND LEAGUES UNDER THE SEA

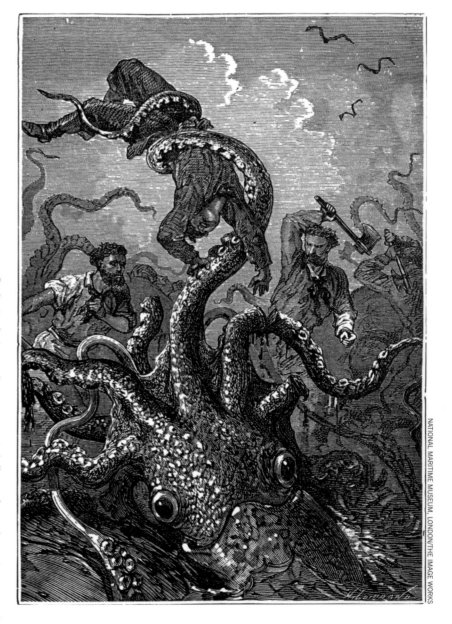

As he did so many times, whether predicting a trip to the moon or to vent fields on the ocean floor, Verne got it exactly right. The ocean is life-giving to an extent unmatched by any other earthly realm. It has kindled a million and many more species, and it nurtures them and their newest offshoots every day.

It does seem supernatural; it has been said that we know as much about Mars as we do our own seven seas. This is a weird, watery world—spooky, increasing in darkness as we descend, until all is black. Yet even there, fish live. In fact, they thrive.

"[T]he sea is itself nothing but love and emotion." That is a poetic and unprovable assertion, but there's something to it. Who among us has not been moved when gazing upon an expanse of ocean at dawn or dusk and wondering what lives beneath? Today, we know so much and have seen so much: whales raising their young, schools of fish acting as a team, little cleaner wrasse unburdening larger fish of the barnacled bacteria clinging to their scaly backs. Love, is it? Or Creation's design? And what is the difference, once the act is observed by man and turned into metaphor?

"The Living Infinite": a perfect phrase. The oceans, as Verne wrote, cover most of the planet's surface; they stretch and reach everywhere. Whether they are tropical or temperate determines which plants or animals might be at home there, and the variety of these life-forms is . . . well, there is no term, so *mind-boggling* must suffice. That variety, so colorful and so regularly odd, is truly mind-boggling at the very, very least. Nature not only "manifests herself" beneath the waves, she exercises her powers, she lets herself go. It can be said: Here, in her vast reservoir, she shows off.

Nature has come up with microscopic zooplankton and the blue whale, which is bigger than any dinosaur that ever lived. For flora, it has given us phytoplankton and also kelp forests that seem as grand as a stand of sequoias. And it has given us everything in between. Coral, for instance. It is an animal, you know. It sits there and feeds on organisms drifting by, angling in its own highly developed way. More direct in approach are the sharks or such species as the speedy sailfish, hunting in a manner man can appreciate. In these pages, the interactivity of the many undersea life-forms becomes clear. On the land, the way life works is now a very

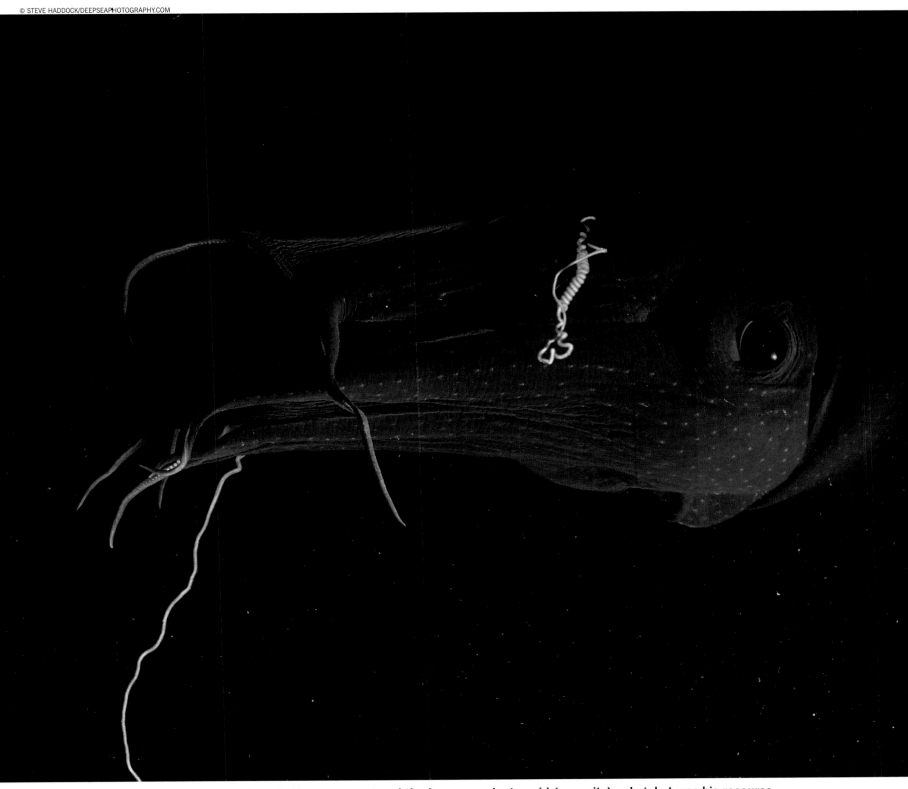

**When Jules Verne's hero Captain Nemo encountered the fearsome giant squid (opposite), a hatchet was his recourse.
Now that all of us know what a squid really looks like (above, the fantastically named vampire squid, which has a curious mix of squid and
octopus characteristics and inhabits waters as deeper as 2,300 feet), we still get chills.**

complicated equation. Below the waves, it remains primal.

In our pages, we deal with these things in our texts. And then, not least because we are LIFE, we present the pictures—images made by some of the best undersea photographers who have ever donned scuba gear or climbed into a bathyscaphe. Some of the images are exciting, some positively thrilling, some heartwarming, some shocking, many extraordinary in what they tell us of what's down there. You are simply not going to believe these species: what they look like, how they persevere. In special sections in this deluxe hardcover edition, we deal, too, with the intrepid men and women who have, down the centuries, made the ocean their second home: the explorers and adventurers who probe beneath the waves, the sailors whose ships, from pirate vessels to the *Titanic*, came to no good end and today reside among the fishes. Life in the sea is nothing if not perilous.

In Jules Verne's day (he published *Twenty Thousand Leagues* in 1870), it was "the great whale" (sometimes the great *white* whale; *Moby-Dick* was published in 1851) or the octopus or the giant squid that caused a child's nightmares. There was evidence of the existence of these large beasts, and also a general lack of

understanding as to how they behaved. So perhaps they behaved abominably! They were the yetis of the deep.

Today, we are so much further along, and the Discovery Channel has an annually successful Shark Week to stir the juices. But more: Just look at the species on the pages that follow. There are truly bizarre, scary-looking animals in the ocean, animals beyond almost any imagining except perhaps Verne's. The denizens of the very deep, including those that live near the vents, haunt in a way the giant squid could only dream of.

But if they haunt, the dolphin and the dugong delight, as does today's tiny Nemo, certainly named for Verne's hero: the clown anemonefish. There is considerable beauty in these pages—the beauty of Nature's vast reservoir.

By book's end, you will feel as if you've paid a visit. This is not, after all, our world, even though it exists on our planet. It is their world, belonging to the plants and animals that have built a life beneath the waves. They feed there, they spawn there, they help the next generation along.

Wonders of the Deep, we call our book. They are wondrous indeed.

LEVIATHAN
King of the Sea

Ahab looked into the eye of a sperm whale. You are looking into that of a gray. For its story, please see page 14.

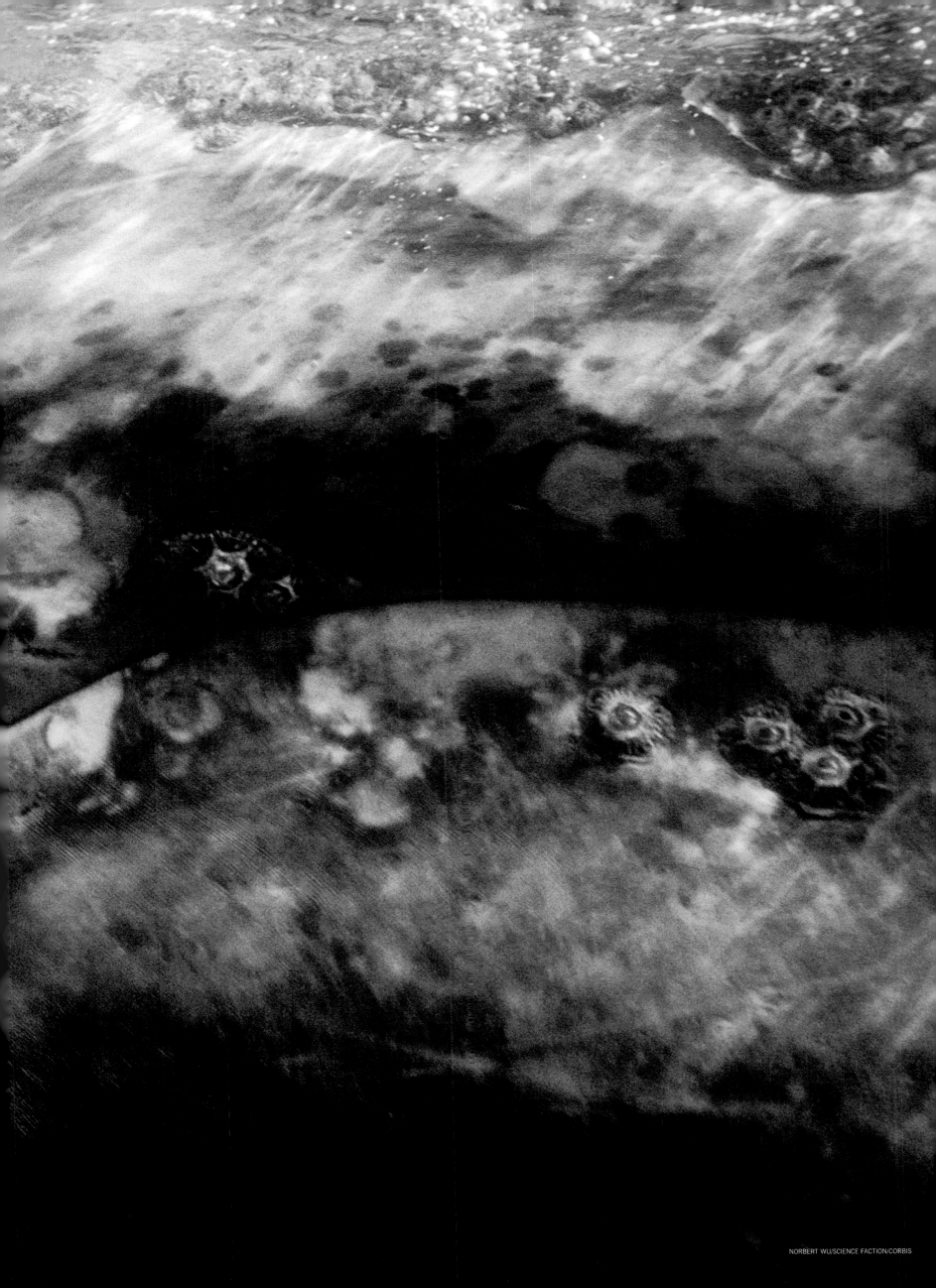

Big Blue

We're not going to hit you with loads of Latin genus names in this book—in truth, we're not going to hit you with many at all—but this one is simply too much (in fact, *tons* of) fun: *Balaenoptera musculus.* That would be the blue whale. It is a baleen, a suborder of whales that feeds largely on small crustaceans known as krill, which the whales filter and then digest. If we can be allowed to reinterpret the "optera" poetically for our own purposes here, you could say the blue whale is the most operatic of beasts: aesthetically riveting like Caruso or Callas, gliding blue-gray through the blue-gray water of all the planet's oceans, all hemispheres, all latitudes, all longitudes, the largest known animal ever to exist on earth, over a hundred feet long and nearly two hundred tons in weight; even in prehistoric times, the blue whale would have dwarfed the largest dinosaur (seawater supports its enormous bulk, and so it could grow much larger than, say, an apatosaurus, which might have stretched to 75 feet long while tipping the scales at 25 to 40 tons). And is it "musculus"? Well, is Schwarzenegger? Are The Situation and Ronnie? The specimen seen here was photographed off the coast of Southern California and illustrates the very best aspect of the blue whale's tale: Our largest-ever animal is still with us. There once were hundreds of thousands; today there are perhaps 10,000 to 25,000. But even that is a blessing, considering the fate of the world's whales—of which we will now learn more.

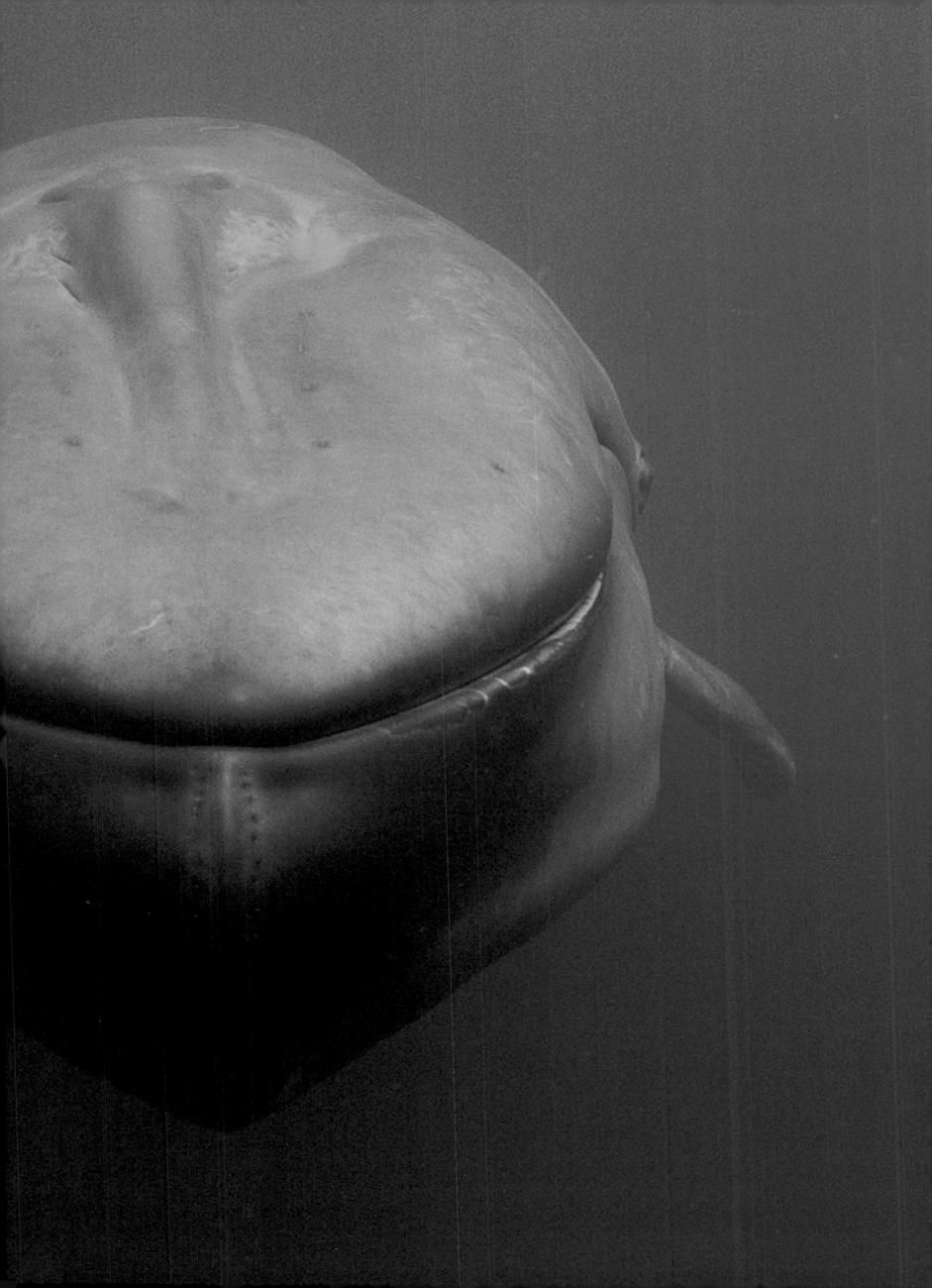

"Right" for the Wrong Reason?

As with the mighty blues, the three species of right whales have baleen plates on each side of the upper jaw to filter the intake of food. The biggest of these creatures, too, are enormous—up to 60 feet in length and 90 tons in weight, 40 percent of which is blubber. They are relatively slow swimmers, and the legend (which is probably just a legend) is that the rights were given their name at the start of the heyday of whaling in the 18th century because a variety of characteristics—including a good store of whale oil and whalebone (baleen), its marginal swimming speed, the species' tendency to swim within sight of shore, and the low density of all that blubber, which causes the whale carcass to float after a kill—led to it being seen as the "right" whale to hunt. They are, today, scarce, and the North Atlantic rights (numbering perhaps 450 whales) and the North Pacific rights (probably fewer than 200) are thought to be headed for extinction. There are 10,000 Southern Hemisphere right whales, and in the Arctic up to 10,000 of the related bowhead whales (opposite). Recent evidence, ivory harpoon tips more than a century old recovered from deceased animals, indicates that some bowheads may be more than 200 years old: the oldest mammals on earth. It is thought that the physiology bowheads have developed over time that allows them to deal with their harsh environment in the far north has also led to this extraordinary longevity.

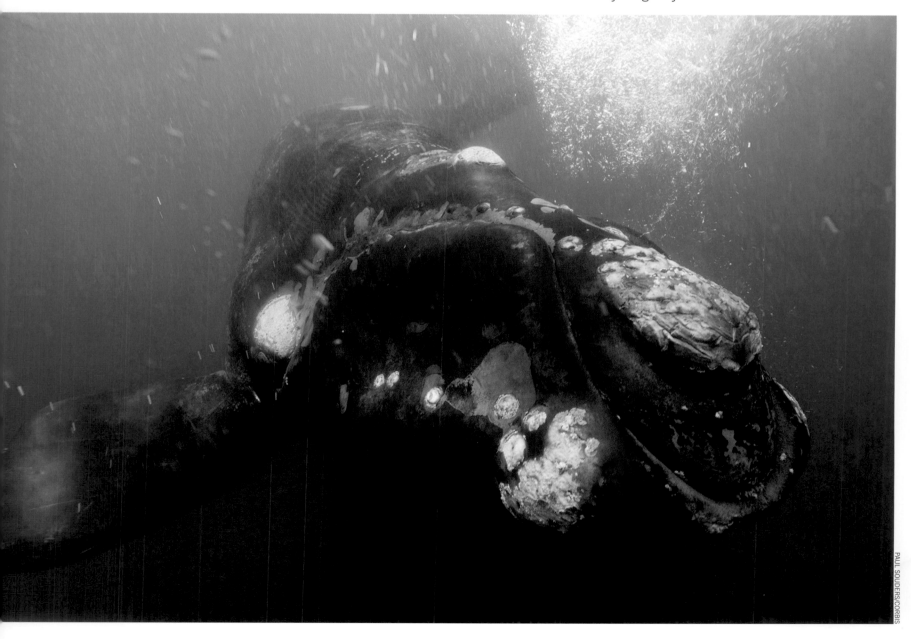

The Comeback Kids

They have been embraced by Drew Barrymore (well, maybe not literally, that would be an impossibly huge hug), and therefore they are among the most famous leviathans since Moby-Dick: the three gray whales that became trapped in the ice off northernmost Alaska in 1988 (one is seen here), and then made their Hollywood bow (portrayed by stand-ins, of course) in the heartwarming 2012 movie *Big Miracle.* The film dealt lightly with some of the controversies surrounding the media-spurred international rescue attempt mounted on their behalf, such as whether it was worth a million dollars and all that human effort to free them from the early-onset pack ice. And the fact is we know one of the whales died, and we do not know if either of the other two, who were in poor health when the ice was finally broken, lived. But what often goes entirely missing in this story is the great news for gray whales. A prevalent theory as to why the trio was so far north in mid-autumn holds that their species had burgeoned in recent years off the North American coast in the Pacific Ocean, and food in their normal migration range was being gobbled up by their brethren. So the woebegone grays had been forced to forage outside their natural range and had got themselves into a pickle when the early ice closed them in. Thus they became unfortunate poster children for what was, actually, an unlikely success story. Grays, big baleens that can stretch to over 50 feet, had been hunted to extirpation in the Atlantic in the late 1700s, and had seen their populations severely diminished in the Pacific. But once attitudes and laws changed, the migratory grays of the Californian coast, who travel tirelessly and winter off Mexico while summering off Washington and Alaska, grew their community to roughly 20,000 whales. In our recent history, that fact squeezed three whales out, tugged at our heartstrings, and led to a movie. It's a good thing.

The Hunted, the Hunters

Whale hunts continue in the present day. Inuit communities in North America are allowed to cull a certain number of bowheads or grays in a season in keeping with cultural tradition; and annually Iceland, Japan, Norway and other countries petition the International Whaling Commission for exemptions to treaties, saying most often that there remains a need to hunt whales for "scientific purposes." Their whalers have sometimes reportedly exceeded or ignored any allowed quota, and the whale meat has been sold commercially. The proliferous minke whale (below), a baleen whale related to the blue and humpback but barely more than 30 feet long at maximum, is a prime target of the modern whaling industry; more than a thousand are killed in a given year. It's harsh treatment for an animal so gregarious—a minke whale hung out with a Californian paddle surfer, swimming along and blowing bubbles, for two hours in 2010—and so eager to entertain whale-watchers. Another ready-for-prime-time whale is the beautiful, sleek, black-and-white orca (right)— the so-called killer whale. Also not endangered, it is by contrast a toothed whale, and can indeed kill, sometimes cleverly. An orca kept at Marineland in the city of Niagara Falls, Ontario, learned that by leaving its food—fish—out for the seagulls, it could attract the gulls, which could then be seized and eaten. In other incidents, human handlers of the orcas have been attacked as well.

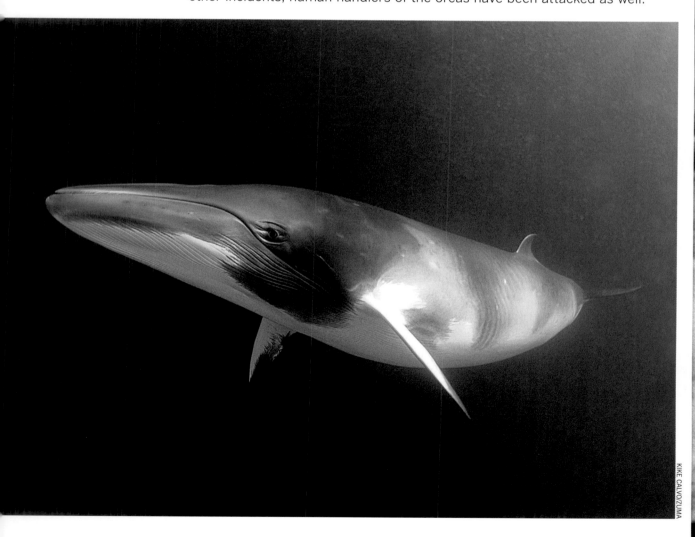

KIKE CALVO/ZUMA

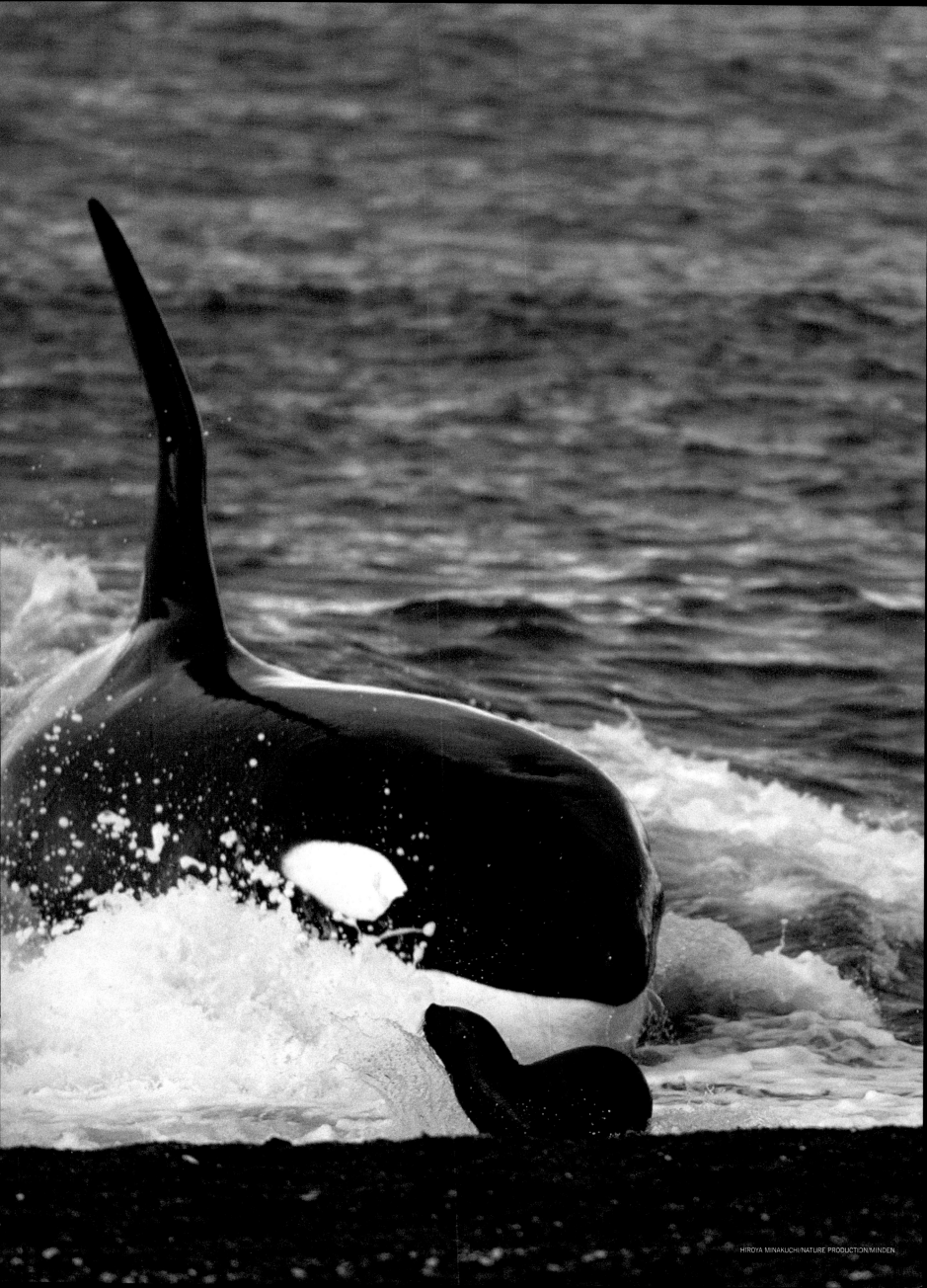

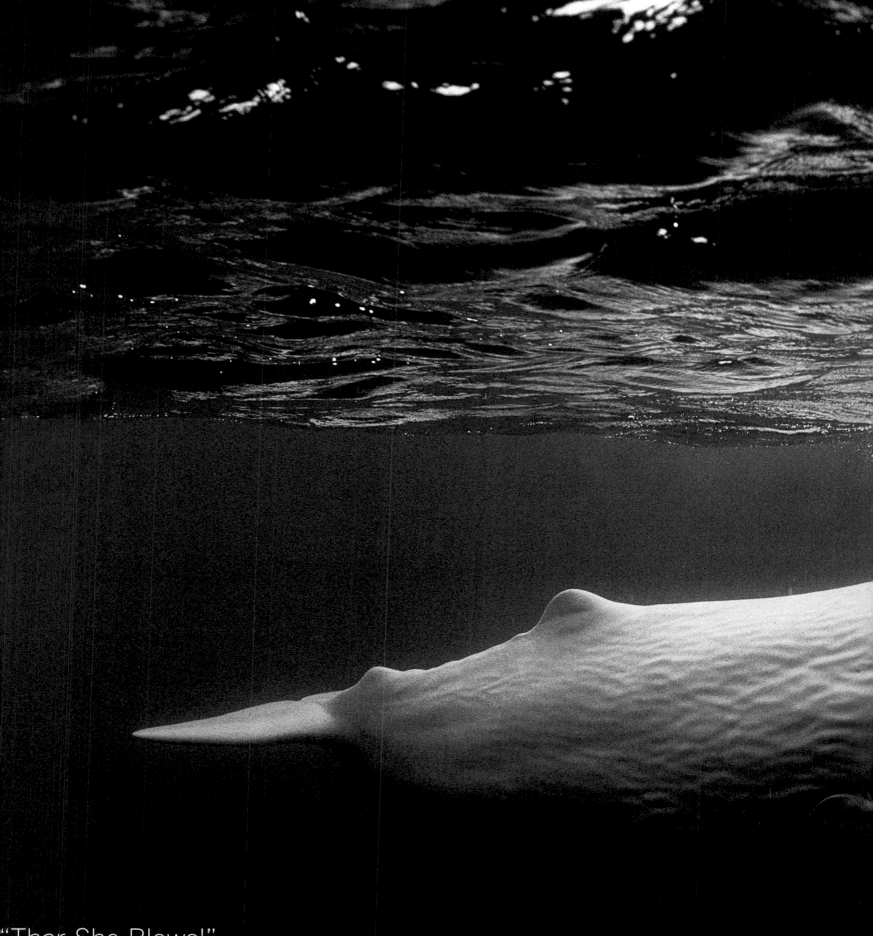

"Thar She Blows!"

Before Herman Melville, there really was a version of the *Pequod,* a real-world whaling ship out of Nantucket that was in fact known as the *Essex.* And there really was a gargantuan and storied sperm whale in the South Pacific; its nickname—passed from ship to ship and, we can imagine, in hushed tones—was Mocha Dick, and obviously that is a short journey to Moby-Dick. Nantucket was the hub of American sperm whaling. Melville crewed for a time on whaling ships. And so: a book waiting to be written. Sperm whales, which Melville thought were the largest in the world (his knowledge of the blue was incomplete), have had a bad reputation ever since. Well, that's not quite true: The novel was a flop in its day, so Melville didn't contribute a lot to the conversation in

1851, but down the decades, his moral tale has come to define this mammoth as a nightmarish beast who might blast or chomp any human adversaries to smithereens. Sperm whales are indeed a toothed, not baleen, species, and they are indeed big, growing to as much as 65 feet in length. They have the largest brains of any mammal on earth, and employ them during dives of more than an hour to depths of nearly 10,000 feet as they hunt for giant squid, a favorite, and fish. The clicking noises employed by the sperm whale for sonar navigation during these extraordinary forays are some of the loudest sounds emitted by any animal on the planet. Melville might have done the sperm whale a disservice by demonizing it so, but he did pick a pretty fine monster—of which perhaps 300,000 remain.

I Am Humpback, Hear Me Sing!

The humpback whale is another big baleen—achieving lengths in excess of 50 feet, and weights of up to 40 tons—but it has several characteristics that set it apart from the blues and the rights. It features long pectoral fins and a head as distinctive, in an entirely different way, as the bowheads. It has an interesting annual program, traveling up to 16,000 miles each year from its summer home in the Arctic, where it gets fat eating krill and fish, and its winter vacation destinations in the tropics and subtropics, where it slims down (in fact, it fasts, living off its fat) and fools around. The males are crooners, their song lasting as long as 20 minutes and repeated all the day long, and the prevalent theory is that it's directed at the ladies during mating season. In other ways, too, the humpback is a born entertainer: a huge whale that nonetheless breaches toward the sky, and thus is a star attraction in the modern-day industry known as whale watching. Tourists certainly present a more welcome audience for humpbacks than the whalers of yore, who killed off the historical population to near extinction. But like the grays of the Pacific coast, this species has bounced back and now numbers at least 80,000 members, half of them singing their happy song as they travel their many miles in all the world's oceans.

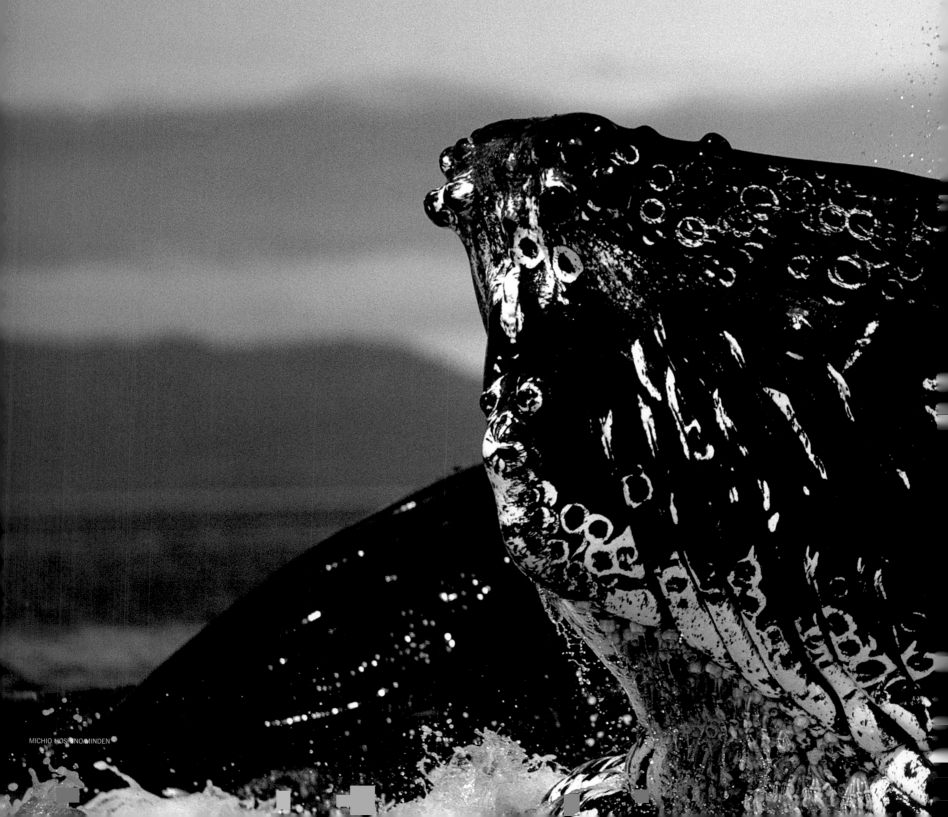

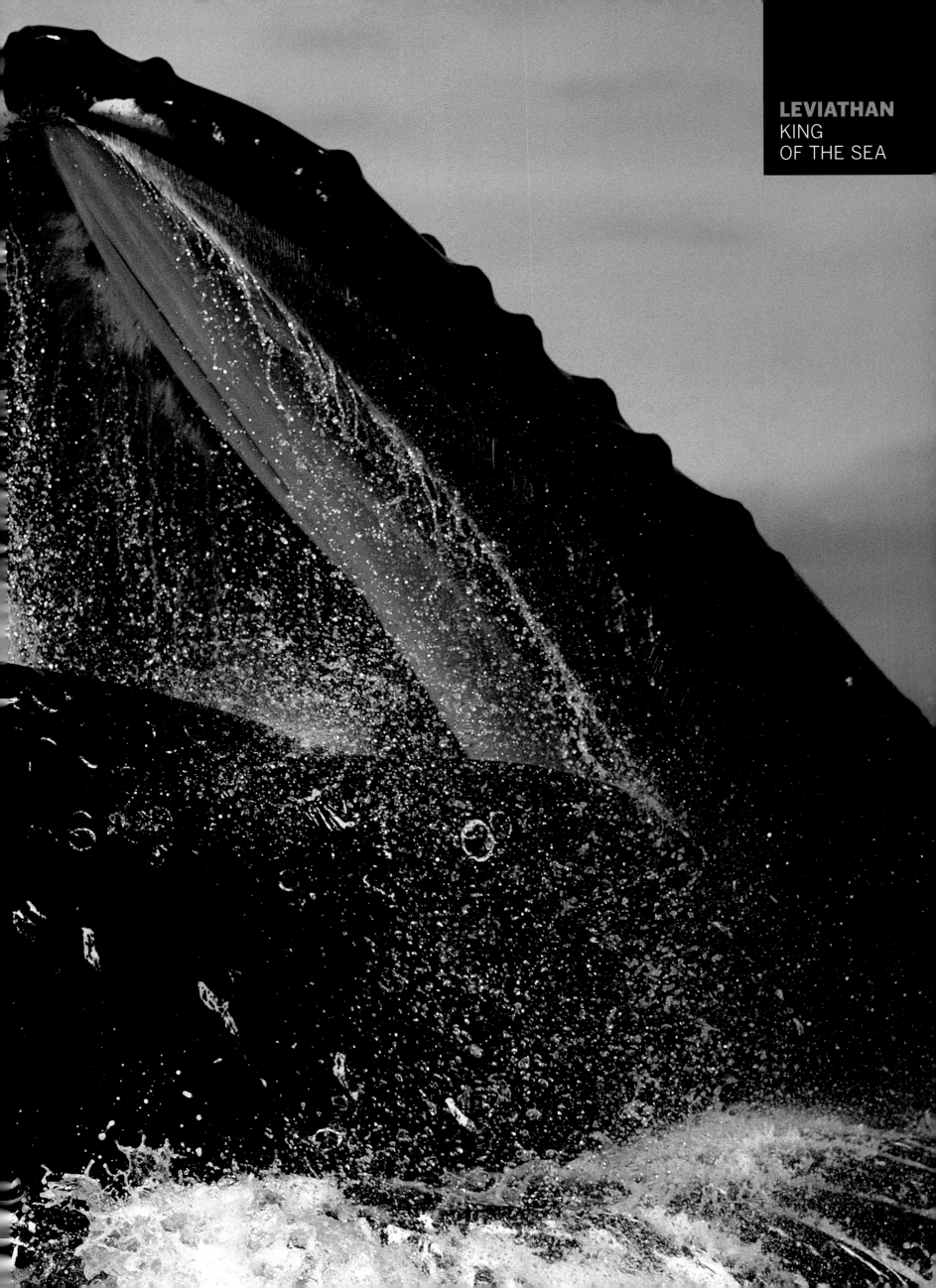

LEVIATHAN
KING
OF THE SEA

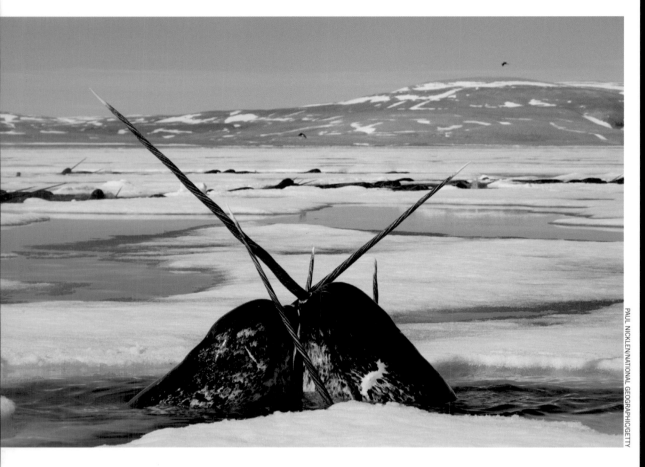

PAUL NICKLEN/NATIONAL GEOGRAPHIC/GETTY

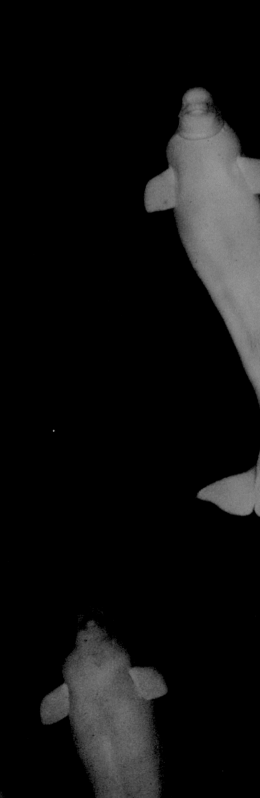

FLIP NICKLIN/MINDEN

Unicorns of the Sea, and Their Tubby Cousins

So this is what happened: An Inuit woman was hunting beluga and she got her harpoon firmly into a big one. The harpoon rope got looped around her waist and she was pulled into the Arctic Ocean, where she drowned and was transformed into a narwhal. Her hair had been done up in a knot, and the topknot metamorphosed into the narwhal's famous tusk. Magic, you say? Ludicrous? Well, look at our friends above, who are the subject of this northern folklore: as mystical an animal as exists on the planet. And surely it does exist: There are 75,000 narwhals, a close relative of the more docile beluga, swimming in the waters off far northern Canada and Greenland (right). Both species are toothed whales, but the narwhal, which regularly grows to 16 feet in length, is a toothed whale that brings true distinction to the term with its long, signature tusk, which is actually an incisor that can grow to nearly 10 feet. In days gone by, the narwhal was hunted more for ivory than meat, and often the tusks were represented on the black market as those of the legendary unicorn. As for the beluga, it is all white, also Arctic and sub-Arctic, and, as we see, equally funky looking. Because of this, it has long been, like its even more exotic fraternal species, a showpiece: A beluga was part of P.T. Barnum's American Museum show in New York City back in 1861. The narwhal and the beluga are happy enough in their natural realm, which most of the rest of us find inhospitable. It would be nice if we left them to it.

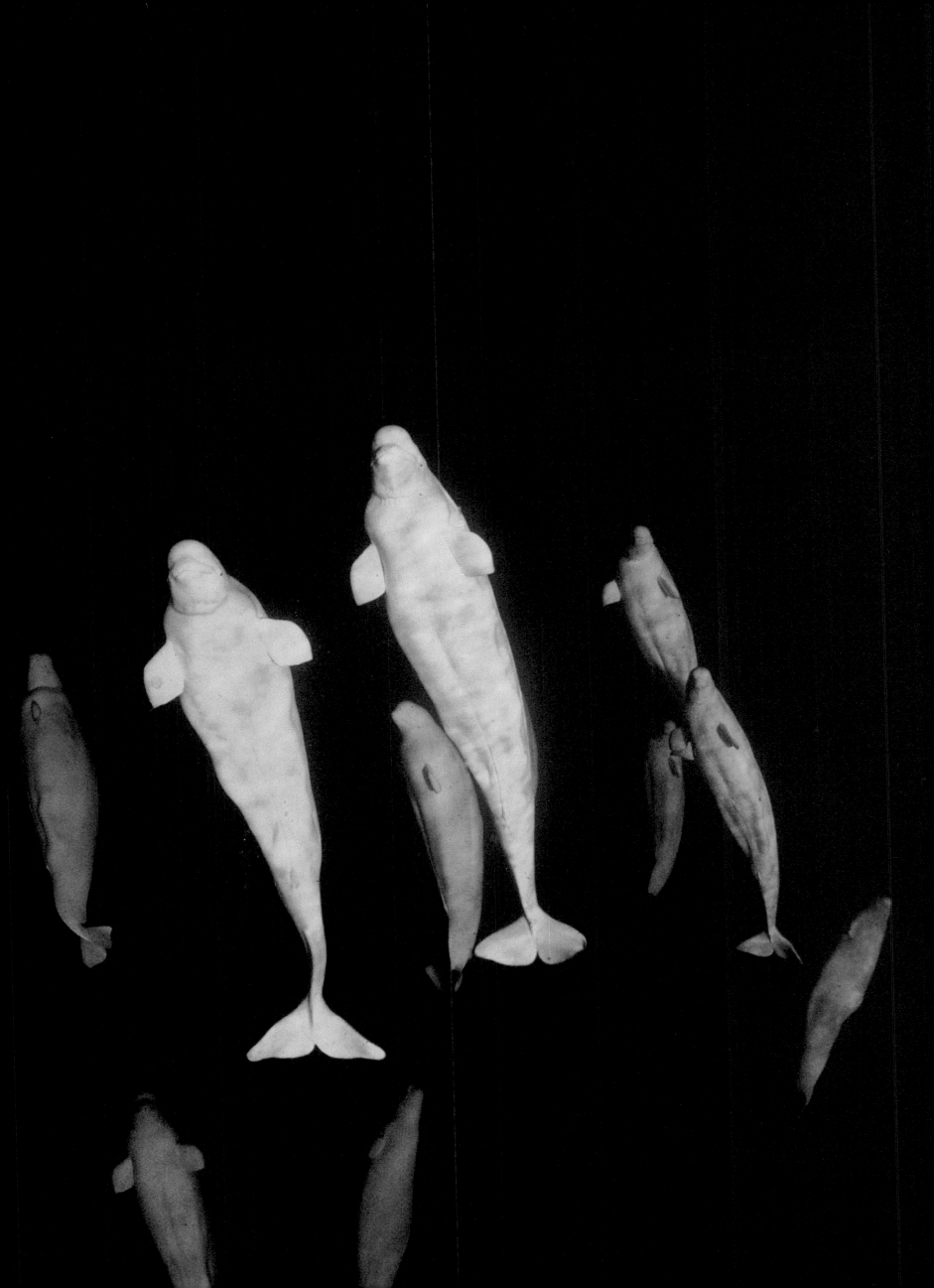

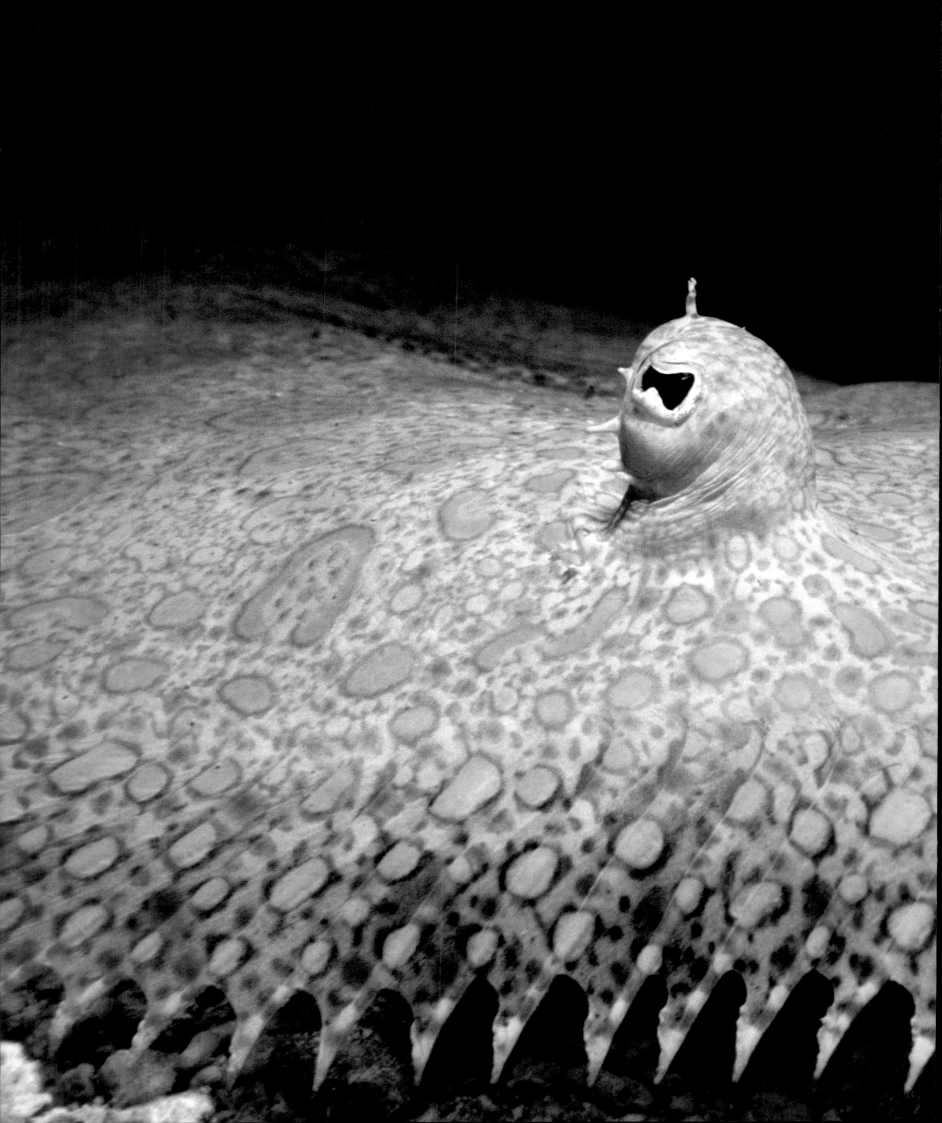

The Smaller Fish
HUNTERS AND PREY

Now You See Me. Now You Don't.

Found in the eastern Atlantic off Ascension Island and in the Gulf of Guinea, and in the western Atlantic from Florida to Bermuda and the Bahamas to Brazil is one of the ocean's greatest masters of disguise, the equal of the bright young batfish we will meet on the following page or the astonishing stonefish we will meet on page 44. This is the peacock flounder. Although obviously here in its uncloaked olive green and peacock blue spots, this flatfish possesses a rapid-fire camouflage reflex and can often be found—if found at all—posing as part of a coral reef or the sandy ocean floor. How does such a peculiar looking fish make with the invisibility cloak? It's a mind-body connection. Like most fish, it is born with an eye on each side of its head, but as it grows, one eye gradually moves around to meet the other on the left side of its face. At about this time, the peacock flounder also begins to swim sideways—or flat—against the sea bottom. Capitalizing on this low-lying position, it uses one protruding eye (each eye works independently of the other) to scan the surroundings for prey and predators, while the other is responsible for noting the color and pattern of its environment. This ocular observation quickly sets off hormones when the need arises, and these spark skin pigments that begin the camouflage process. In scientific research, the peacock flounder's talent for mimicry has proved so exact, certain specimens have been able to duplicate the pattern of a checkerboard. A last, equally fascinating fact about this fish: If its one photographic eye is obstructed by sand or disabled by injury, the chameleon fish is unable to change color at all.

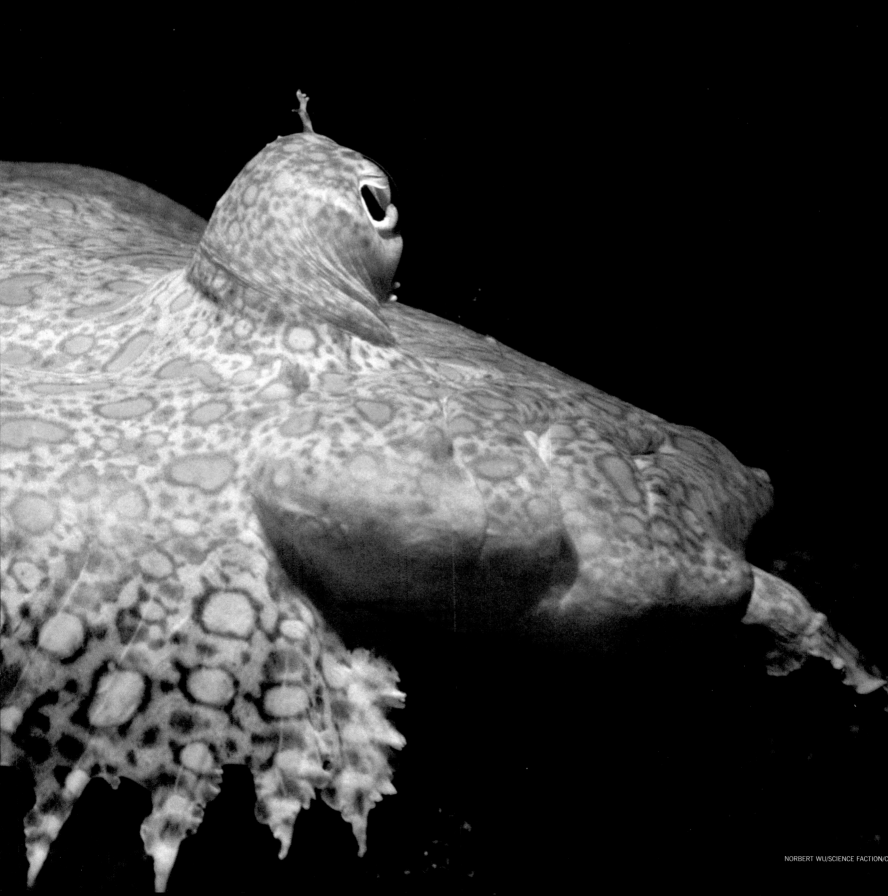

Tricksters

Thousands of ornately colored and singularly eccentric creatures inhabit the warm waters and reefs of the Indo-Pacific ocean region. Two of these aquatic beauties are the pinnate batfish and the orange-striped triggerfish. Known by several names—including dusky and long-finned—the biggest pinnate batfish still reach only 20 inches top to bottom. As juveniles (shown below, left, on a Philippine reef), pinnate batfish practice a unique impersonation: Swimming solitarily in a velvety black suit trimmed with vivid

DAVID FLEETHAM/VISUALS UNLIMITED/GETTY

BIRGITTE WILMS/MINDEN

orange, the youth is the spitting image of a poor-tasting polyclad flatworm in shape, color and locomotion. Because of the young batfish's similarities to that undesirable, most predators stay away, leaving the child to mature into a silvery adult that travels in shoals and hardly resembles its younger self at all. If the batfish is an entertaining trickster, the orange-striped triggerfish, seen below in Egypt's Red Sea, has a meaner streak. Known for its nasty demeanor, this bottom dweller uses tough teeth and jaws to aggressively dine on shellfish and worms. It exhibits few scruples, going so far as to squirt water from its mouth to unearth prey or to flip over sea urchins so it can dig out their tasty bellies. This fearless 12-inch terror will, when nesting, charge and even bite human divers. The triggerfish is named for a set of dorsal spines it uses to lock itself in place while hiding from predators in rocky holes and crevices. Once this mechanism has been "triggered," it is nearly impossible to dislodge the fish. If fish sported sleeves, the batfish and triggerfish would be renowned throughout the seven seas for having nifty tricks up their sleeves.

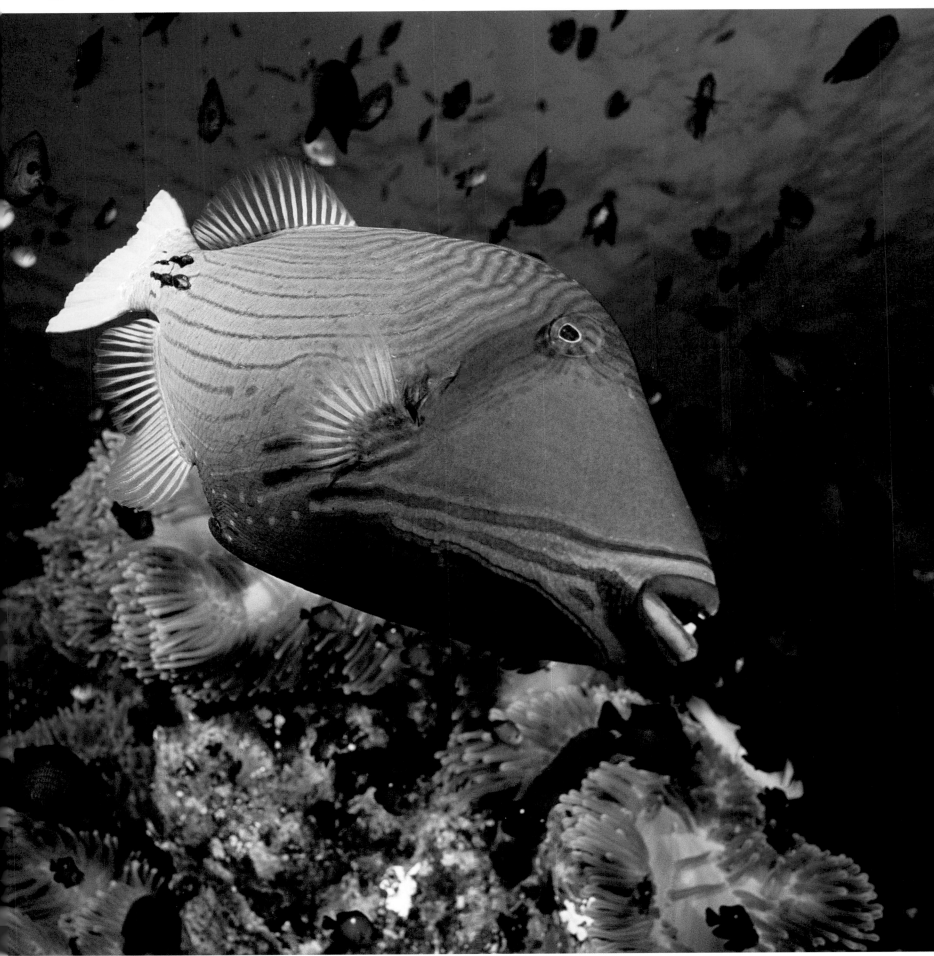

As If Drawn
by Dr. Seuss

As if named by him, too! Meet, here, a freckle face blenny, more formally: a species belonging to a suborder of small fish called blennioids, which trace part of their heritage all the way back to the Paleocene Epoch. This specimen is burrowing in the sand in five feet of water off the Solomon Islands in the Pacific Ocean. That is characteristic behavior: Blennies are generally shy, bottom-dwelling fish that gravitate to rock pools, reefs and kelp beds. (Having said that, several blenny families range as much as 1,500 feet below the surface). The blennies, some of which are herbivorous and some of which are carnivorous, seem willing to acknowledge their relative vulnerability, and will hide in almost anything, including, say, empty clam shells. Though the freckle face likes the warm waters of the Pacific, blennies are found as well in all the world's temperate or cold-water seas. In fact, the blennies living off the U.S. coast in the western Atlantic Ocean enjoyed, decades ago, a singular distinction. The USS *Blenny*, a submarine, was named in tribute to the fish upon her launch in 1944. She sank eight Japanese vessels during World War II and destroyed more than 62 small craft by gunfire. Postwar, she served in the Atlantic Fleet for a time, then was decommissioned in 1969 and purposely sunk in 1989 to form part of an artificial reef off Maryland. It is probably sentimental to think that there might be blennies hiding in her wreckage, wanting nothing more than to be left alone.

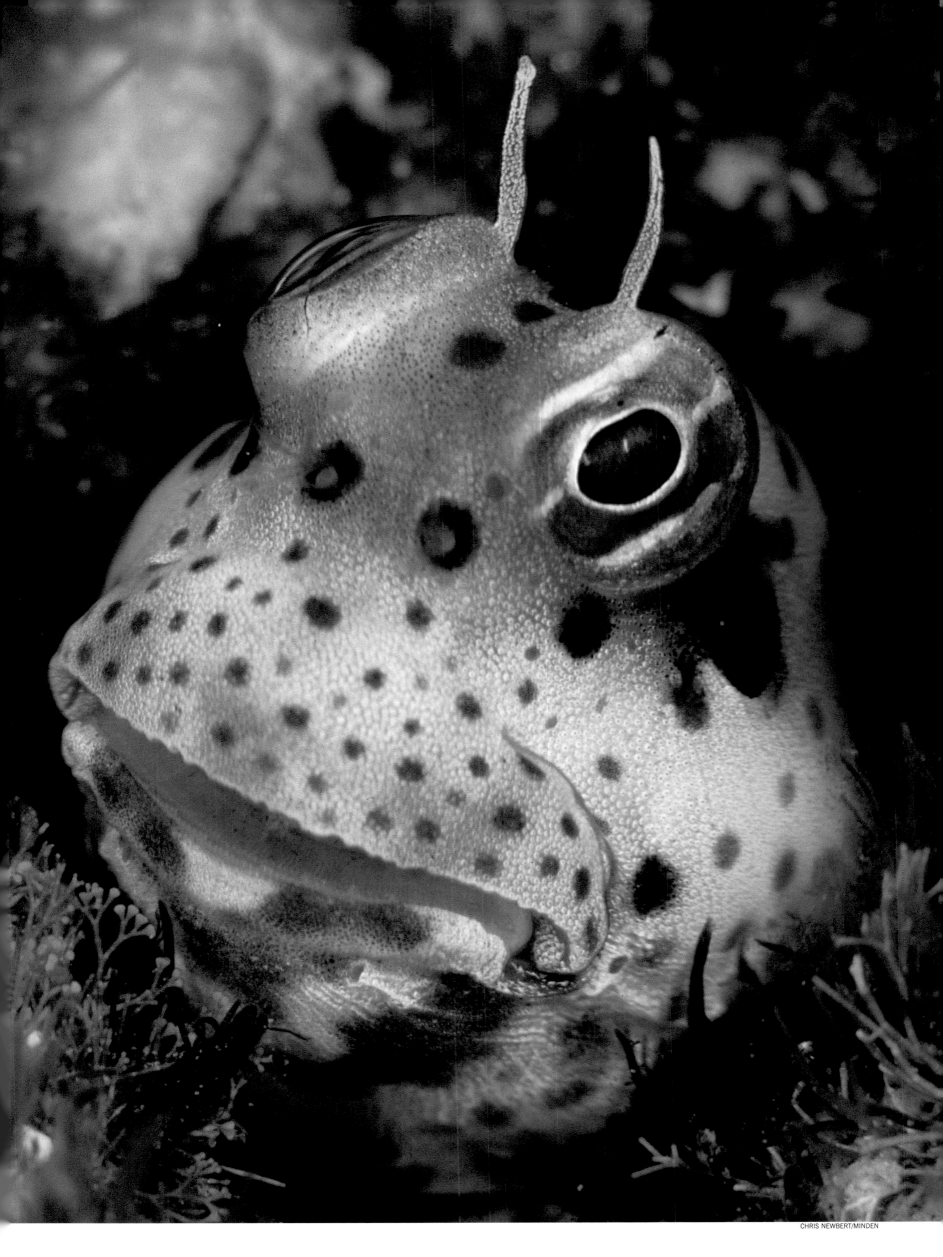

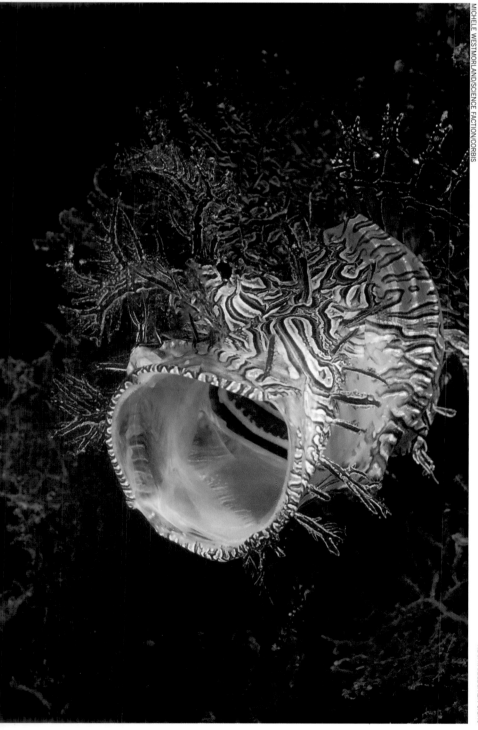

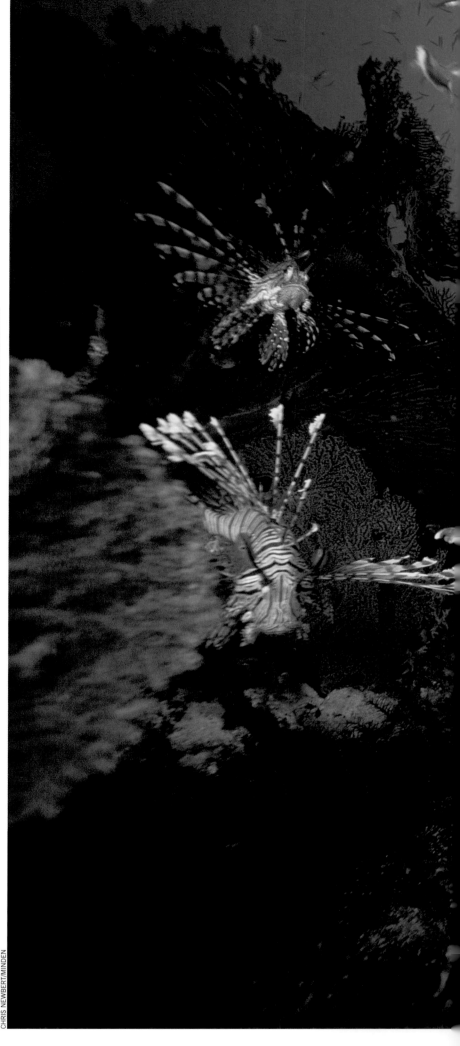

Scorpion, Where Is Thy Sting?

We turn here to two scorpionfish, a collective of which the turkeyfish on the following pages and the stonefish on page 44 are also members. Many scorpionfish look nothing alike, and it is worthwhile and entertaining to visit a few of them to discern how a diverse family adapts and behaves. At left, above, is a yawning, sucking weedy scorpionfish off Papua New Guinea; above, surrounded by sea fans, are lionfish, 60 feet deep off the Solomon Islands. As with the turkeyfish, the lionfish, which can be identified by its red, black and white

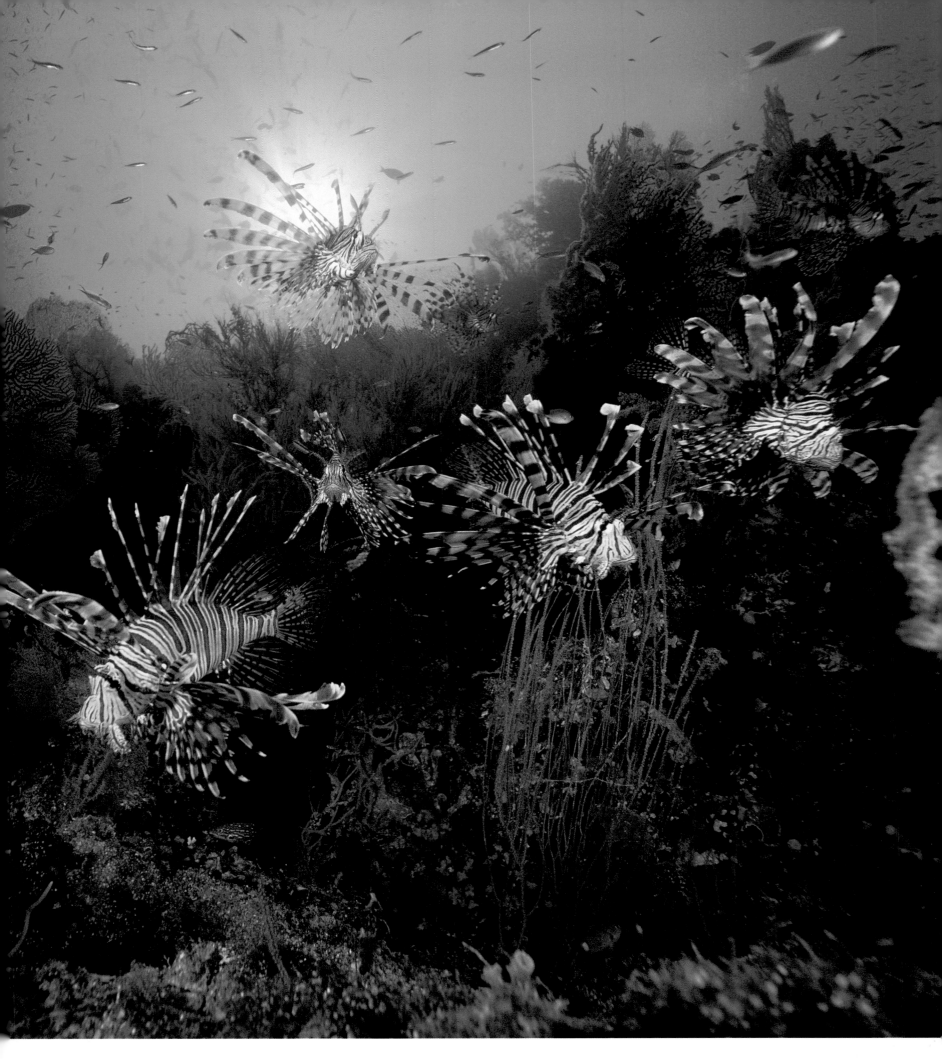

bands, has several spiky fins that are highly toxic. Like the turkeyfish, the lionfish is a hunter given to ambush attacks, and it is more than happy to be the aggressor. This makes it, despite a relative lack of size, a formidable foe, and it has few natural predators this side of sharks. Its toughness and desire to spread its range have, in recent years, caused problems—most notably in the United States. The lionfish is, as this picture implies, native to the Pacific. In the mid-1990s, the red lionfish and the common lionfish were inadvertently introduced to the Atlantic Ocean off the U.S. eastern seaboard, and they have subsequently invaded and conquered various habitats up and down the coast and in the Caribbean. The lionfish population in the Atlantic continues to burgeon today, and eradication efforts have included bounties and "lionfish derbies." More recently, there has been an effort to convince people that these venomous fish are safe to eat; the National Oceanic and Atmospheric Administration calls it "a delicious, delicately flavored fish." Some recent seafood cookbooks have included recipes for lionfish ceviche, grilled lionfish and even lionfish jerky. An odd conservation effort, perhaps, but as they say: Whatever works.

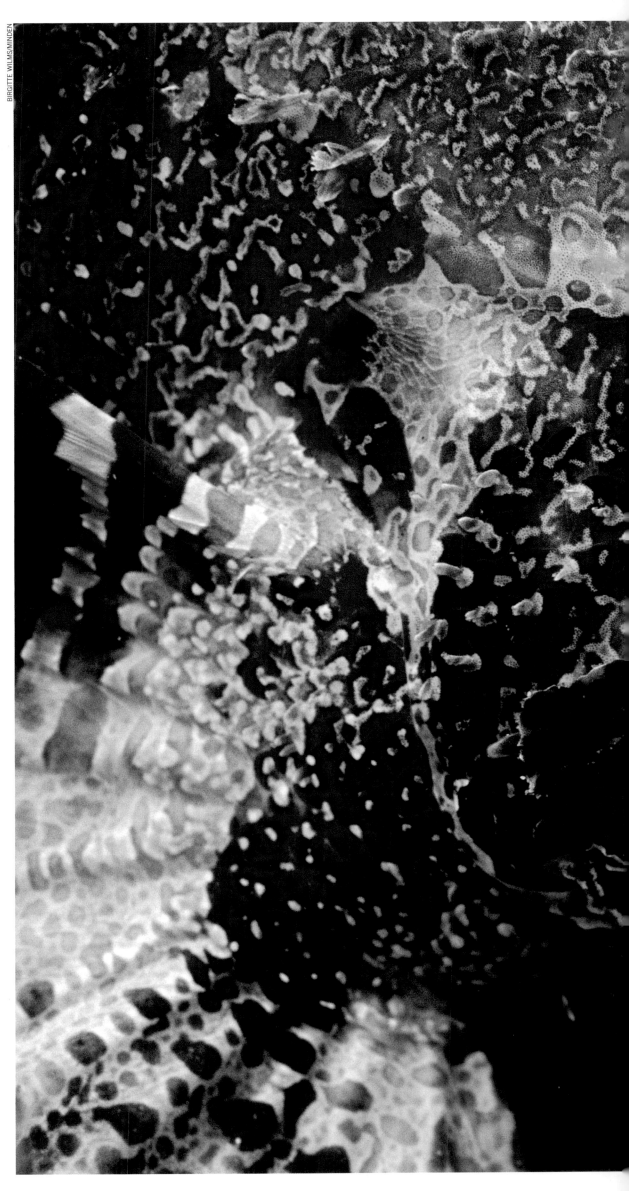

BIRGITTE WILMS/MINDEN

Fish, Not Fowl

The common name for this colorful fellow off the coast of Indonesia is the short-fin turkeyfish. That certainly sounds mild enough, until you consider that it is a member of the family of marine life called scorpionfish and his close brethren include the firefish, the lionfish (whom we just met), the dragonfish and the stingfish. Those monikers tell a more accurate story and give fair warning: The multispecies scorpionfish clan includes many of the world's most venomous marine animals. Most members of the family, including the turkeyfish, come armed to the teeth. The turkeyfish's dorsal fin features over a dozen spines, and the anal and pelvic fins also have stingers. At the base of each spine is a venom gland that secretes a poisonous mucus that coats the fish's weaponry. The good news for human divers in the Indo-Pacific region, where scorpionfish are proliferous, is that the six-inch-long turkeyfish and its relations routinely look the other way when confronted by something as large as man. The shortfin turkeyfish frequents the shallows in lagoons and reefs where it eats even smaller fish and crustaceans, though some live deeper—as much as 250 feet and more below the surface. (Some other species of scorpionfish live as much as 7,200 feet down.) Scorpionfish are sneaky with their venomous spines and also with their dining habits: They open their grim-looking mouths and gills almost simultaneously, creating a suction impossible for their prey to resist. The turkeyfish: small in size, perhaps, but big trouble for any who oppose it.

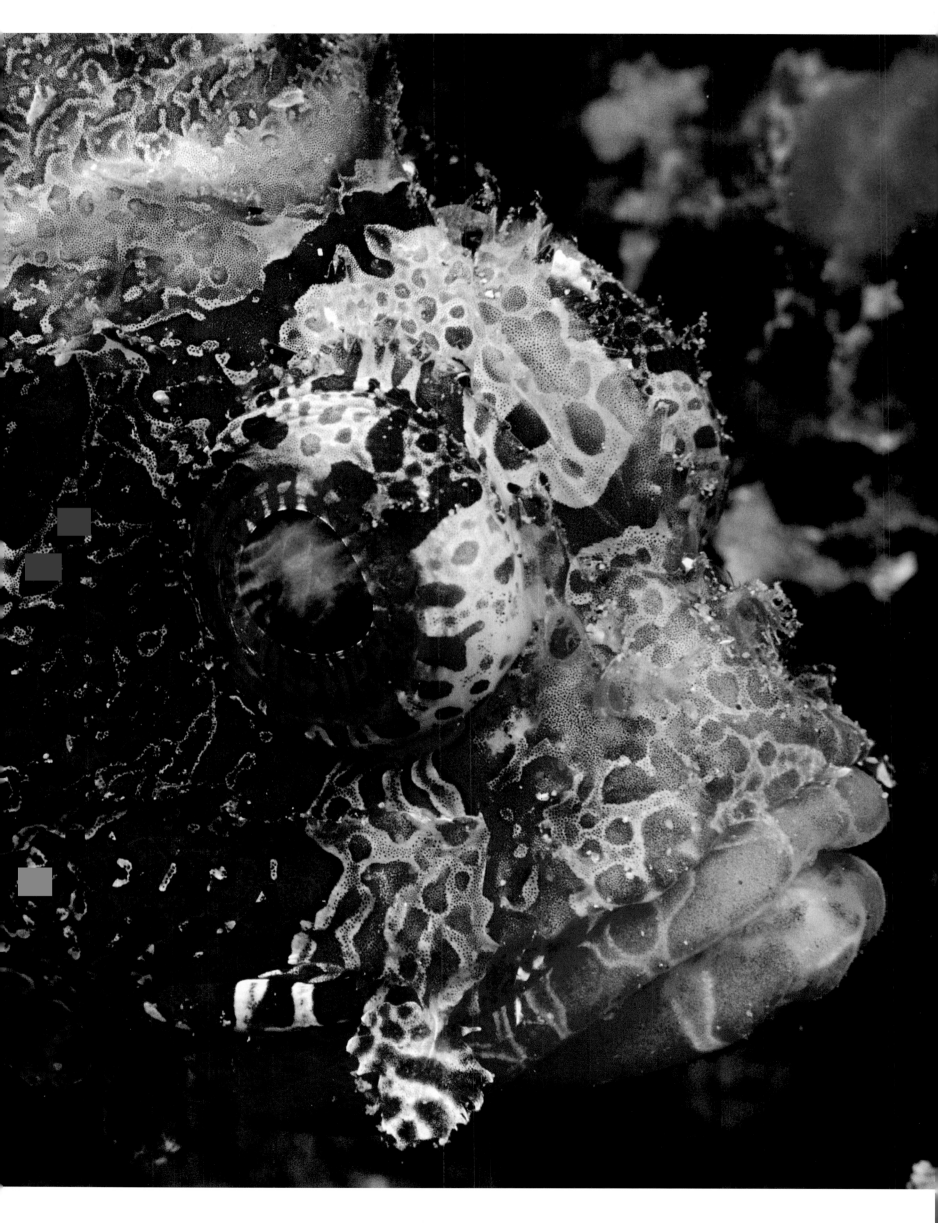

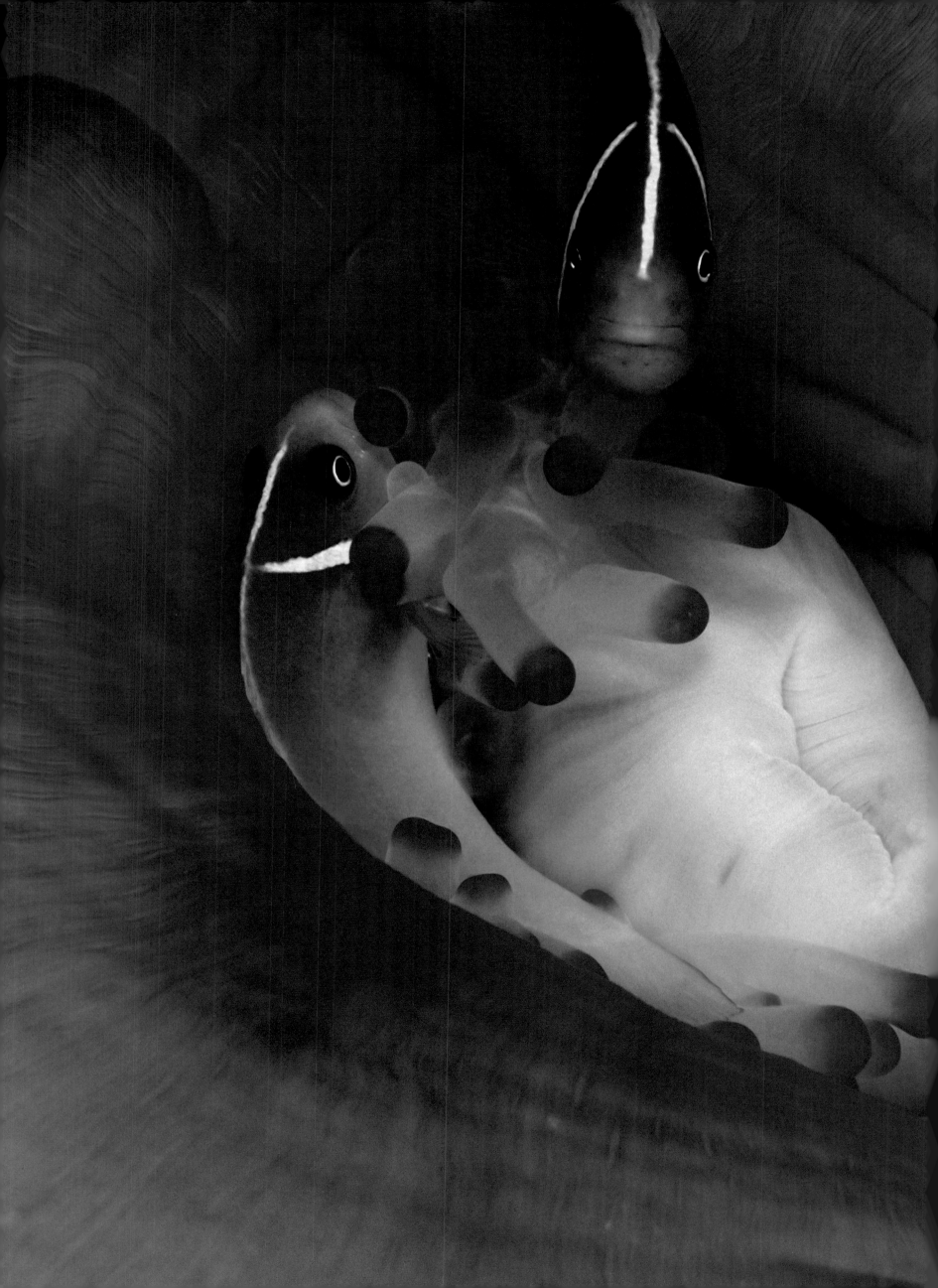

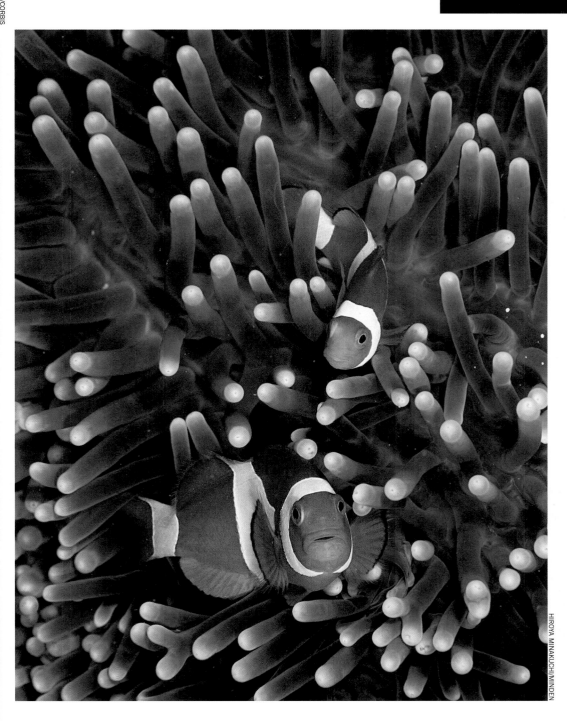

Not Clowning Around

A few years ago, in the considerable wake of Disney's wonderful animated film *Finding Nemo*, the clown anemonefish (above) was, for a time, the best-known and probably best-loved fish in the world. Its short-form nickname—clownfish—only enhanced the cheerful personality Nemo-lovers were ascribing to the little fellow, as did the fact that it was one of the select saltwater fishes that could be tank-raised and, therefore, brought home as a pet. For a while, we had something of a clownfish craze, since abated. Be that as it may, the amazing story of this fish and its symbiotic relationship with its host animal, the anemone, perseveres, and hopefully ever will. Yes, those many-tentacled organisms interacting with anemonefish (left, two pink anemonefish) on these two pages are not plants, but anchored animals—and coconspirators with the anemonefish. The fish's body is shielded with a thick layer of mucus, allowing it to hide amid the tentacles of the fish-eating anemone (the anemonefish is the rare critter that is safe anywhere near this carnivore). On regular occasion, the anemonefish ventures out in service to its pal and protector. When a hungry fish spots one swimming about, it closes in, but the little fellow darts under the anemone's tentacles and the chasing predator gets stung, then pulled into the anemone's hidden mouth. The anemone gives shelter, and is in turn provided with . . . well, with a fishing buddy.

"Ribbet!"

No, that is not the vocalization of the hideous creature seen on these pages, but the creature's name is in fact frogfish. Below, left, is a pair of Commerson's frogfish in Indonesia's Lembeh Strait (divers have found more than a half dozen different species here); and on the right is a striated frogfish attracting a juvenile largescale blackfish with its lethal lure near Nagasaki, Japan. Despite the proximity of these two sites, frogfish are not exclusive to the Pacific but are found in tropical and

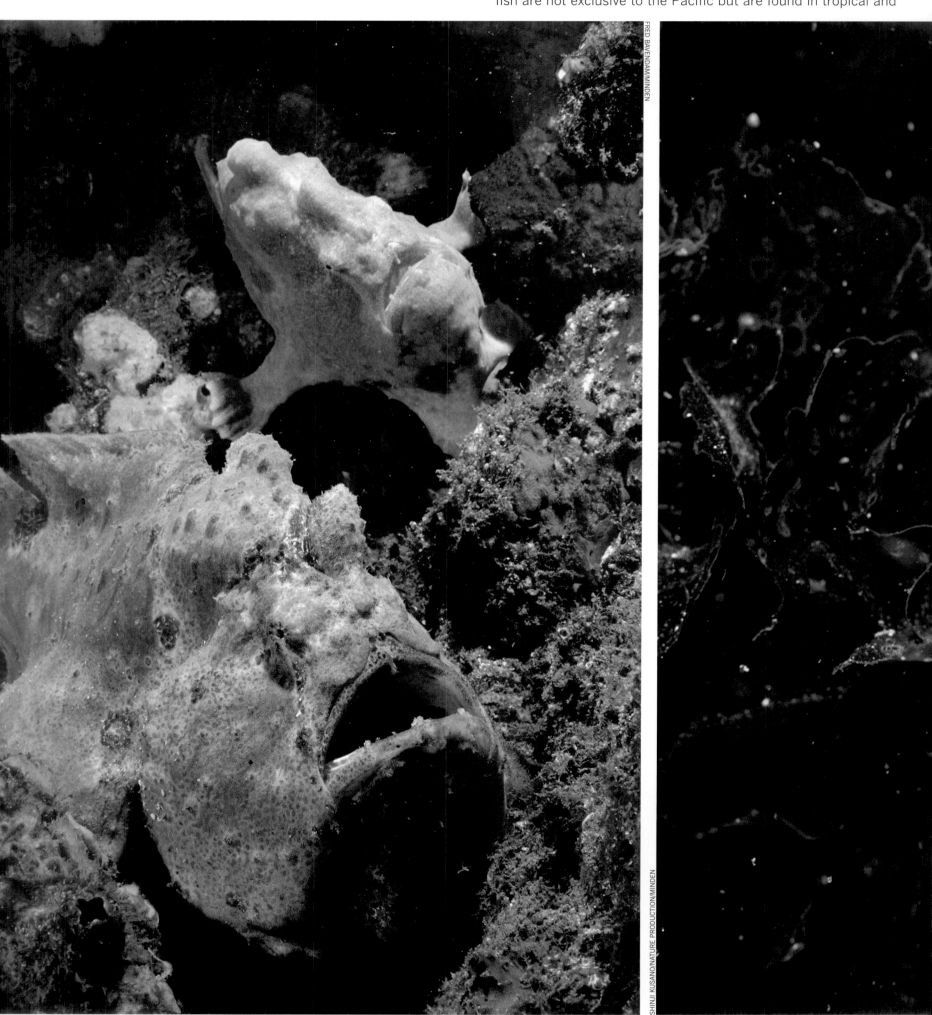

FRED BAVENDAM/MINDEN

SHINJI KUSANO/NATURE PRODUCTION/MINDEN

subtropical regions of the Atlantic and Indian Oceans, as well as in the Red Sea. The frogfish lives at depths of 300 to 700 feet, far shallower than those frequented by its even more bizarre cousins in the anglerfish family (please see page 78). The brackishwater frogfish, in fact, is happy in the ocean, but also swims into brackish water or even freshwater at a river's mouth. Ranging in size from an inch to just more than a foot, frogfish come in many colors—white, yellow, red, green, spotted—and blend in with coral when swimming on the reef. As for that lure: It's a feature of many frogfish. It is actually one of the animal's three fins, and mesmerizes prey. Crustaceans or smaller fish come in for a close look, then find themselves in the frogfish's large, upturned mouth. The frogfish is something of a custom-made model: It has its anglerfish hunting mechanisms and instincts; a wonderful talent for camouflage like the stonefish we will meet on page 44; and the ability to inflate as if to threaten, like the pufferfish on page 46. Nature gave the frogfish everything it needs, except perhaps good looks.

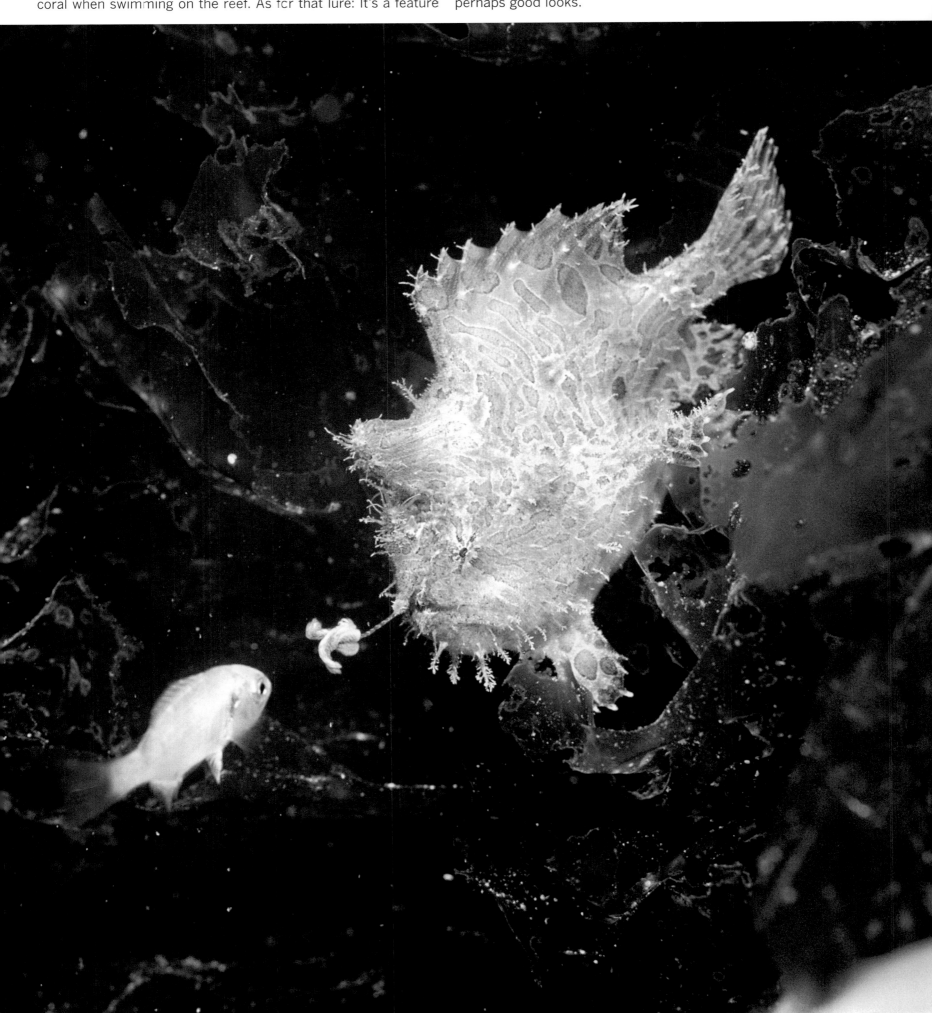

The Preyed Upon
and the Predator

Swirling like a silvery tornado under a pier at Esa'ala Wharf, which extends into Milne Bay in Papua New Guinea, is a dense school of sleek silversides. Found in tropical and temperate salt- and freshwater environments, silversides are a large family of small fish that make up approximately 25 genera and 160 species worldwide. Known for traveling in crowded clans, silversides employ a "safety in numbers" mentality to ward off predators while feeding on zooplankton. On paper, this appears to be a sound tactic, perhaps, but in practice it does little to protect the

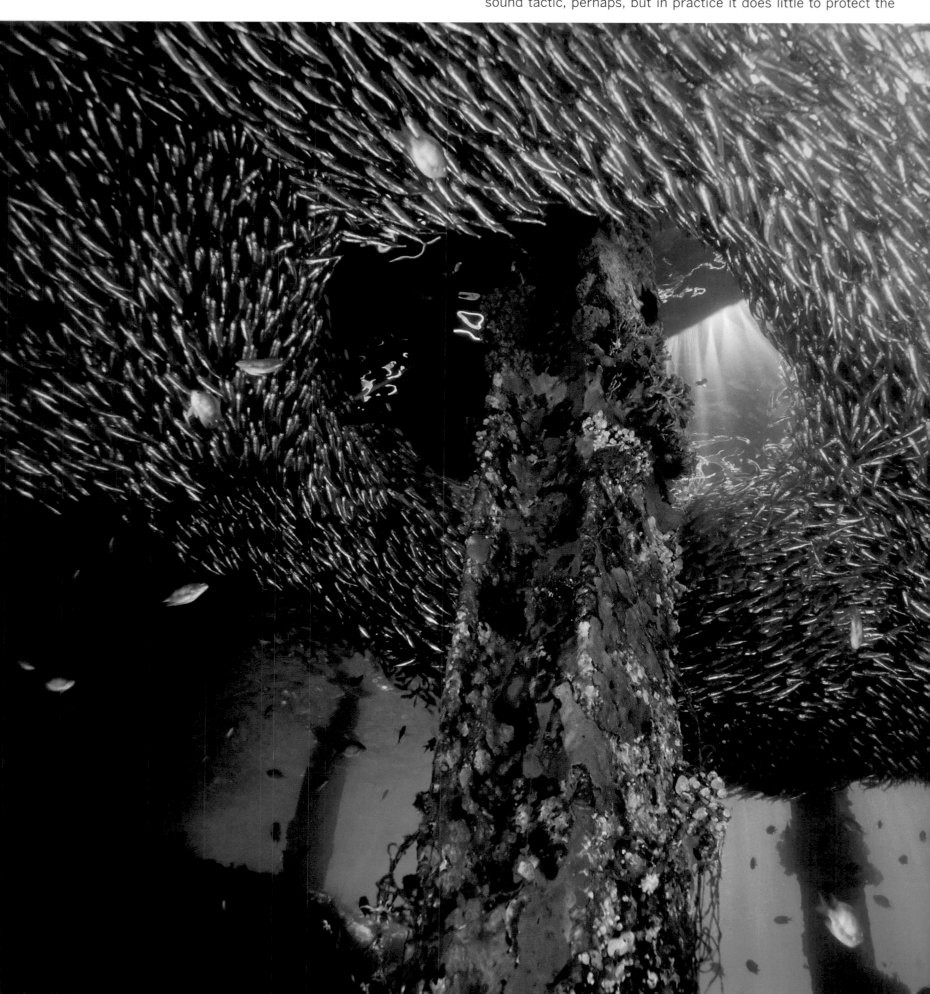

fish, which are not only plentiful in number but conveniently bite-size. Sadly for them, the silverside's principal role is to provide a vital link in the food chain as a very important nutrient source for bigger fish, aquatic birds and mammals. By contrast, the noxious stargazer (right) is nobody's free lunch. Seen here buried up to its eyelids in the sands of Lembeh Strait in North Sulawesi, Indonesia (where we just met a specimen of his philosophical kinfellow, the diabolical frogfish), the stargazer has adapted to a grounded life—literally, a life in the ground. It possesses shovel-like pecto-ral fins powerful enough to burrow in and bury itself in a matter

of seconds. From underneath all that sand, the stargazer's round eyes look up toward the heavens—hence the name—while its flat head, tapered body and upward-slanting mouth, fringed to keep out debris, remain still, poised for unsuspecting passersby. When a victim comes along, the stargazer leaps and gobbles it whole. Venomous in the extreme, the stargazer is a potent defender as well as aggressor, able to inject poison from spines on its back or produce an electric current—up to 50 volts!—via a specialized organ behind its eyes. It's hard to conceive that such as silversides and stargazers share the same seas.

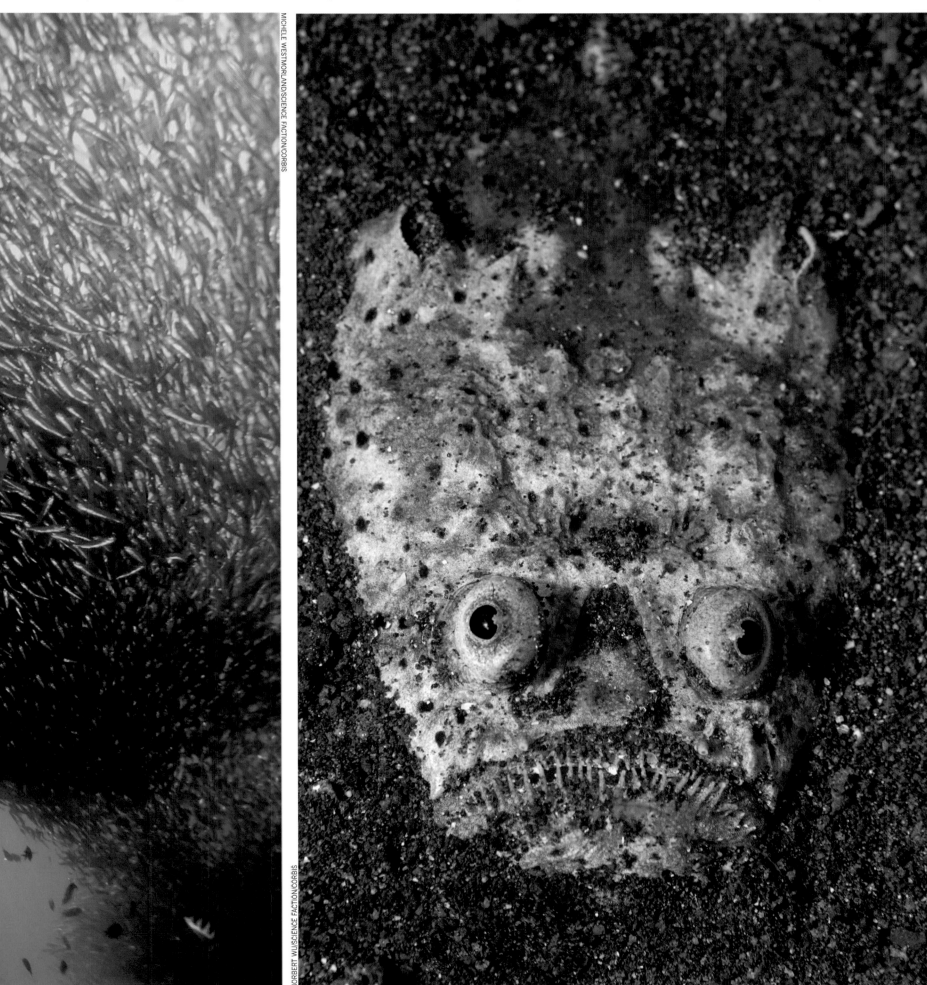

Slim and Sly

Hovering here over the world's largest coral reef, the Great Barrier Reef off the northeastern Australian coast, is a decidedly different looking fish: the bluespotted cornetfish. An inhabitant of the Indo-Pacific, eastern-central Pacific and Mediterranean Sea regions, the bluespotted is long and slender and maxes out at five feet in length. Tipped with an extended tubular snout and small mouth at one end, and a white tail filament at the other, the bluespotted cornetfish is olive green in color with either two blue stripes or rows of blue spots down its back. Closely related to (but looking nothing like) the sea horse, the cornetfish is yet another camouflage artist. When stationary, it adapts a barred pattern to blend against rocky reefs or beds of sea grass. When swimming near the surface, these mottled markings are replaced by the bluespotted cornetfish's signature blue stripes and spots. As both a preyed upon fish and an ambush feeder, this changeover technique not only works as a defense mechanism but also a predatory tactic. Drifting motionless like a stick on the surface, the cornetfish stalks small fish, crustaceans and other invertebrates then suddenly comes alive to suck them up like a vacuum. There have even been reports that the bluespotted cornetfish uses its stealth approach to feed on the venomous lionfish, sneaking up and catching it from behind, and eating it tail first to avoid its poisonous spines. Just desserts, you might say, for the lionfish, which also prides itself on its talents at ambush.

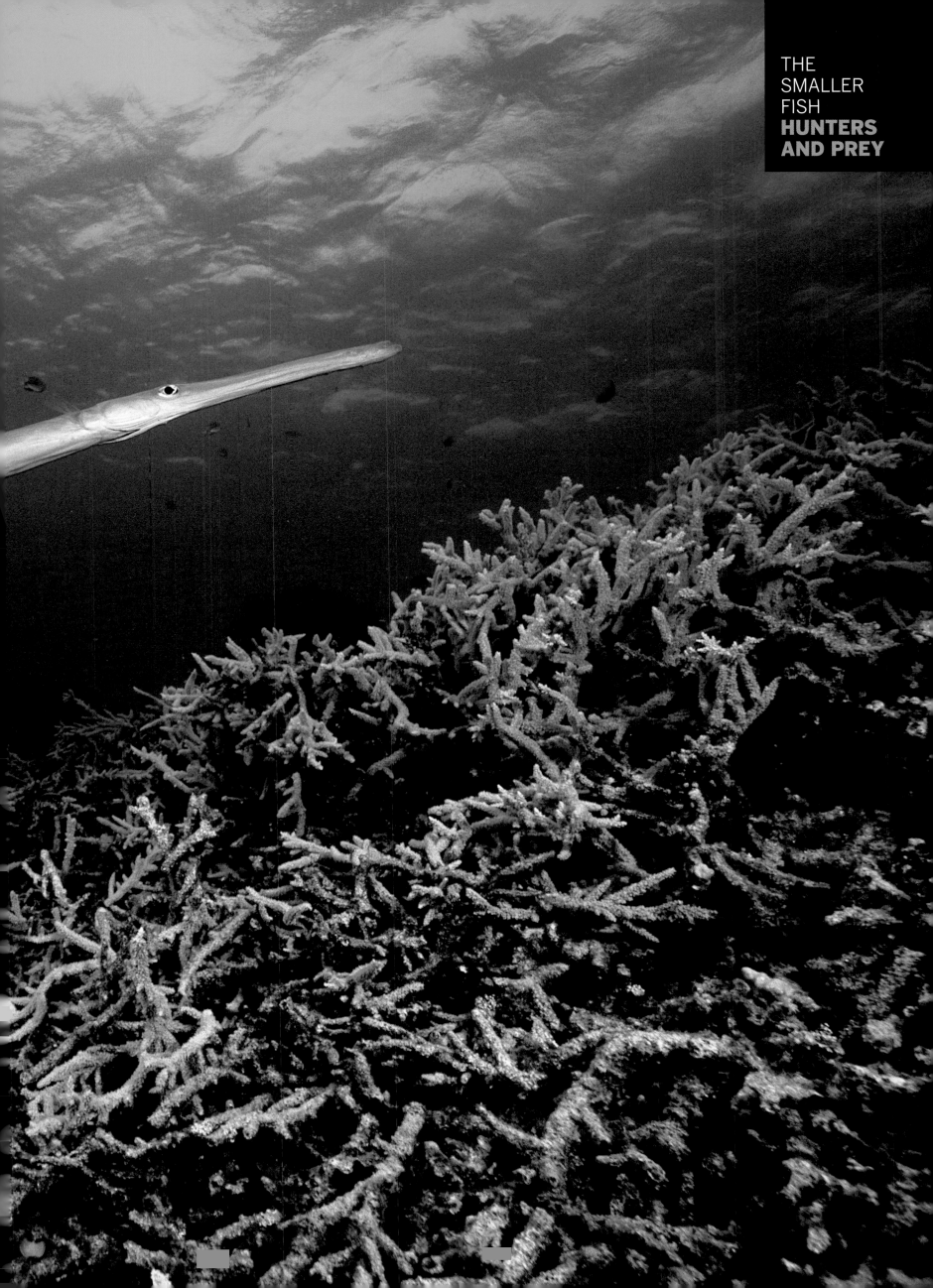

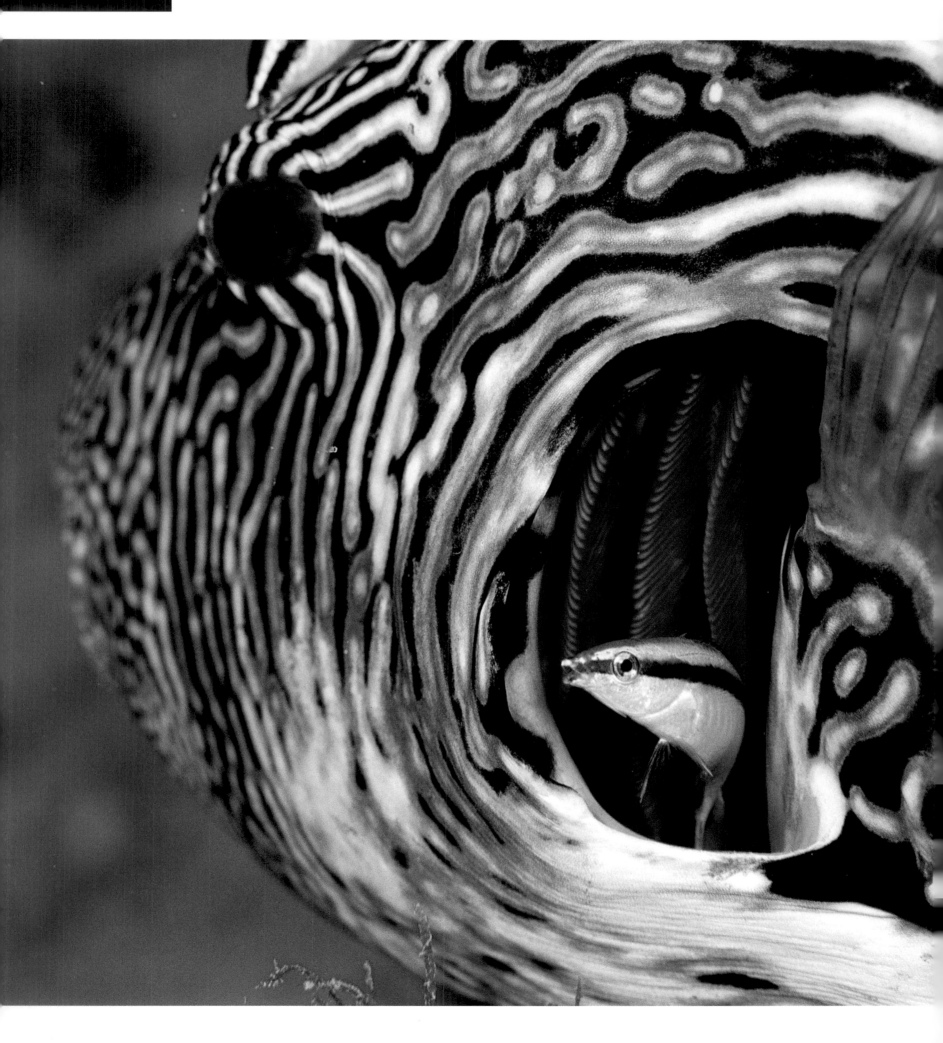

Helping Itself, Helping Others

The names of the fish species on these pages say much. Below is a lizardfish off Borneo's Sangalaki Island. *Boooo!* At left, the wee fish is a bluestreak cleaner wrasse, happily mopping the gills of a map pufferfish in 80 feet of water off the Solomon Islands. *Yaaaay!* The lizardfish is a small predator represented in more than 60 species throughout the world. It is all dentistry. Its relatively large and long mouth is filled with spiny, needle-like teeth. Stranger and more ominously: Even the fish's tongue has teeth on it. The lizardfish's modus operandi is hunting, for which it is clearly well equipped, and it will venture to surprising places—brackish water at the shore, silt-filled areas, rubble-choked habitats—in search of prey. The cleaner wrasse could not be a more distinct counterpoint. This is the very definition of an aquatic altruist. "Symbiosis" in the animal kingdom is when one entirely unrelated species helps another. A small bird, for instance, eats parasites off a hippo. Or a cleaner wrasse does the same in an act that provides not only food but protection for the smaller fish (cleaners grow no bigger than four inches) and relief for the larger one. In the ocean, "cleaning stations," which work like car washes, become destination sites for animals from pufferfish to sea turtles. The stations are manned, so to speak, by small, algae- or parasite-eating fish; not all of these are cleaner wrasses, but various species in need of a wash do recognize cleaners by the stripe running the length of their bodies. The bigger animal submits, allowing the cleaner free access to gills, body and even mouth—places hard to otherwise reach. Lest you think the lizardfish wouldn't appreciate this manner of kindness, look closer: It, too, is getting a once-over by a wrasse.

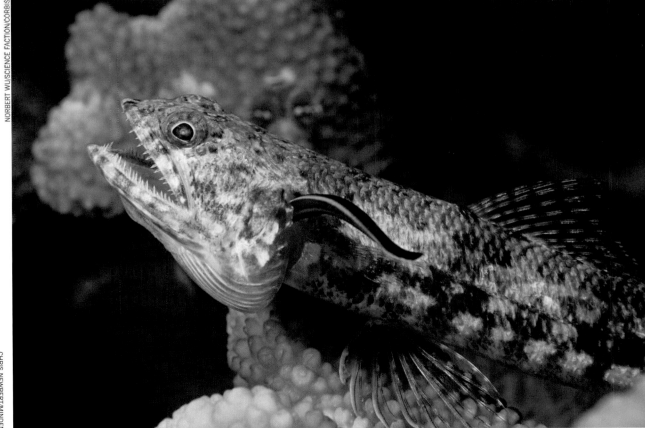

NORBERT WU/SCIENCE FACTION/CORBIS

CHRIS NEWBERT/MINDEN

NORBERT WU/SCIENCE FACTION/CORBIS

A Rocky Prospect

Once more to our toxic scorpionfish friends like the lionfish and turkeyfish, and this one the most poisonous of all (in fact, the very most venomous fish in the world). Can you guess its name? If your answer, given quickly at a glance perhaps, is stonefish, then you take the prize. This specimen is a reef stonefish, lying in the sand and pretending to be something it is not, off the coast of Papua New Guinea. There are five species of the genus *Synanceia* in all, including the alarmingly named *Synanceia horrida*, the estuarine stonefish, which lurks in the mouths of rivers in the Indo–Pacific coastal regions. Fish and man, both, are usually very surprised when they confront a stonefish. The animal is clearly a master of camouflage—blending into the coral or sand of its surroundings—and possesses the patience to wait, stonelike. When prey (fish or crustacean) passes by, the stonefish attacks; it has been said that high-speed camera equipment is necessary to record a stonefish kill. The problem for swimmers and divers, particularly in Australia but elsewhere in the Pacific realm as well, comes with stepping on a stonefish by accident, either in the shallows or even on the beach (a stonefish can survive for up to 24 hours onshore). This will trigger a poisonous sting, the severity of which is usually related to the depth of penetration and the number of spines involved. The stonefish's toxin can certainly kill a person if the wound is not tended; in Australia, stonefish antitoxins are the second most regularly used.

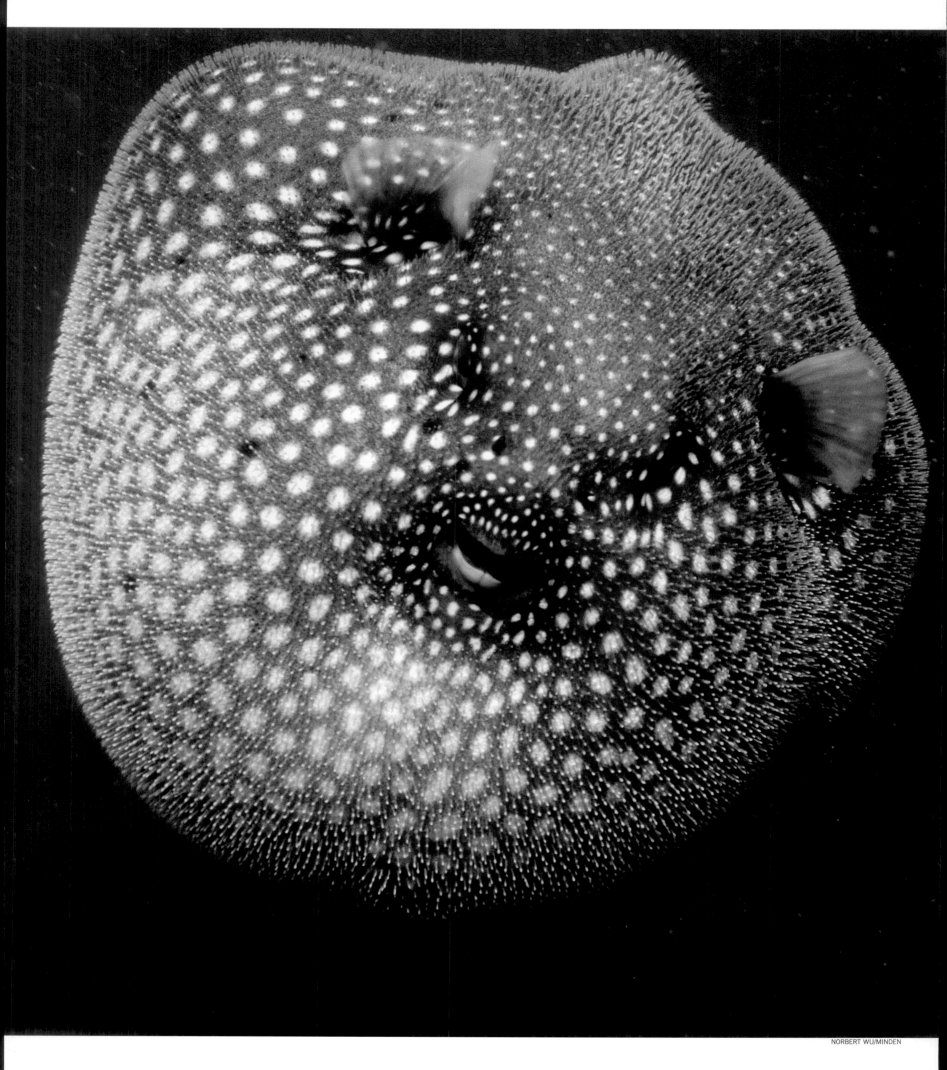

Cute, But That's Not the Goal

A little while ago, when visiting with the cleaner wrasse, we briefly met a pufferfish, and now we greet two more: A guineafowl pufferfish near Hawaii (opposite) and a sleeping blackspotted pufferfish, off Palau (below). There are more than 120 species of puffers in 19 genera (29 species spend their lives in freshwater), most of them small to medium in size, with the giants reaching only three feet. The guineafowl pufferfish is one of the world's most extraordinary (which is to say from man's vantage: best performing). Feeding on coral, seaweed and whatever floats by, this species grows to just over a foot in length, but its length is clearly not its distinguishing characteristic. Shortly put: With encouragement, it inflates (it is obviously in full flourish here, either in order to impress or to strike fear, or both). It feels no compunction to hide from predators, it just does its unique thing. Still, this display is not the puffer's strongest weapon of defense; its toxicity is. While not quite a stonefish in deadliness, all puffers are highly toxic, possessing a poison that can easily kill fellow fish. (The most dangerous of puffers are generally considered the second most poisonous vertebrates in the world.) Some pufferfish organs, such as the liver, are problematic whenever eaten, but this fact doesn't deter licensed chefs in China, Japan and Korea, who carve carefully and isolate the safe puffer meat as a delicacy. Their clientele pay top dollar, then puff out their own chests.

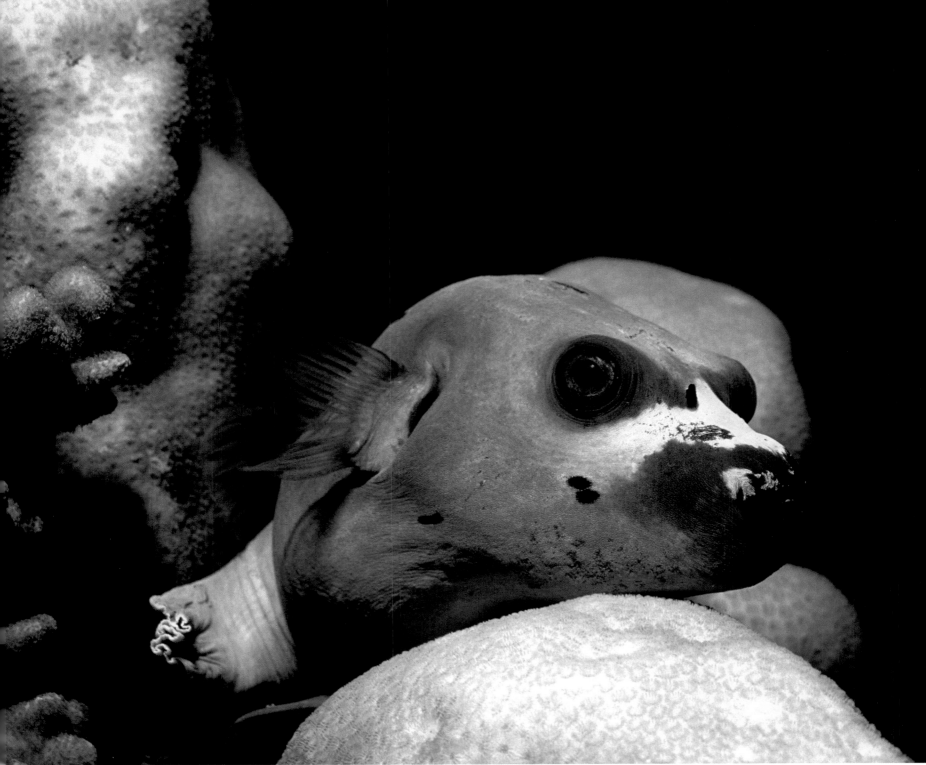

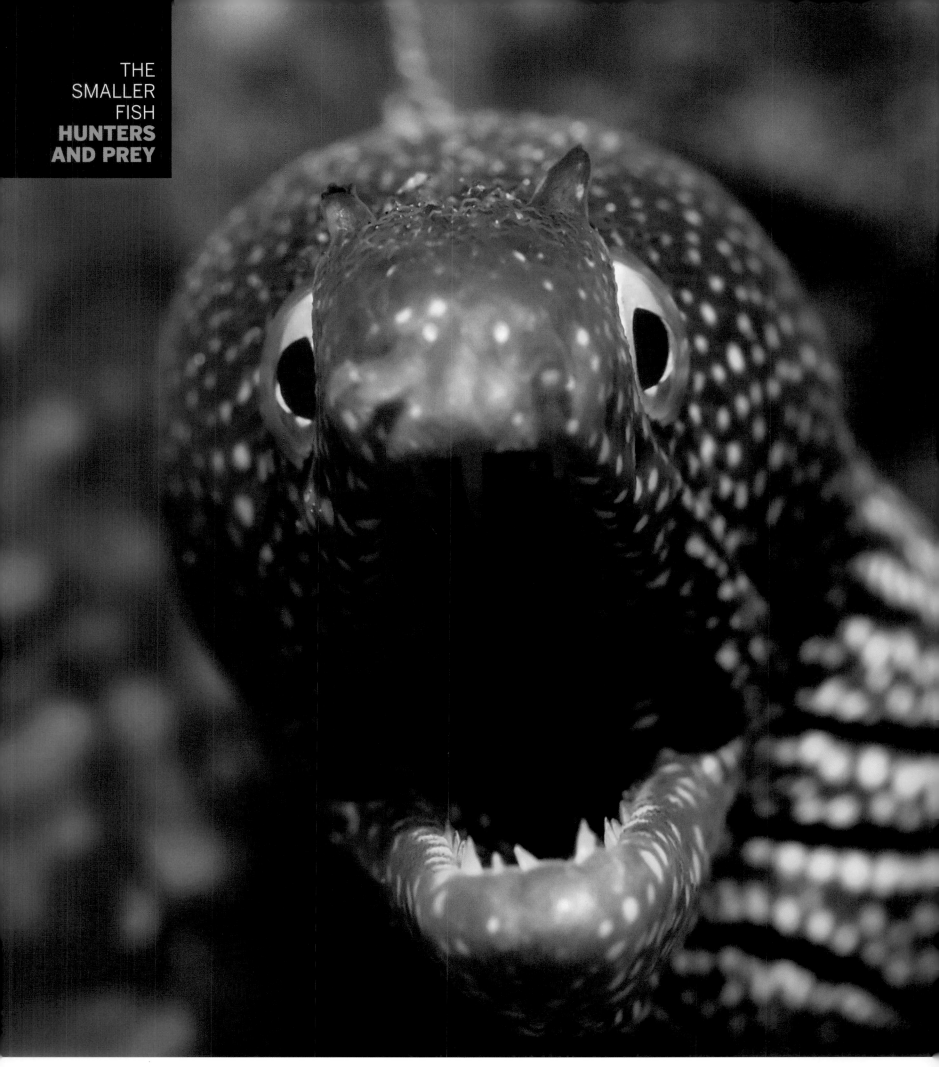

A Fish with a Reptilian Rep

All agape and peering out from their rocky abodes are two species of moray eel: above, the jewel moray, pictured in Mexico's Sea of Cortez, and, opposite, the ribbon moray, photographed in Indonesia. Like most morays, these two fish are snakelike in shape and covered in a scaleless skin coated with a layer of protective mucus that helps them slither through their reef habitats unscathed. Morays have a bad reputation, and it's deserved. Their bite is vicious (if nonvenomous) and they have a nasty temper to boot. Nocturnal feeders, they emerge after dark when their poor eyesight is not a handicap and they can rely on their superior sense of smell. Lying in wait, they ambush crustaceans and smaller fish, lunging forth to clamp their prey in super-strong jaws. Speaking of those jaws: When they are opened wide (not in attack mode,

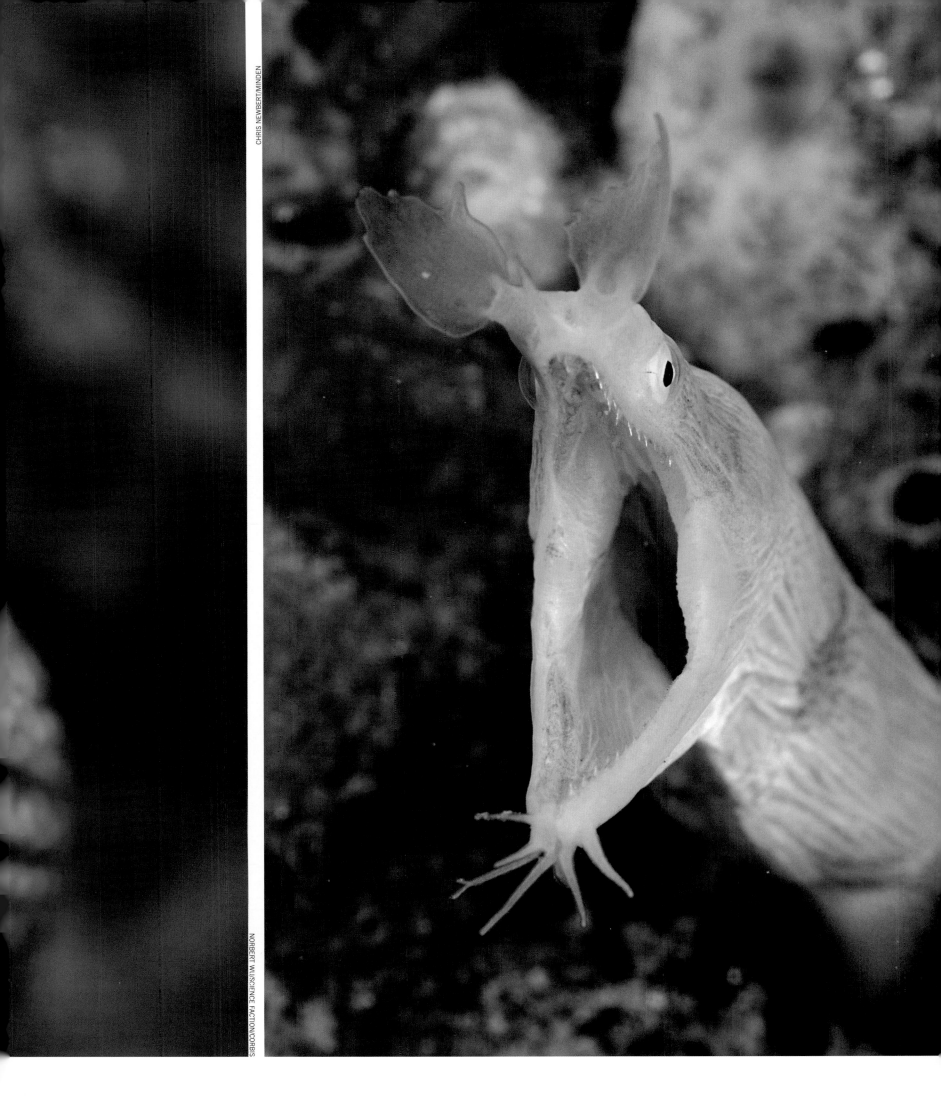

by the way, but in order for the animal to breath), they make for a fearsome aspect (note the resemblance to the monster in *Alien*!). The giant moray, which ranges to 10 feet in length and more than 60 pounds, adds to the family's fright factor, but most morays are far smaller, and neither the jewel nor ribbon exceeds two feet in length. Some last, interesting notes about the striking colorations of these two: The jewel moray, purplish brown with bright yellow spots, is so suited to match its environment that even the inside of its mouth is camouflaged. The juvenile ribbon moray is black with yellow dorsal fins, then undergoes a sex and color change, with mature females becoming yellow, while males turn electric blue with a yellow snout. At a certain point, some male ribbons switch sexes again, becoming egg-laying, yellow-colored females, like the moray pictured above.

Lost in the Deep

They are permeated with a tragic romance. Each of them went, as the phrase goes, to its watery grave, some of them taking down pirates or plunder; wartime sailors or servicemen; heroes or people who, in the moment of truth, behaved horribly. Today, treasure hunters go in search of the lost shipwrecks of the distant past, while recreational scuba divers go in search of adventure. These are among the oddest of all wonders of the deep: lifeless but often teeming not only with sheltered sea life but the many stories of human lives that were cut short. They were once man-made, but are now a fixed part of the oceanic environment that surrounds them. They are rusting away but more spectrally beautiful for it. Ghostly but not ghastly, shipwrecks beckon to us: Come closer, lads and lassies, and let me whisper my tale.

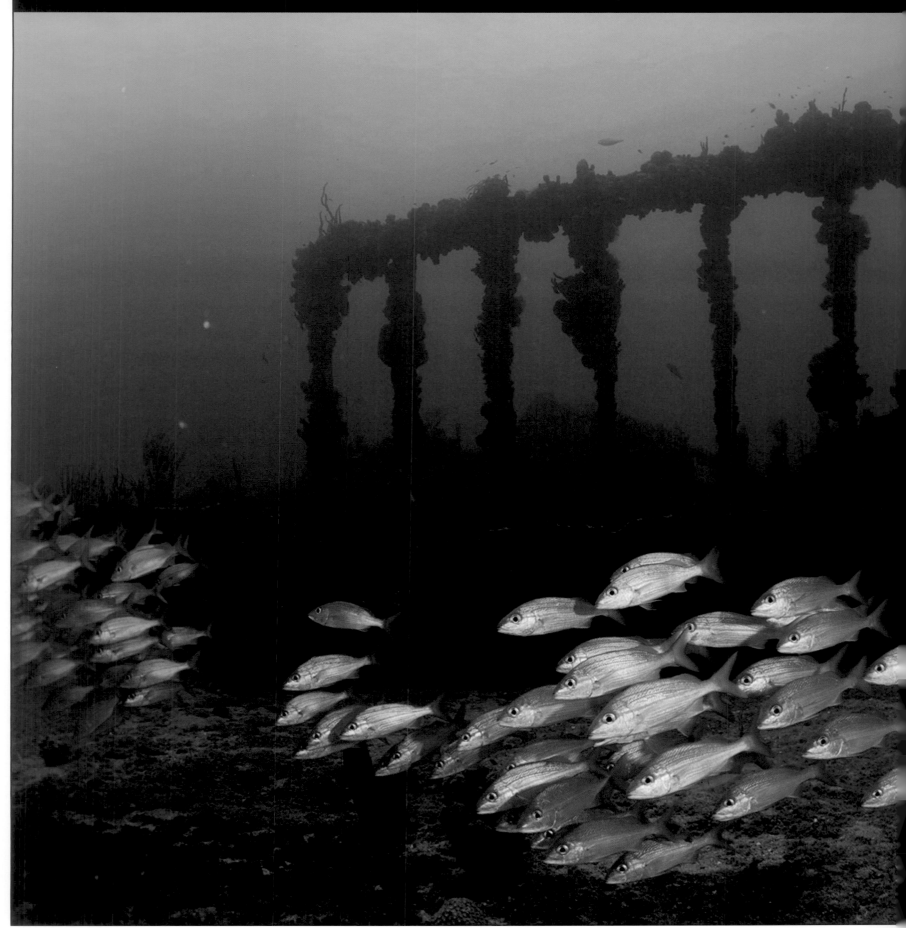

They went down during storm or in battle, but no matter their provenance or the circumstances of their long-ago sinking, today they share a fate: tourist attraction. Whether they lure divers to their resting place or museum-goers to an exhibit of the treasures and artifacts they have yielded, in the modern day each serves as an austere, even somber sideshow.

Below is a school of fish swimming in and around the wreck of the *Rhone* off Salt Island in the British Virgin Islands. The vessel's major distinction is that its skeletal remains are so well preserved, the *Rhone* is routinely rated as one of the best—sometimes *the* best—dive site in the Caribbean. Bright and varied coral and thousands of fish add to the beauty and aura of this spot, which is not only wonderful to behold but photogenic in the extreme: Underwater scenes were filmed here for *The Deep*, the hit Hollywood movie based on the Peter Benchley novel.

But what was the *Rhone*? That can be explained by her full name: the RMS, or Royal Mail Steamship, *Rhone*. The 310-foot-long British packet steamer was traveling in the Virgin Islands archipelago in late October 1867 when a hurricane swept in. Captain Robert F. Wooley was in charge and perhaps 150 passengers and crew were aboard when the ship arrived at Peter Island and anchored off the ominously named Deadman's Bay. Reports differ: Some have her breaking free of her anchor, others have her attempting to head for safety at sea. In any event, the *Rhone* was driven back upon Salt Island and foundered off Lee Bay. Wooley and more than 100 others perished that 29th of October; 23 survived; the villagers of Salt Island were able to recover only eight bodies, and gave each a respectful burial.

The skull below belongs not to one of those killed during the *Rhone* disaster, but is that of one of 800 Swedish men who died nearly two centuries earlier when the enormous three-deck warship *Kronan* went down in the Baltic Sea. This was the Swedish navy's proud flagship during the Scanian War battle of Öland on June 1, 1676, and when she foundered, after an accident that caused her powder magazine to explode, nearly 10 percent of the nation's navy plus its acting commander-in-chief were lost. The wreck of *Kronan* was discovered in 1980 by amateur researcher Anders Franzén. It has yielded some 30,000 artifacts and is today considered the Baltic's second-most-famous shipwreck, and Franzén's second-most-famous find. The leader in both categories can be seen on pages 56 and 57.

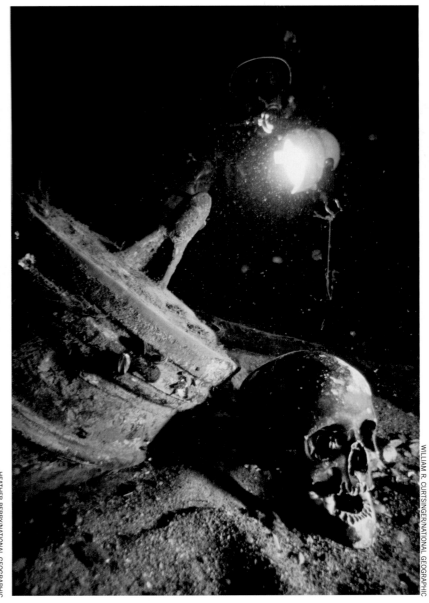

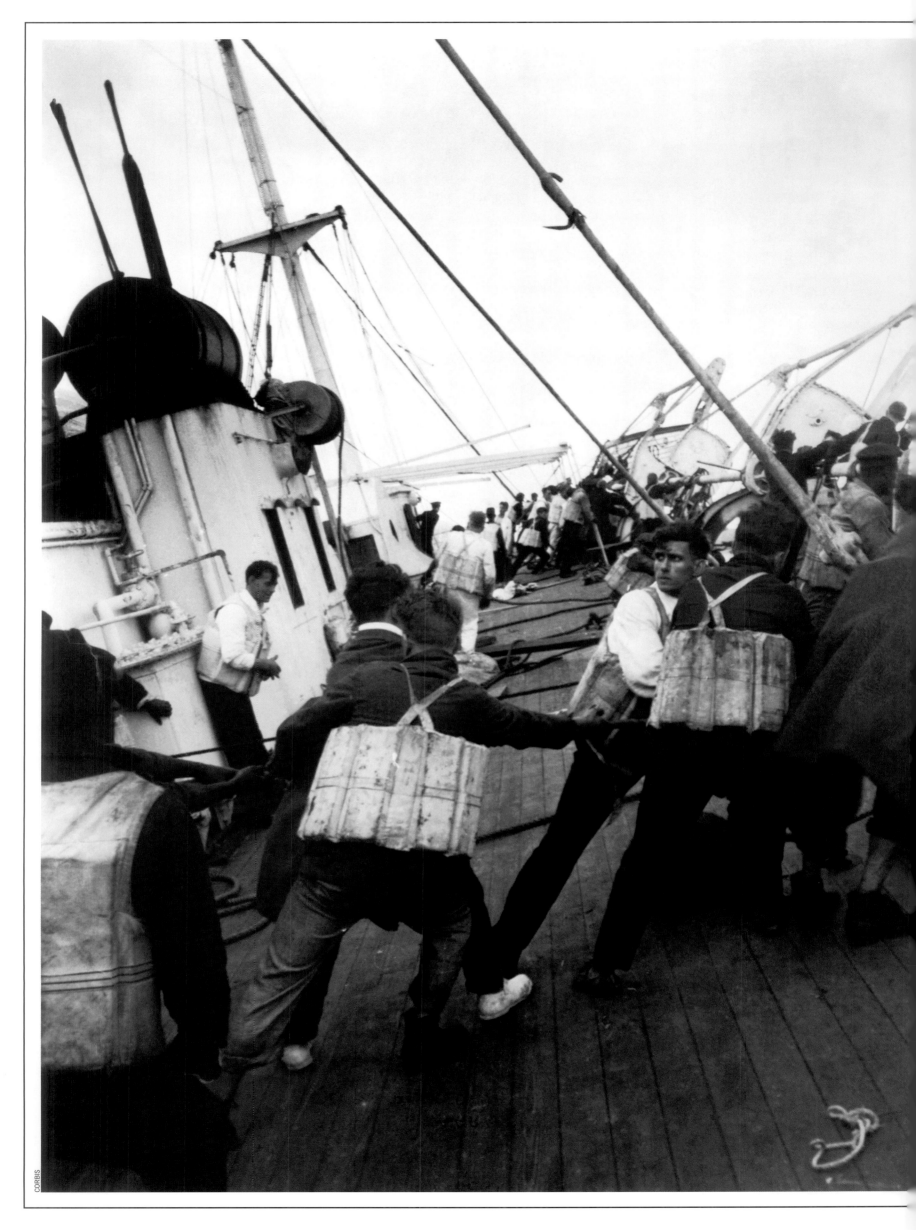

When a ship sinks it is often the case that all is lost. Certainly among the last things a passenger might reach for in the moment of truth is his or her camera, and even if pictures are made at the crucial instant, the film often goes to the bottom. Some of the better-heeled passengers aboard *Titanic*'s maiden voyage surely had cameras, but no images exist of the prolonged sinking of that storied ocean liner. The photographs on these pages, then, are rarities; and the one on the opposite page in particular, which shows passengers frantically donning life preservers as the *Vestris* sinks into the Atlantic off Virginia on November 12, 1928, is remarkable in its sense of moment—its terrible sense of moment.

The *Vestris*, a steamship built in 1912, may have been overloaded with cargo and passengers when sailing on her ultimate voyage from New York City to Buenos Aires; the ship developed a starboard list that became severe as she traveled down the eastern seaboard. As for the photo, which is certainly one of the most dramatic of shipwreck pictures: It was taken by crewman Fred Hanson just before the ship rolled on her side and sank to the bottom of the Atlantic. Other members of the crew and passengers are at the ropes as the last lifeboats are lowered. The man on the left, leaning against the cabin, is George Bogg, whose arms have been broken in the fracas—and now he stands by helplessly and prays, until he is carried from the ship. The long black cape in the foreground at right belongs to Captain William Carey, who will perish with his vessel—along with 111 of the 128 passengers and 198 crew members.

On this page, at top, the Italian ocean liner *Andrea Doria* sinks in the Atlantic off Massachusetts's Nantucket Island after her 1956 collision with the eastbound Swedish ship MS *Stockholm*. This could have been a second *Titanic* tragedy, as more than 1,700 people were aboard, but it turned out quite the opposite. The crew acted efficiently, and the latest technologies kept the ship afloat for more than 11 hours after she had been mortally wounded. Some 1,660 passengers and crew were rescued, while only 52 died, 51 of those at the time of impact.

At bottom: *Oceanos*, a Greek luxury liner, sinks off the coast of South Africa on August 4, 1991, surrounded by floating deck chairs. By this modern date, helicopters and other aircraft can be deployed in rescues at sea, and all 571 on board are saved. Other things have changed, too: Photographs of sinkings are readily available (in fact, video of the *Oceanos*'s final minutes aired on ABC News), and the chivalric codes have eroded. The *Oceanos*'s captain Yiannis Avranas—who says in his defense, "When I order abandon the ship, it doesn't matter what time I leave. Abandon is for everybody. If some people like to stay, they can stay"—is found guilty of negligence by a Greek board of inquiry.

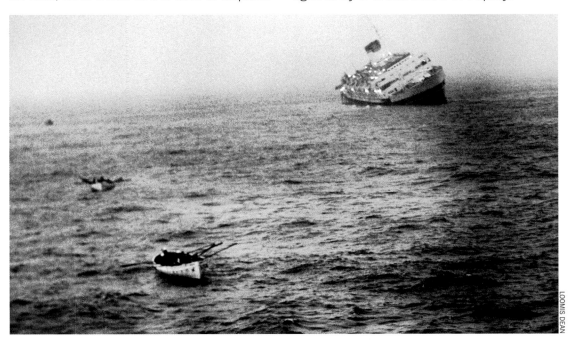

LOOMIS DEAN

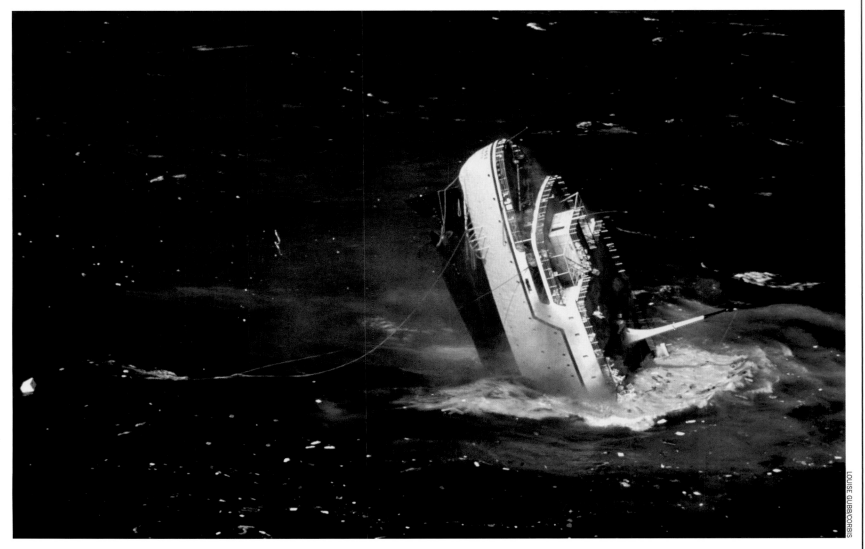

LOUISE GUBB/CORBIS

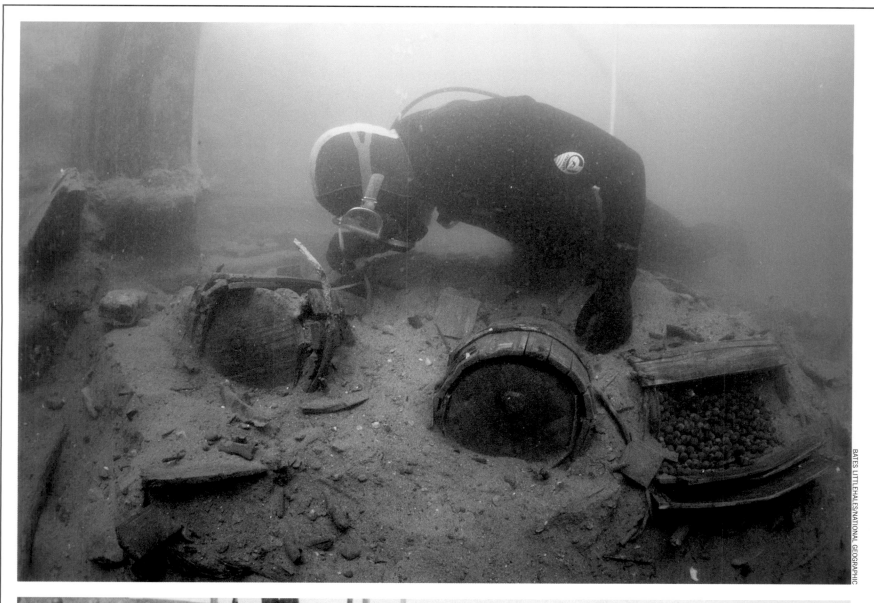

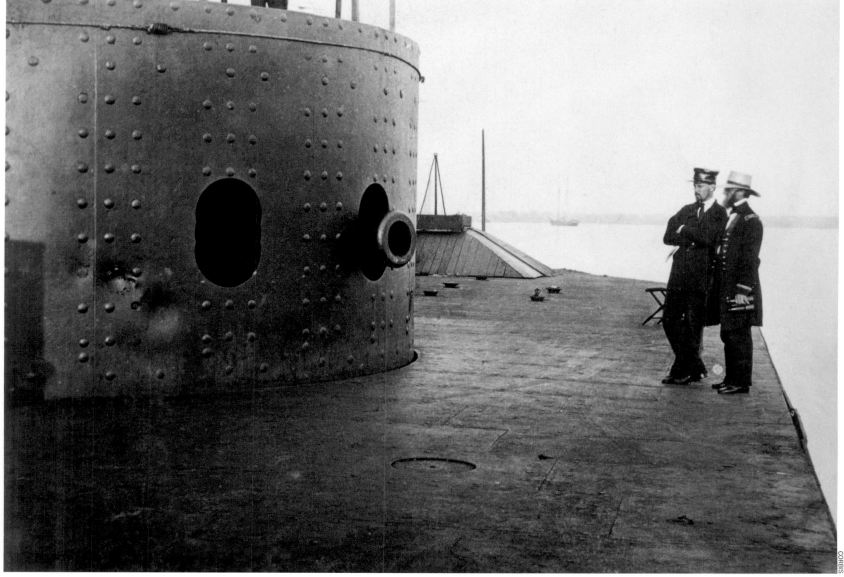

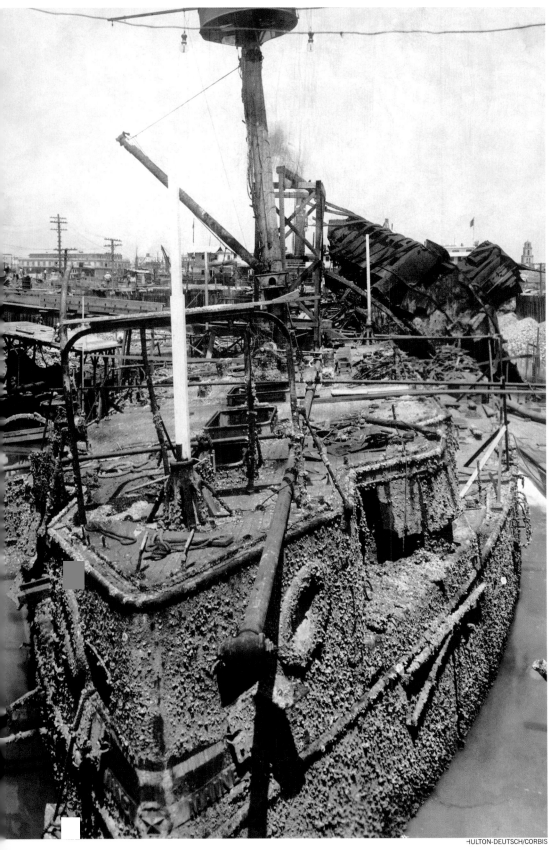

HULTON-DEUTSCH/CORBIS

After they sink, they sit, until found. On the opposite page, top, a diver in the York River in Virginia inspects one of nearly a dozen ships that have been found there in recent decades. The vessel probably dates to the Revolutionary War, and is probably British in origin. We know this because in 1781, during the battle of Yorktown in Virginia, British General Charles Cornwallis, concerned about the possibility of an amphibious assault on the British fleet near Yorktown Beach, to be perhaps launched by the Colonies' French allies, ordered several ships sunk with the thought that they would be raised again later after the threat had passed: an elaborate subterfuge, to be sure.

By the time of the United States' great domestic crucible, the Civil War, battleships had evolved significantly, and in the photo at bottom we see, on July 9, 1862, Union naval officers inspecting the damage done to the turret of USS *Monitor* during a battle on the James River—the first-ever fight between iron warships. *Monitor*'s rotating armored gun turret could swing 360 degrees and her underwater hull was protected by armor as well, but none of this advanced design, which served her well during river combat, helped her in rough seas—in fact, it added to her ponderousness. On December 31, 1862, she was swamped by waves while under tow in the Atlantic off Cape Hatteras, North Carolina. Sixteen of her 62 men died when she went under. In the years since World War II, there have been several initiatives to raise *Monitor,* which lies about 16 nautical miles off shore. As it is, most of her bulk rests where she sank, although the revolutionary turret, a cannon, a propeller, an anchor, an engine and other artifacts have been recovered and are on permanent display at the Mariners' Museum in Newport News, Virginia.

Left: The wreck of another famous U.S. battleship, the *Maine,* having been raised from the sea in Cuba's Havana Harbor. The fate of this vessel, both before and after her sinking, was quite different—and more ignominious—than that of the earlier *Monitor.*

The armored cruiser with two turrets was built specifically for service in Latin America, where the Spanish were posturing. But *Maine*'s construction was fraught and prolonged, and she was nearly obsolete by the time she was pressed into service. During the Cuban revolt against Spain in 1898, she was sent to defend the United States' point of view, and boldly entered Havana Harbor. Suddenly, on the evening of February 15, she exploded mysteriously. Three fourths of her crew were killed in the sinking.

What had caused the tragedy? While both mundane possibilities and conspiracy theories were floated—a simple accident; intentional sabotage by the U.S. meant to provoke war with Spain—William Randolph Hearst and his yellow journalists in America went to town, blaming the Spanish: "Remember the *Maine,* to Hell with Spain!" Later in 1898, the Spanish-American war was in fact joined. The remains of the *Maine* were raised and scuttled in the winter of 1912. What secrets the wreck held will probably never be known for sure.

In the photograph at bottom, the remnants of a fourth warship: USS *Arizona.* The ship was a victim of the Japanese attack on Pearl Harbor in December of 1941, and so like the *Maine* was an unwilling catalyst in a declaration of war. Today the wreck is the centerpiece of the USS *Arizona* Memorial.

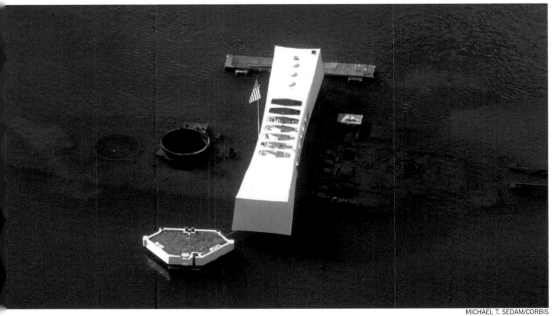

MICHAEL T. SEDAM/CORBIS

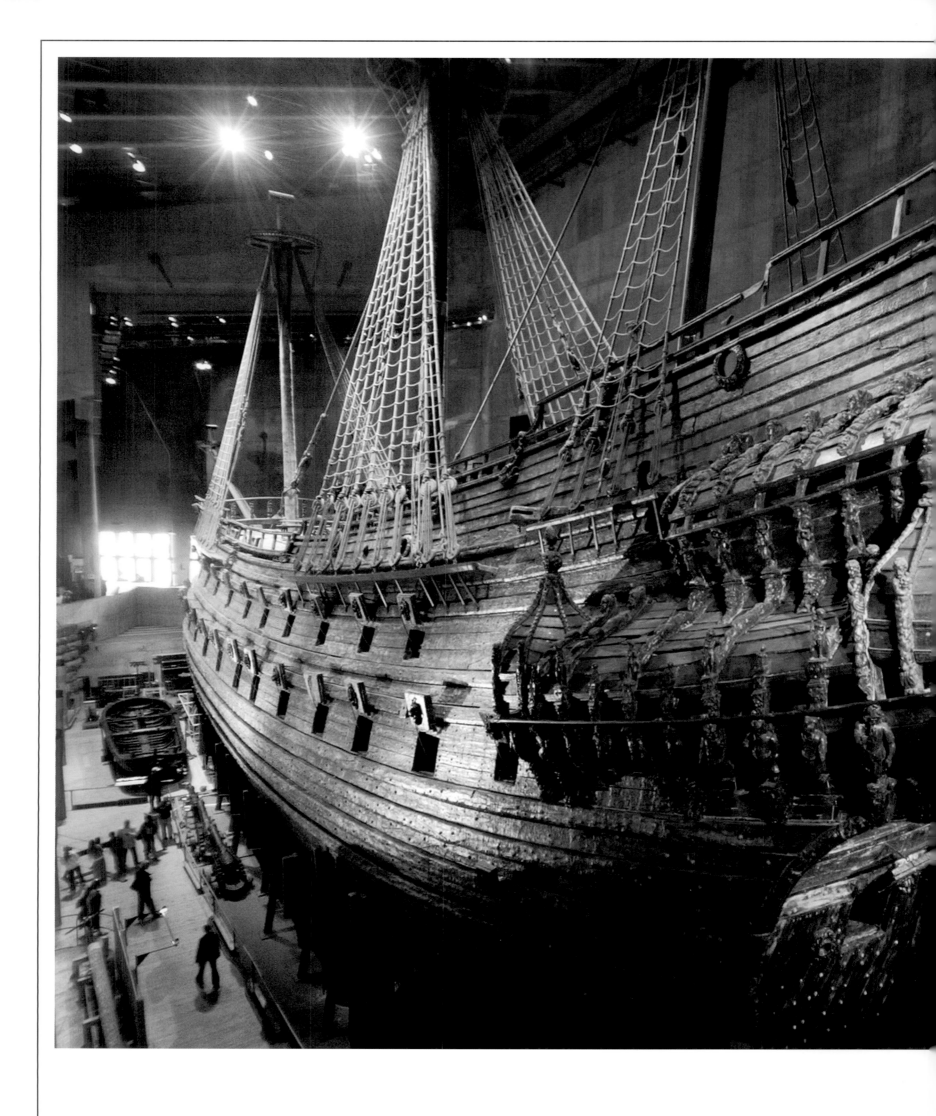

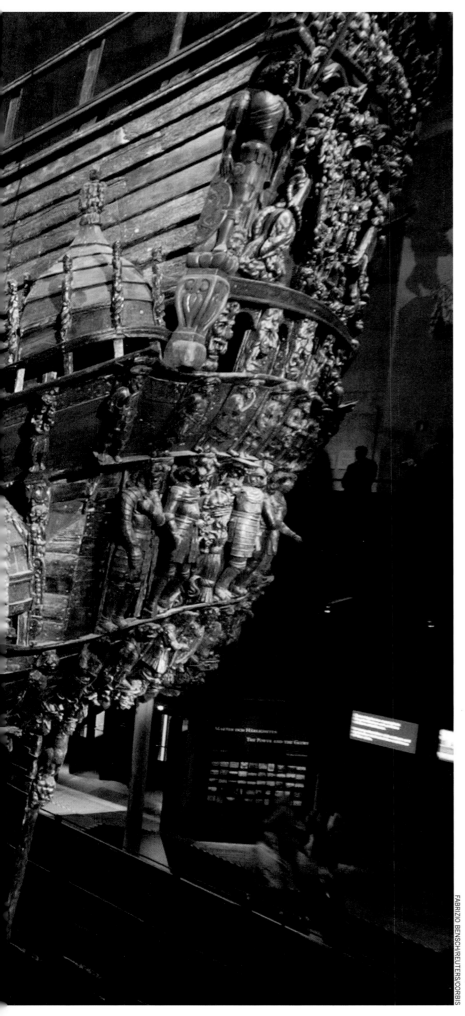

On page 51, we first met Anders Franzén in connection with his 1980 discovery of the wreck of the Swedish warship *Kronan* in the Baltic Sea. Decades earlier, in 1956, the marine technician and amateur naval archaeologist, based in Stockholm, had made his reputation by locating the Swedish galleon *Vasa*, also in the Baltic. While much was salvaged of *Kronan*, all of *Vasa* was, and today it is the world's only complete surviving ship from the 17th century. It is, needless to say, the principal attraction at the Stockholm museum that bears its name.

The royal warship *Vasa*, which is one of Sweden's very most popular tourist draws, had a far less exalted career above the waves. She foundered and sank on August 10, 1628, only moments—less than a nautical mile in distance—into her maiden voyage. The bronze cannon was brought up, but this loser of a ship was largely ignored for more than three centuries. Then, resurrected, it became a glorious thing.

Below, top, are Spanish coins and a ring from the *Whydah*, found in 1984 off Cape Cod, Massachusetts. This British-born ship served nefariously in two enterprises: the slave trade, then the pirate industry. When she went down in a storm on April 26, 1717, taking her master and most of his men with her, she was in the possession of "Black Sam" Bellamy, who had seized the ship earlier that year after a three-day chase off Cuba.

In the bottom photograph are gold coins and bars found aboard the sunken 19th century sidewheel steamer SS *Central America*, which was sunk in a hurricane off the Carolinas in 1857 during a voyage from Havana to New York City. When she went under, she took with her more than 550 passengers and crew and 30,000 pounds of gold (the loss of which, with a worth of approximately $2 million at the time, contributed to the Panic of '57). When the *Central America* was found in 1987, precious metals salvaged constituted the largest treasure cache in American history: between 100 and 150 million dollars in value. After almost a decade in court, the discovery team was awarded 92 percent of the loot. One 80-pound ingot from the so-called Ship of Gold sold for $8 million in 2001—one of the most valuable single pieces of currency in the world at that time.

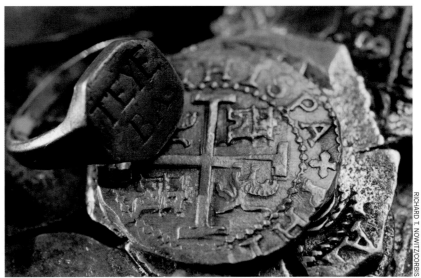

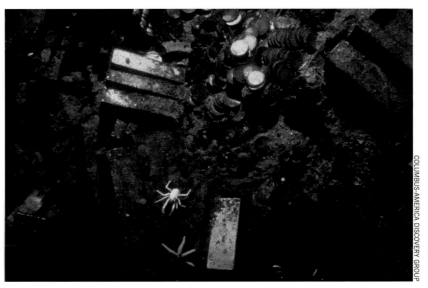

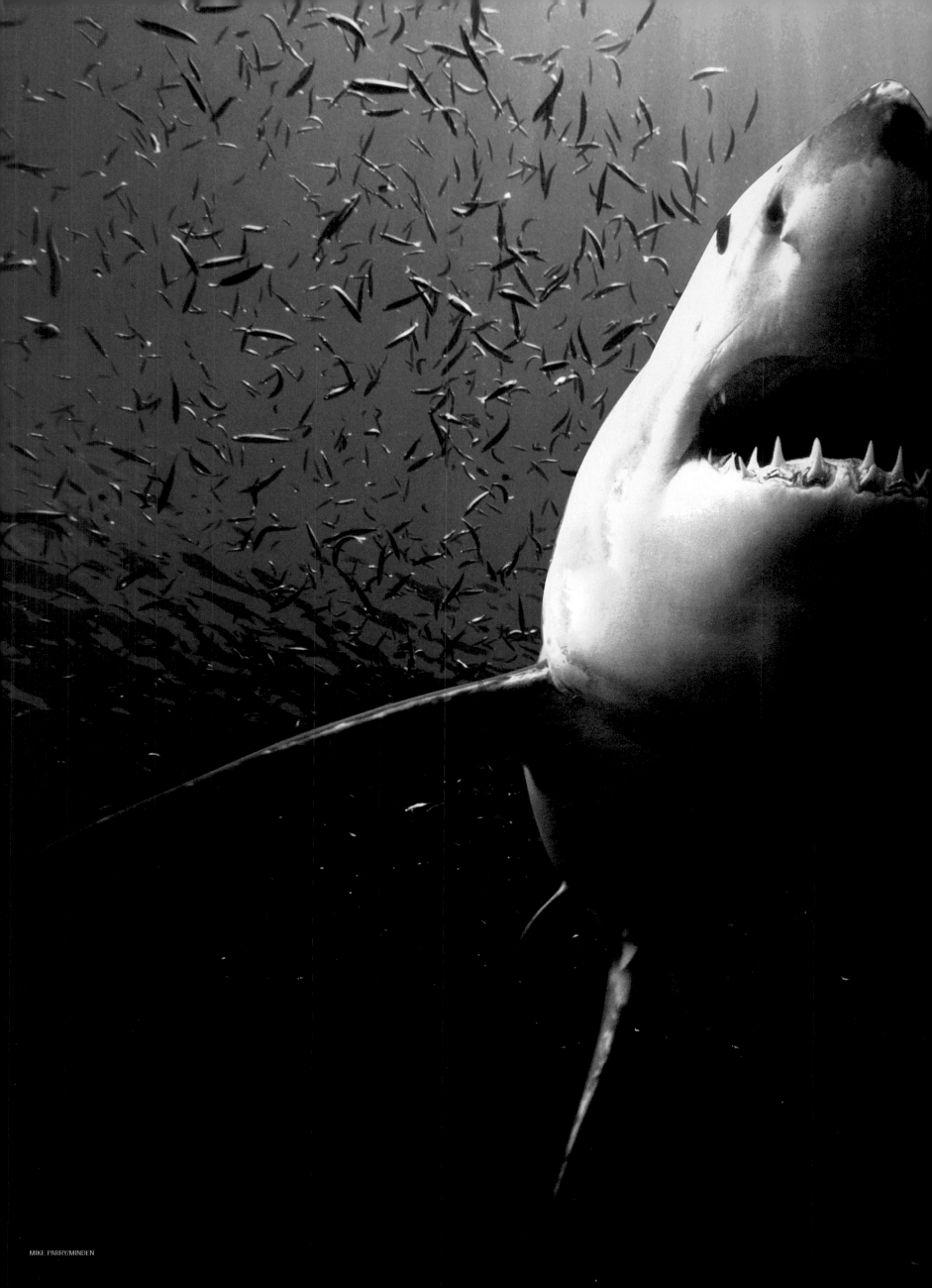

The Word that Strikes Fear:
SHARK!

Call Me Jaws

Just when you thought it was safe to go back in the water (not that you did, after meeting stonefish and morays), we give you: the great white shark. Found in the cool coastal waters of all major oceans, this legendary creature can grow to more than 20 feet in length and weigh in excess of 5,000 pounds—the largest known predatory fish in existence. To say he's carnivorous is to state the obvious. Within those jaws are up to 300 serrated teeth, and he employs them daily, catching and dining on a preferred variety of marine life such as tuna and dolphins, seals and sea lions, even other sharks. And what about . . . us? Well, in 1974 novelist Peter Benchley wrote *Jaws,* about a man-eater with a 'tude, and the following summer director Steven Spielberg eternalized the image of the great white as a cartilaginous torpedo, a ferocious human-hunter of the first order. The truth of the matter? Somewhat less dramatic. Sure, great whites are known to do "taste tests" on foreign objects, and sometimes an arm or leg gets into the mix. But they don't generally like to eat people. As the late Canadian shark expert R. Aidan Martin once explained to *National Geographic:* "Great whites are curious and investigative animals." When they chomp something unfamiliar to them, "they're looking for tactile evidence about what it is. They spit us out because we're too bony." Only the latest evidence that you can't be too rich or—especially—too thin

A Garrulous Bigmouth

The name "whale shark" implies an animal of two worlds, but it is not: It is all shark, all fish, and it is seen on these pages in three situations. With a squarish head and nostrils connected to the mouth by grooves, these nonwhales (and nonmammals) look like oceangoing vacuum cleaners, and that is how they act, swimming open-mouthed through schools of very small

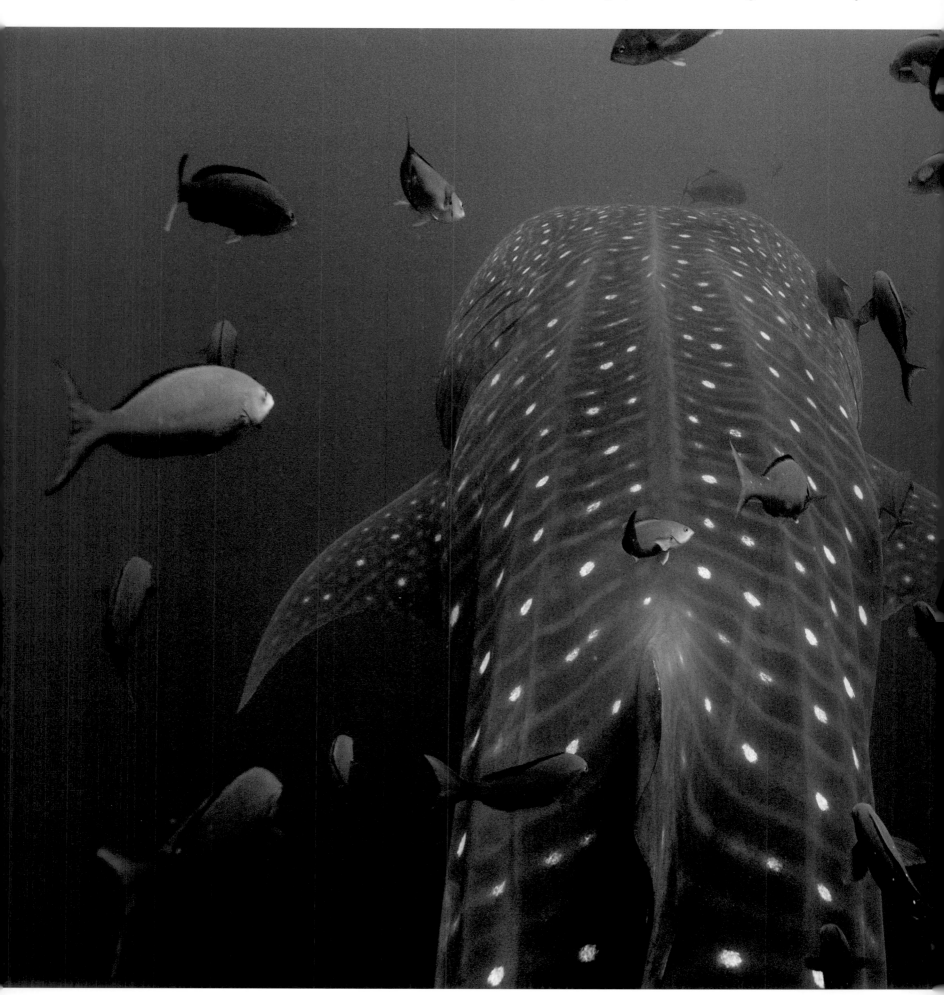

fish, ingesting these tiny victims as well as plankton. The largest ever measured came in at 41½ feet, but sightings include whale sharks half again as large, and they are wanderers: One was tracked for 8,000 miles. Though its mouth is big enough to ingest a scuba diver, it never does so. In fact in its intrinsic way of being not quite what it seems, the whale shark can be notably playful. That's good news for the fishermen in the canoes at bottom, who are happily surrendering their bait to a fish they will emphatically *not* be bringing aboard. In the top photo, during the bonito fish spawning off Mexico's Isla Mujeres, a whale shark is laying motionless and gulping large quantities of water in what could be termed a discreet feeding frenzy. Below, left: A whale shark swims with tropical fish off Wolf Island in the Pacific Ocean's famous Galápagos Islands.

PETE OXFORD/MINDEN

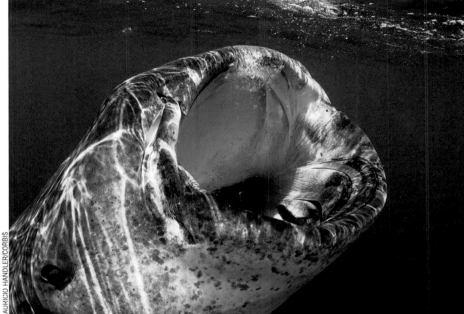

MAURICIU HANDLER/CORBIS

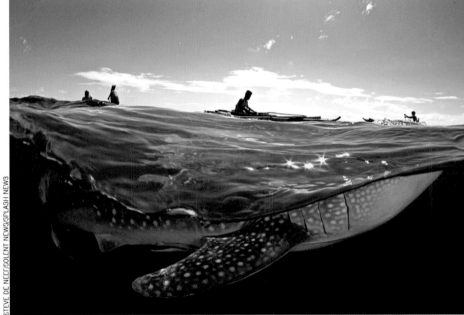

STEVE DE NEEF/SOLENT NEWS/SPLASH NEWS

Identity Crisis

Like the whale shark, the wobbegong seems more like something it is not. A not terribly large bottom-dwelling fish who goes in some of its various species by nicknames such as "ornate" and "floral banded" and "tasseled" (the one seen here is a tasseled wobbegong on Australia's Great Barrier Reef), it must be regarded by the great white as a pretty poor excuse for a shark. But a shark it surely is, the wobbegong. That wobbly word derives from the

Australian Aboriginal phrase meaning "shaggy beard," and this and some of those other monikers clearly refer to the weedy lobes near the fish's mouth and elsewhere on its body. These whiskery extensions are part of the animal's camouflage strategy: It lies much of the time on the ocean floor, and with its patterned skin and these lobes, looks like nothing so much as a three- or four-foot-square shag rug. (That's another nickname that must irk the great white: a "carpet shark." It's a wonder Jaws doesn't just chew up all the wobbegongs and put an end to the humiliation.) The wobbegong is hardly a man-eater, but will bite a snorkeler or swimmer with its sharp teeth if it is stepped on. (One of the problems with camouflage: You get stepped on.) Left alone, it will wait on the reef or a bit deeper for smaller fish to venture close, then will strike. We've met a number of devious "ambush predators" already, but they are not sharks. The wobbegong is, whether its brethren want to believe it or not.

All in the Family

We have met a whale shark, and now we are presented with an elephant shark, or an elephant fish, this one swimming, where most of them do, in the very deep waters (down to 1,500 feet) of the Pacific Ocean off southern Australia and New Zealand. It is a strange, very old and mysterious creature, all of which has led to its most evocative nickname: the "Australian ghost shark." It is small, growing to a few feet at most, and has a life's journey including not just the depths but the shallows, when it ventures inshore to estuaries and harbors to mate in spring. (During this time, it is often caught by man and winds up on the menu in fish-and-chips shops.) The elephant shark holds an intense interest for scientists, particularly geneticists, since it is so ancient in its heritage, and because, like all sharks and rays and skates of the subclass Elasmobranchii, it is a cartilaginous fish—which is to say, it has a skeleton made of cartilage. Cartilaginous fish are the oldest living animals among today's jawed vertebrates, and the elephant shark is old even within this group. It is already known that man and the elephant shark shared a common ancestor 450 million years ago, and the recently established Elephant Shark Genome Project hopes to learn much more. Peer at this picture, and say hello to your cousin.

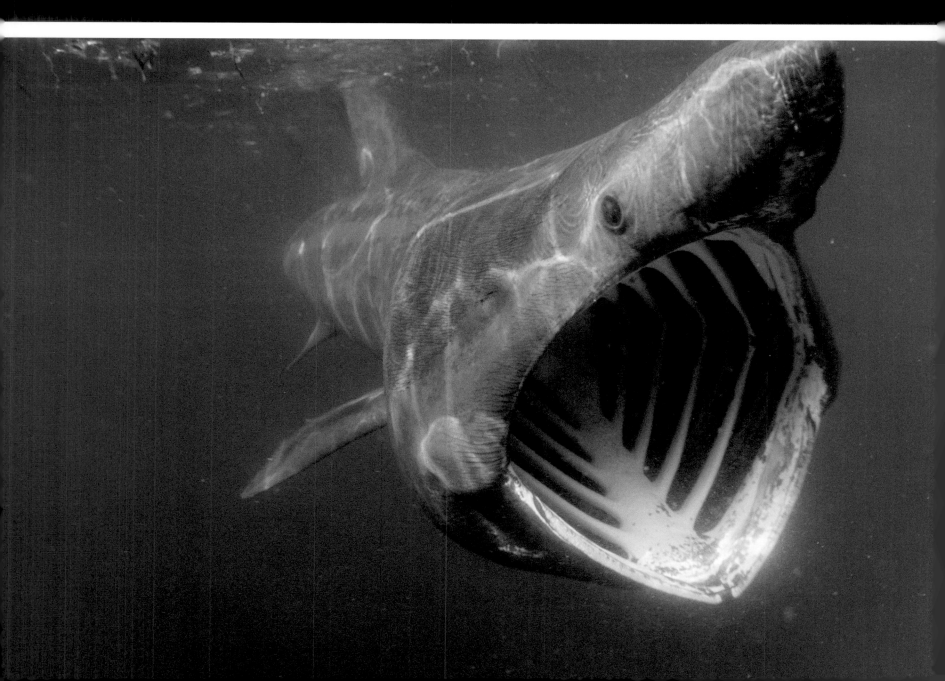

World Traveler

So many of our pictures are from the Pacific—it is such a vast ocean, where tropical and subtropical fish thrive—but not this one. This is a basking shark filter-feeding in the Atlantic Ocean off Cornwall in the southwestern corner of England. The second largest of all living fish after the whale shark, it is what is called a "cosmopolitan migratory species" and visits all of the world's temperate oceans. It travels wide and far but not fast, often moseying along with its oversize mouth agape and its gill rakers at work, separating the wheat from the chaff, so to speak. This fish follows the plankton, and where it is richest, the basking shark is often observed near the sea's surface, casually going about its feeding. This is how it got its name: It seems to be basking in the sun, not a care in the world. That is often, for fish, a dangerous attitude. Some basking shark communities have been erased and others are threatened by overexploitation because man has determined that this fish is a useful source of shark liver oil and fodder for animal feed. And, oh yes: shark fin. In certain Asian cuisines, notably Japan's, this is a delicacy that commands a high price. Horrifically, some shark hunts target only the fins, which are cut off and the victim is then left to swim away and die. This hardly qualifies as "fishing," and has earned the opprobrium of the conservation community—as of yet, to no satisfactory end.

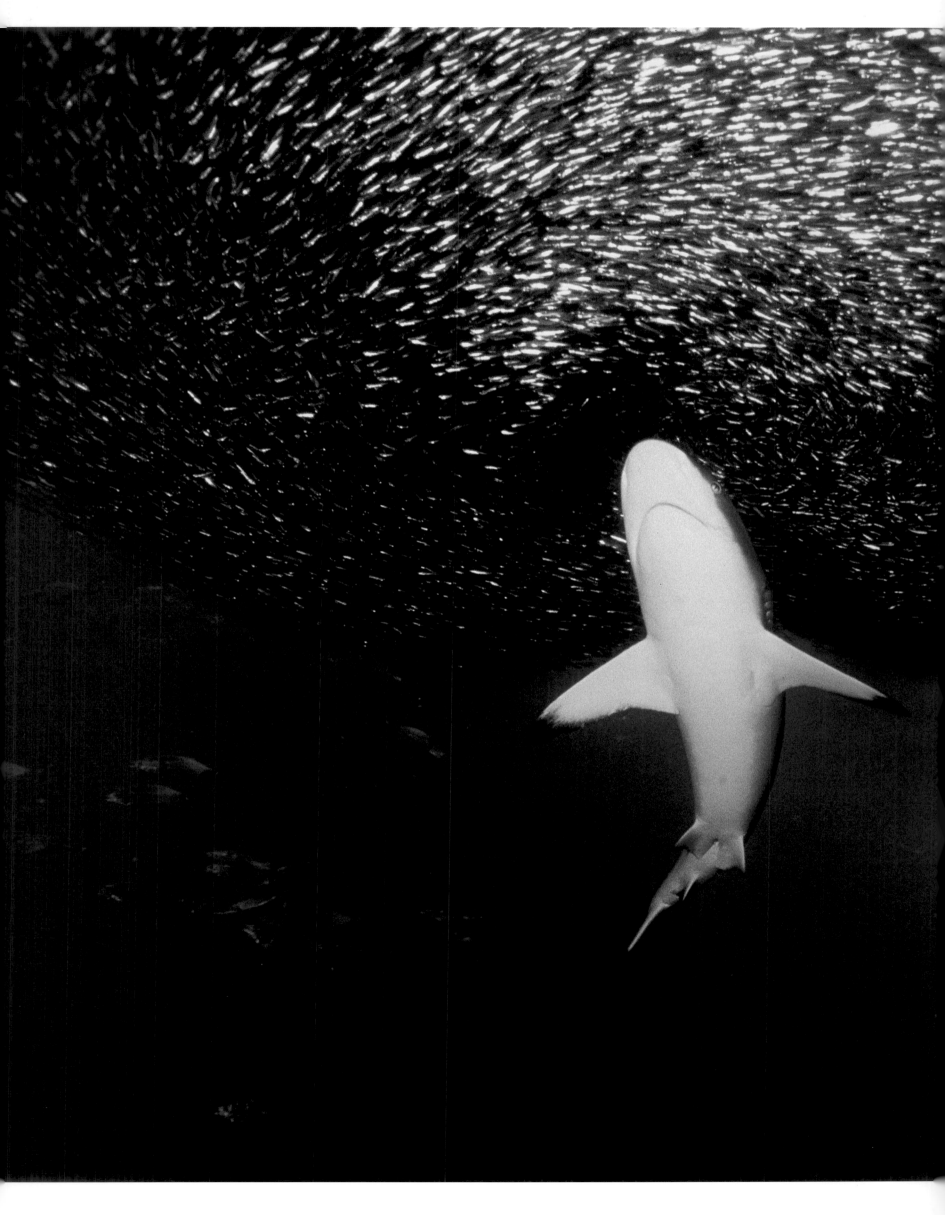

FRED BAVENDAM/MINDEN

Poetry in Motion

We're back to the Indo-Pacific region now, where this gray reef shark is about to dig into a large baitfish ball, just off the Solomon Islands. These are speedy, agile predators whose diet of choice includes bony fish and cephalopods (which include several species of marine mollusk such as octopus, squid, cuttlefish and nautilus), with crustaceans such as crabs and lobsters representing a secondary choice. Gray reef sharks will attack divers after exhibiting a threatened, hunched display, and are more dangerous in the open water than on the reef. But of course in the man-fish relationship, theirs is the short end of the stick, as they are sought after for use in fishmeal and shark fin soup. Furthermore, the degradation of coral reefs in their part of the world poses, for them, a large problem. According to one study, in sections of Australia's Great Barrier Reef where boats are allowed, there has been a 97 percent greater decline in the gray reef shark population than in places where boating is prohibited. The International Union for Conservation of Nature currently lists this shark as Near Threatened, and since the gray has a relatively low reproduction rate (litters of one to a half dozen pups born every other year), recovery will be problematic. Ranging in size between five and eight feet, strong and swift, fluid, beautiful (its other nicknames include "graceful shark" and "graceful whaler shark"), the gray is every inch a shark: a signature shark. Certainly a shark worth saving.

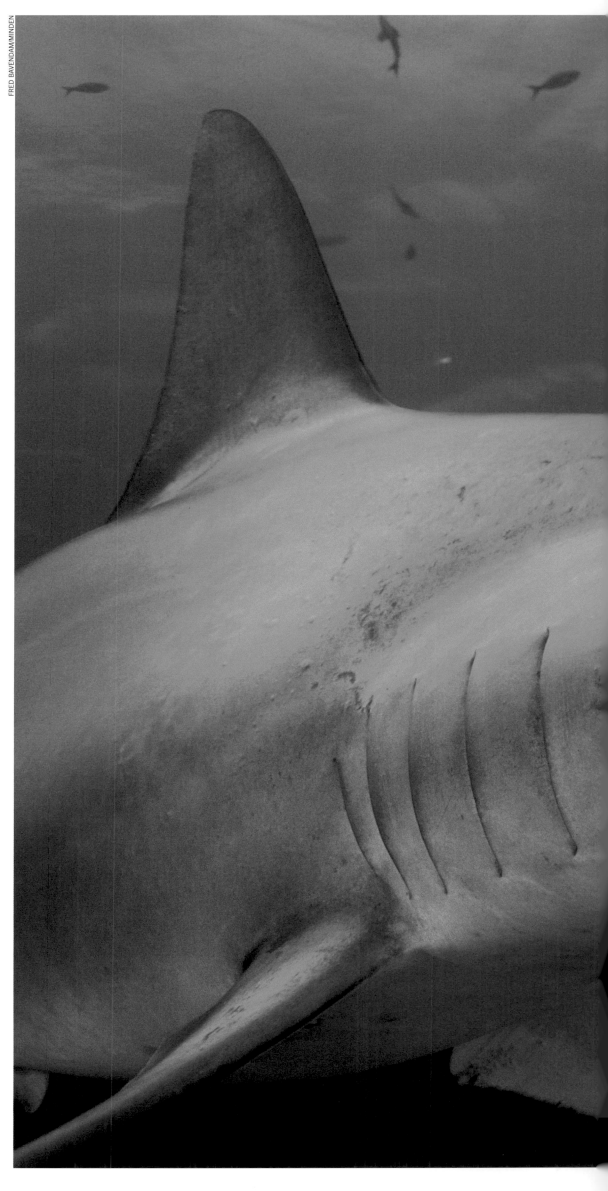

FRED BAVENDAM/MINDEN

Sharpest Tool in the Shed

From the sublimity of the gray reef shark we transition to the surreality of the hammerhead. This species really forces you to ask: fact or sci-fi, a textbook fish or something out of Jules Verne? The camera does not lie, and these creatures certainly do exist. The scalloped hammerhead shark swimming at right off the Galápagos Islands is a member of one of nine hammerhead species known for, well, the hammer that is its head. Interestingly, though their unusual appearance might imply a relic from eons ago, hammerheads are among the most recent of the shark family to evolve; the lateral head lobes, with the wide placement of the nostrils and eyes on the ends of the lobes, are seen as an advanced feature, perhaps improving visual and scent abilities. It is also hypothesized that the altogether remarkable head is an asset when maneuvering—diving, twisting, turning—in the sea. Hammerheads are sociable, and unlike most of their brethren sharks, often swim in schools during the day (some schools numbering up to a hundred), breaking off in the evening to become solitary nocturnal hunters. Ranging in their various species from three to 20 feet in length and 500 to 1,000 pounds, they need a lot of food, and prefer fish (including fellow hammerheads), squid, octopus, crustaceans and especially stingrays. In turn they are hunted by man for the usual reasons, right down to the fins. Would that the philosophy of the traditional Native Hawaiian culture could be exported. In it, the hammerhead and some other sharks are considered gods of the sea, and also *aumakua:* protectors of man. Some natives of the island of Maui believe that when a hammerhead is seen offshore, it is a sign that the gods are watching over their families.

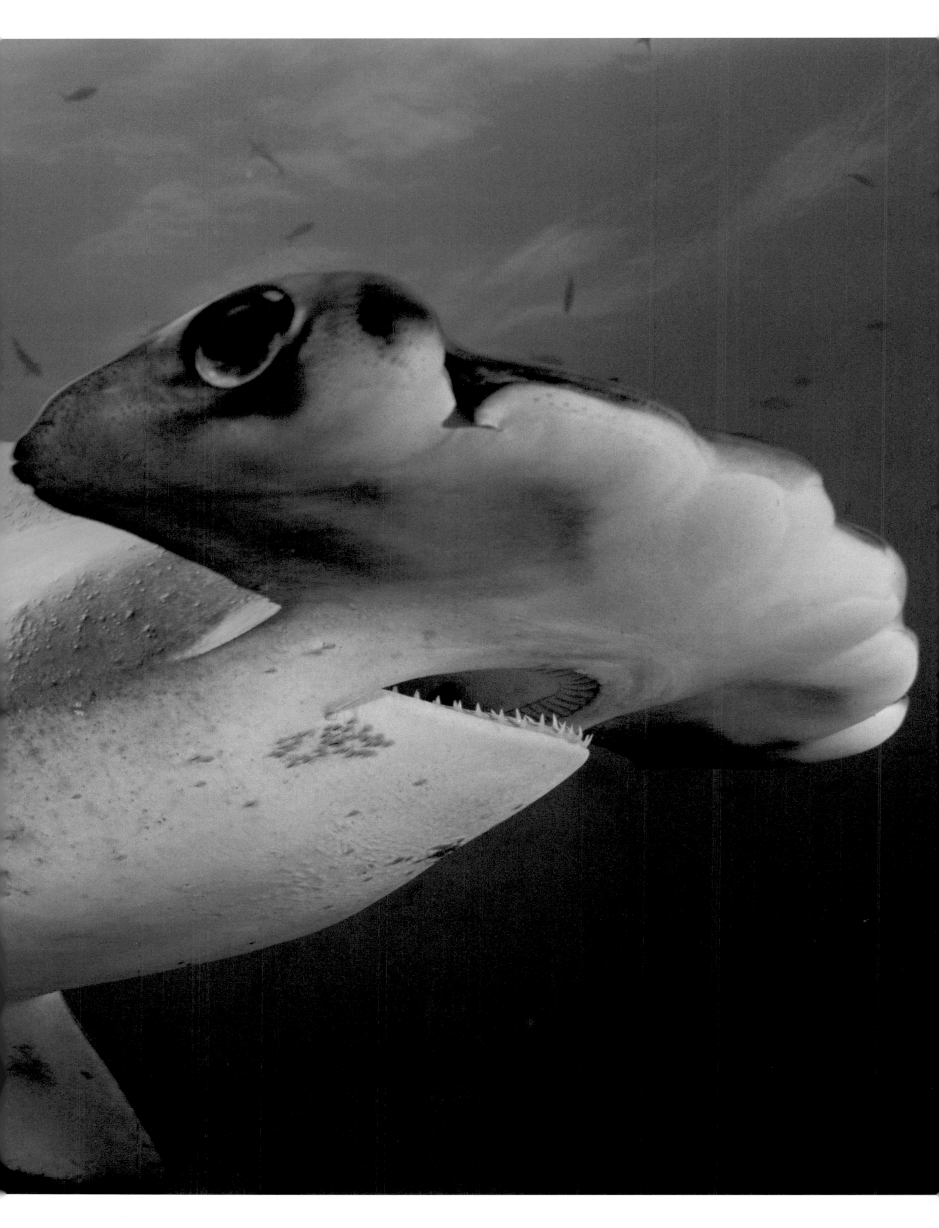

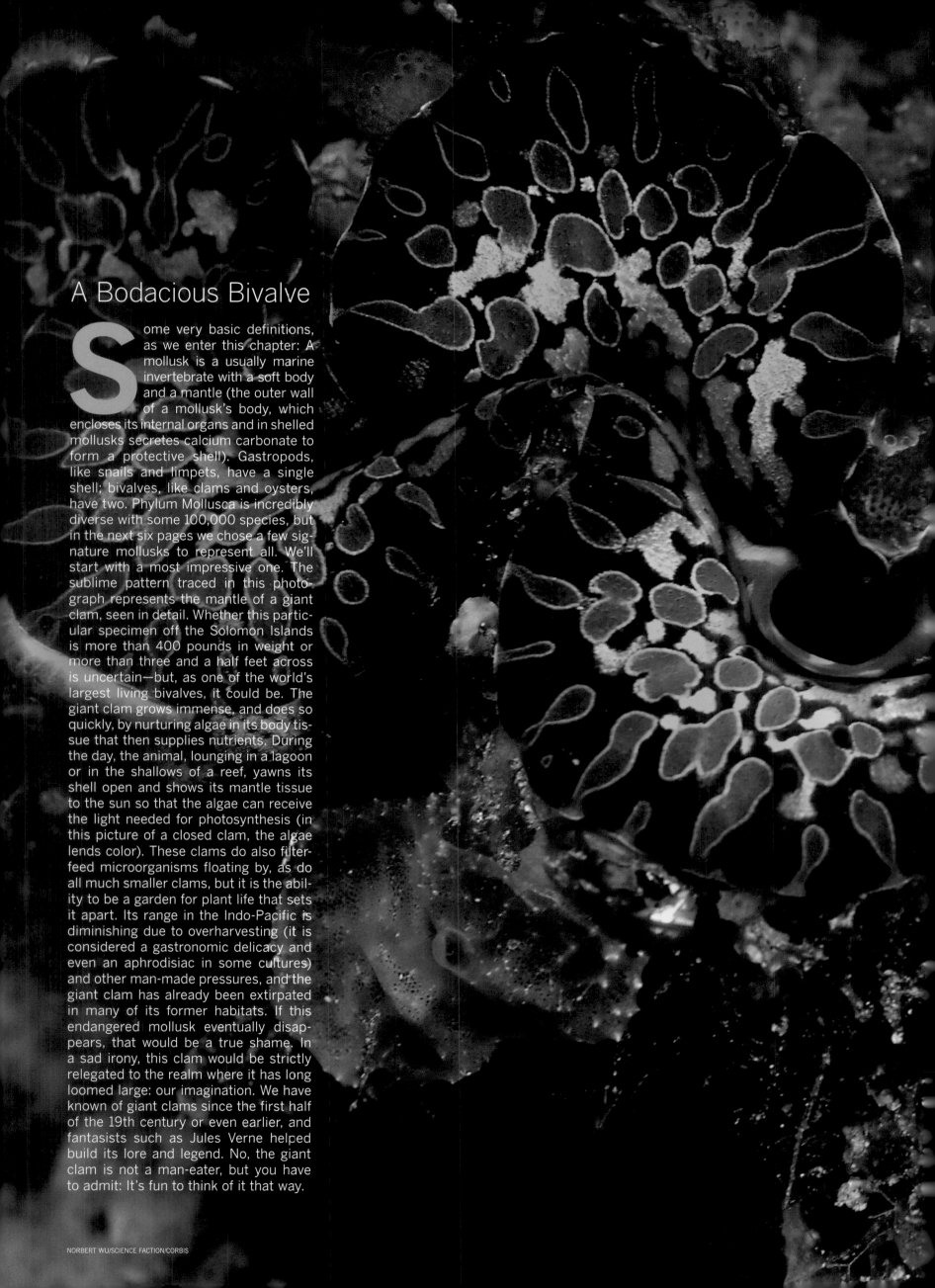

A Bodacious Bivalve

Some very basic definitions, as we enter this chapter: A mollusk is a usually marine invertebrate with a soft body and a mantle (the outer wall of a mollusk's body, which encloses its internal organs and in shelled mollusks secretes calcium carbonate to form a protective shell). Gastropods, like snails and limpets, have a single shell; bivalves, like clams and oysters, have two. Phylum Mollusca is incredibly diverse with some 100,000 species, but in the next six pages we chose a few signature mollusks to represent all. We'll start with a most impressive one. The sublime pattern traced in this photograph represents the mantle of a giant clam, seen in detail. Whether this particular specimen off the Solomon Islands is more than 400 pounds in weight or more than three and a half feet across is uncertain—but, as one of the world's largest living bivalves, it could be. The giant clam grows immense, and does so quickly, by nurturing algae in its body tissue that then supplies nutrients. During the day, the animal, lounging in a lagoon or in the shallows of a reef, yawns its shell open and shows its mantle tissue to the sun so that the algae can receive the light needed for photosynthesis (in this picture of a closed clam, the algae lends color). These clams do also filter-feed microorganisms floating by, as do all much smaller clams, but it is the ability to be a garden for plant life that sets it apart. Its range in the Indo-Pacific is diminishing due to overharvesting (it is considered a gastronomic delicacy and even an aphrodisiac in some cultures) and other man-made pressures, and the giant clam has already been extirpated in many of its former habitats. If this endangered mollusk eventually disappears, that would be a true shame. In a sad irony, this clam would be strictly relegated to the realm where it has long loomed large: our imagination. We have known of giant clams since the first half of the 19th century or even earlier, and fantasists such as Jules Verne helped build its lore and legend. No, the giant clam is not a man-eater, but you have to admit: It's fun to think of it that way.

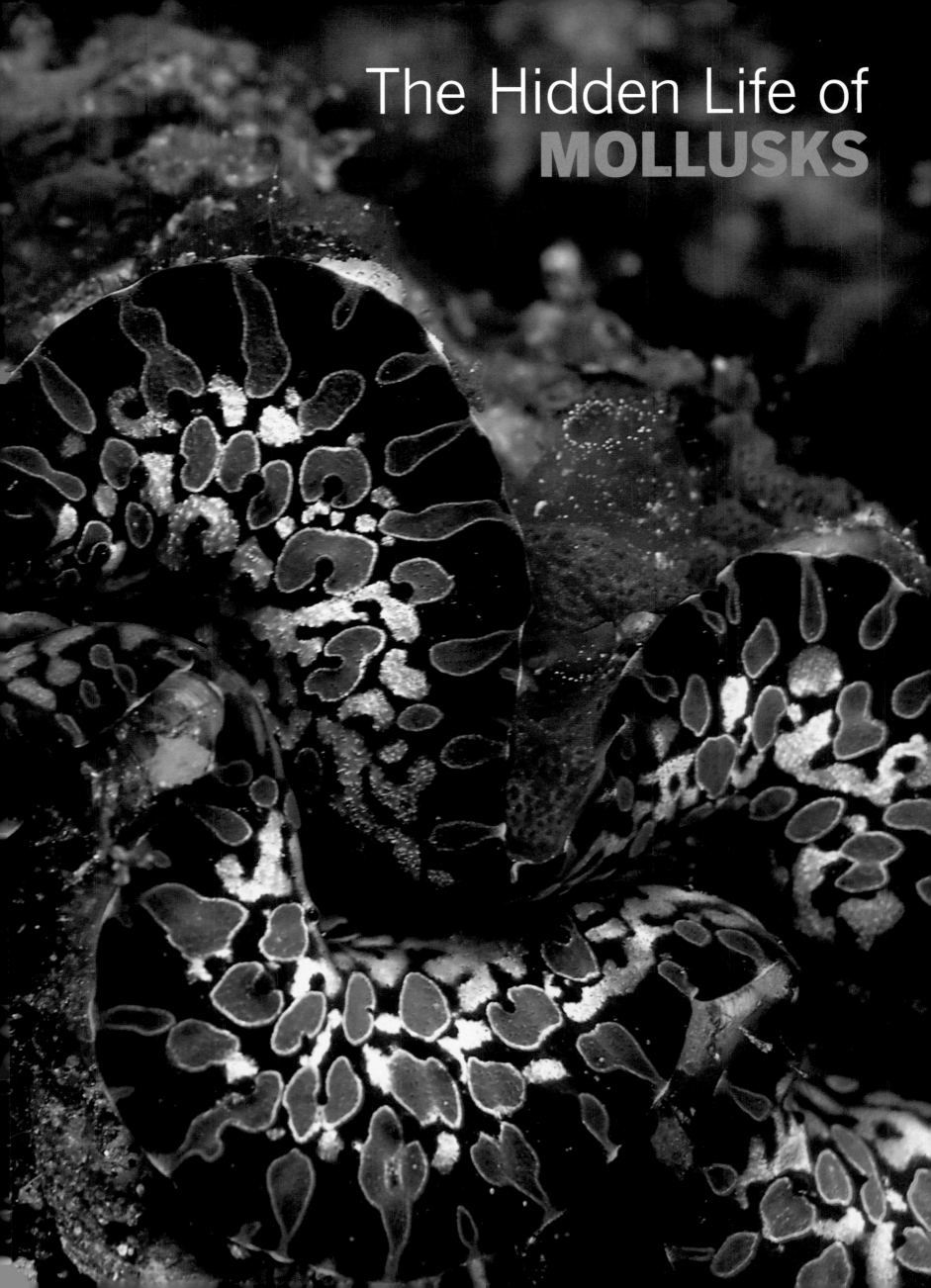

The Hidden Life of
MOLLUSKS

CHRISTIAN ZIEGLER/MINDEN

COLIN MARSHALL/FLPA/MINDEN

Lightweight Contenders

Here we have two members of phylum Mollusca and one member of the Mollusca Diners Club. This page, above: A lettuce sea slug feeds on algae in Bastimentos National Marine Park in Bocas del Toro, Panama. This marine mollusk practices a unique form of photosynthetic dining called kleptoplasty. While eating, the slug sucks out and digests only part of its algal meal. The undigested portions are then stored in the sea slug's lettuce-like leaf frills, where they continue to photosynthesize, providing nutrients for the host for up to nine months. Below: Named after the nudibranch taxonomist Dr. Richard C. Willan, this second sea slug in Tanjung Pisok, Manado, Sulawesi, Indonesia, is called by its binomial name: *Chromodoris willani* or *C. willani,* for short. It is an illustrative example that not all mollusks have shells, which would put it at a distinct disadvantage in a contest with the shelled crustacean at right, the peacock mantis shrimp—not that it would much matter in the end. Resembling both a mantis and the shrimp, of which it is in fact a relative, this six-incher, known as a "smasher," is famous for a pulverizing punch. Using its club-shaped raptorial appendages as fists, the bullying shrimp (something of an oxymoron) literally beats its prey to a pulp with repeated blows clocked at speeds equivalent to 45 miles per hour; it's the fastest puncher among all living creatures. The peacock mantis shrimp seems to know how tough it is and enjoys a challenge, regularly taking on the hardest-shelled mollusks or fellow crustaceans, pummeling away until the victim yields and gives up its savory meat.

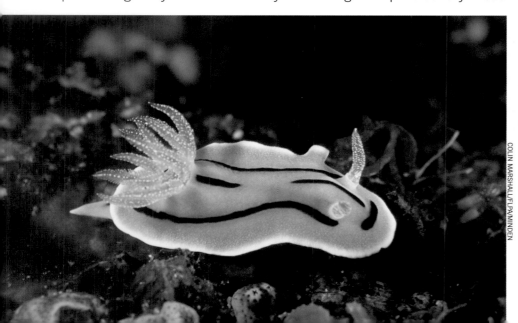

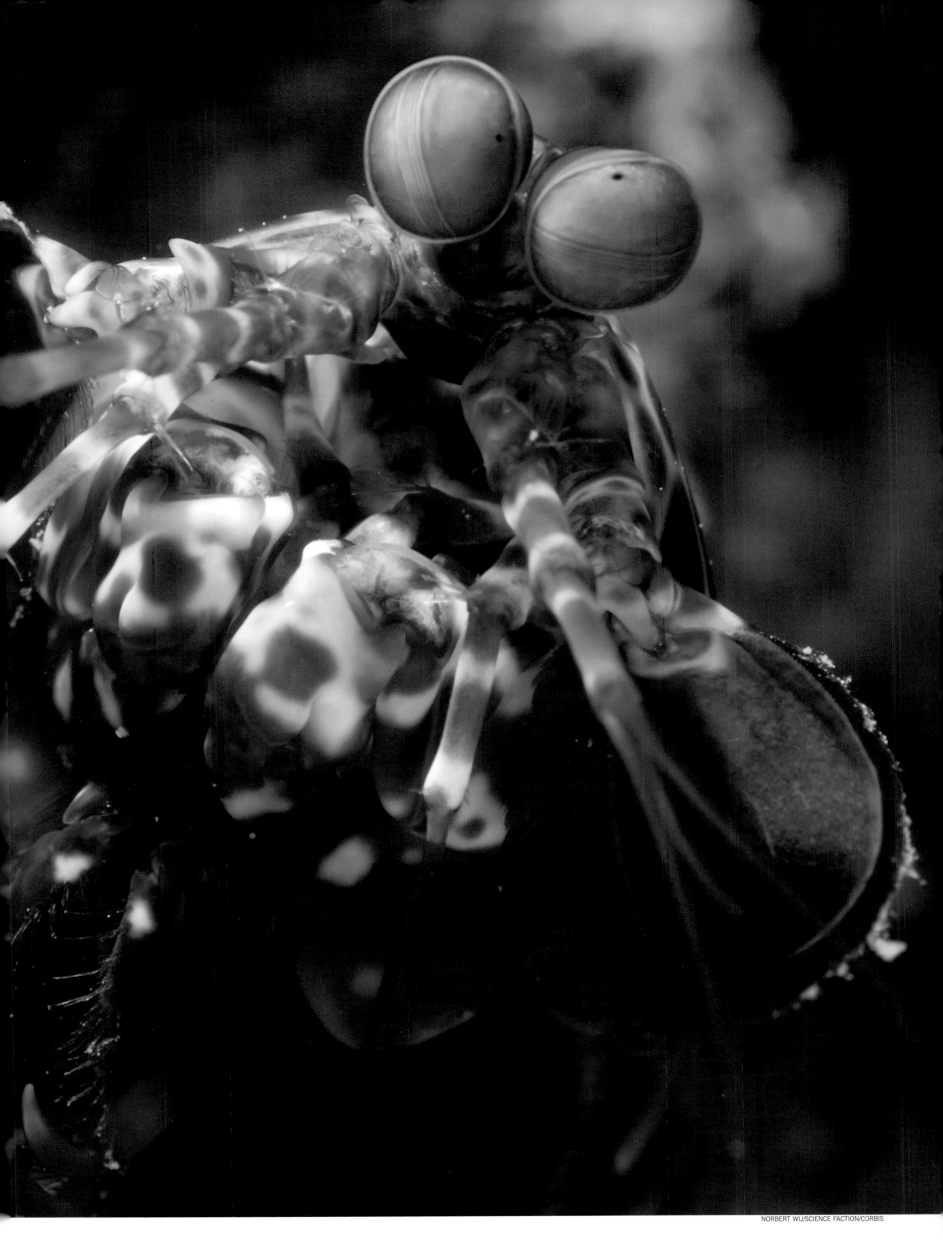

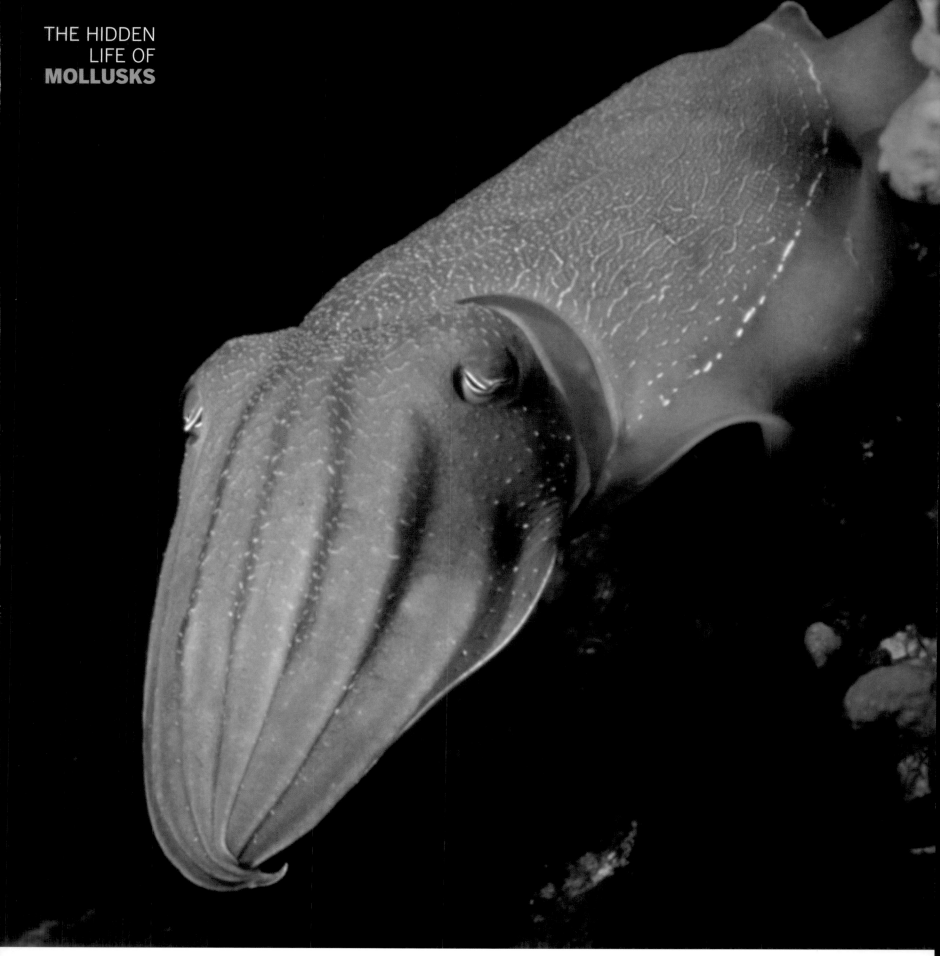

Well-Armed

What is a cephalopod? It is a symmetrically arranged mollusk with gills, a distinct head (it is considered highly intelligent for an invertebrate), advanced eyesight, a mantle, a complex digestive system and arms, often more than two; the three species on these pages have eight arms each. Above, we have a giant cuttlefish aswim in Jervis Bay off the southeastern coast of Australia; opposite, top, is a bigfin reef squid at night off the coast of Indonesia's Pura Island; and below

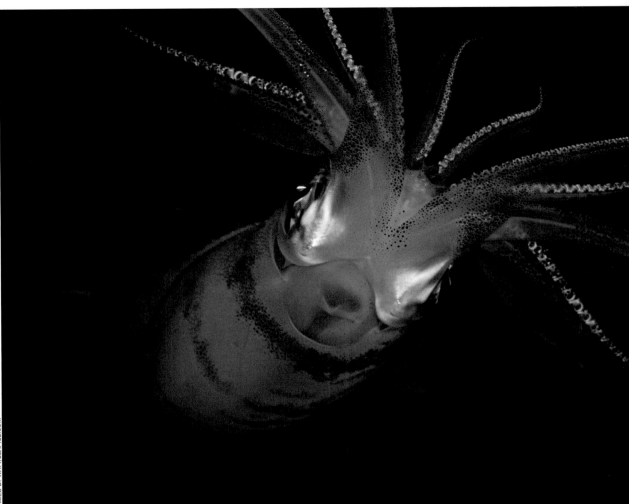

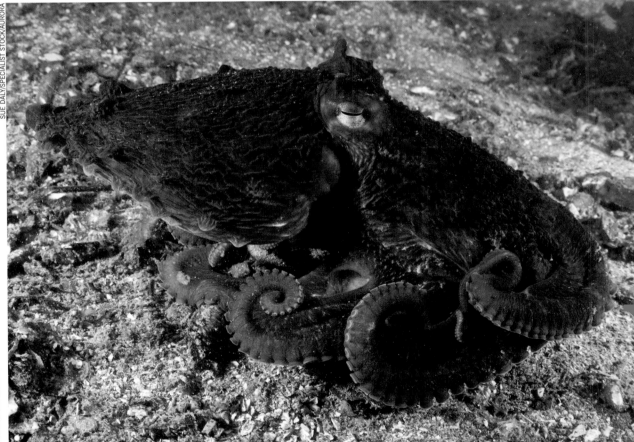

that is a giant Pacific octopus. As indicated, a cuttlefish is not a fish at all but a mollusk; you can't be both. Ranging in size from half a foot to about 20 inches, it dines on crabs, shrimp, fish, worms, other cuttlefish and small octopi. Its brain is very large in relation to its body (for an invertebrate, that is), but it still is not regarded as an octopus's intellectual equal. Octopi seem to have both short- and long-term memory and have exhibited problem-solving capabilities. Combine that, in the giant species, with a size that usually ranges to four feet (although the historical record is 30 feet) and you have a most formidable beast. A giant squid is even more imposing still, reaching lengths greater than 40 feet (though most species, including the reef squid, grow to two feet or less). The squid, the octopus and the cuttlefish are all possessed of hard beaks with which to tear their prey, and in all three of these animals, tentacles and/or suckers are to be feared. Another peculiarity in common: All these animals have three hearts. In the Mollusca honors-earning society called Cephalopoda, these creatures are members in high standing.

Denizens of
THE VERY DEEP

Venting

I n 1977 the submersible *Alvin,* which can take three people nearly 15,000 feet below the sea, was engaged in one of its amazing ventures, this time to explore a volcanic rift in the Pacific Ocean. As so often happens in the business of science, a "routine" exploration opened the door to another universe, one bursting with entirely new life-forms in an ecosystem that was itself a novelty. Deep-sea vents, also known as hydrothermal vents or "black smokers" (below, with tiny crabs and other sea life skittering nearby), are essentially geysers on the ocean floor. Seawater slips beneath that floor, is heated by volcanic rock and thrust upward through cracks, where it collides with cold water, forming a toxic, superheated plume. In the land of the plumes, chimneylike structures composed of mineral deposits, primarily metal sulfides, arise. In this environment of extremely hot and bitterly cold temperatures, of powerful poisons and acute acidity—with a total absence of sunlight and intense underwater pressures that would crush most living creatures—an eerie world thrives, one apart from all others. Right: Giant tubeworms near the deep-sea vents (with eel-pout fish and crabs in attendance) can grow to eight feet and are kin to many smaller species of tubeworms inhabiting shallow waters around the world. Opposite, bottom: Brittle stars, worms and limpets carpet the outside of vent mussel shells.

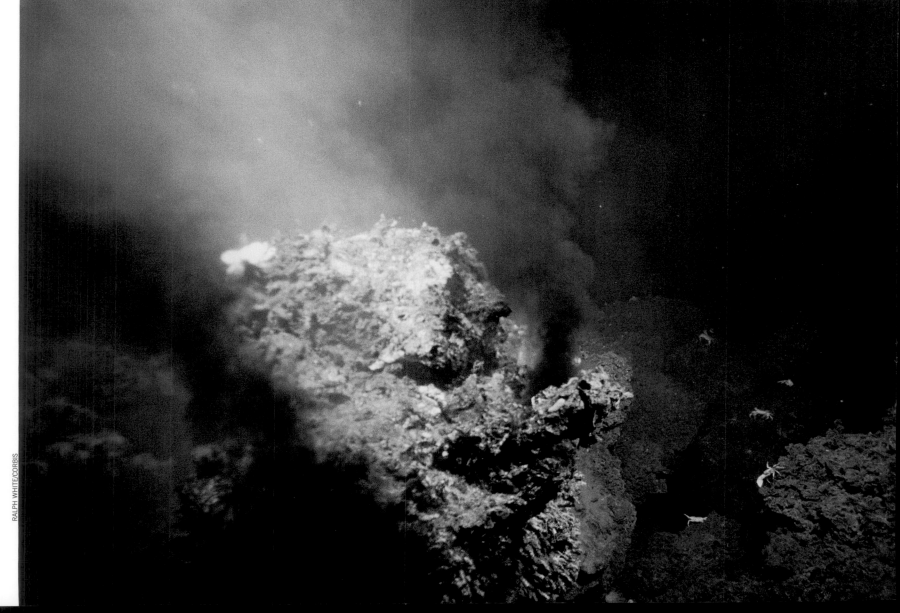

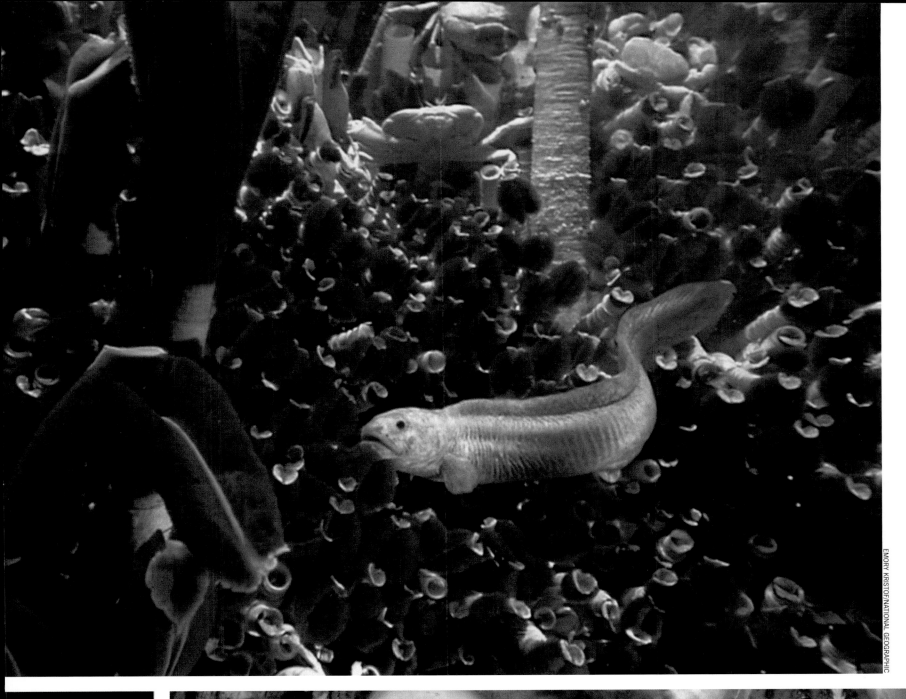

The Horrorshow

The specimens on these pages are not technically classed among vent fish, but are very-deep-sea dwellers and part of that extended community. Above, we have a black dragonfish, a species of deep-sea dragonfish—it exists over a mile down—with fanglike teeth, light-producing photophores covering its body and "headlights" that allow it to see what's coming, or what is trying to get away. Opposite, top, is a sabertooth. You can see how

it got its name. It usually trawls a thousand feet down, ranging to three times that depth. In the center is a gulper eel, which is not an eel at all, just a plain old fish. It, too, has bioluminescent properties and, in certain species, can live as deep as 10,000 feet. At the bottom is the malevolently named black seadevil anglerfish. Earlier in our book we met the interesting frogfish (please see page 36), which is related to the deep-sea anglers, but seems milder by comparison. Deep-sea anglerfish, which are very small

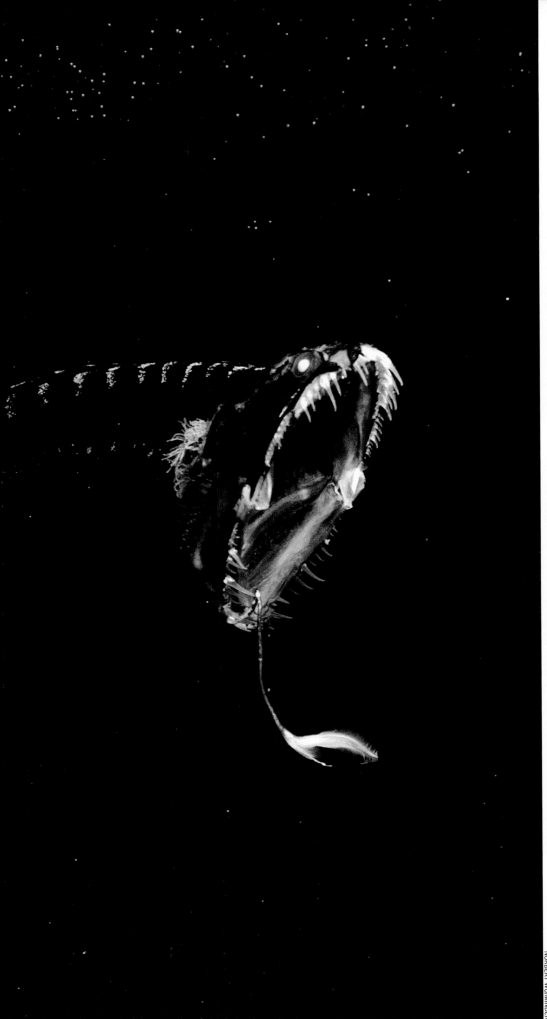

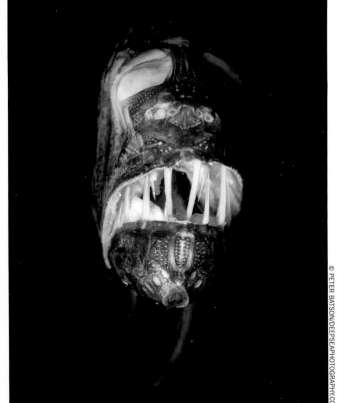

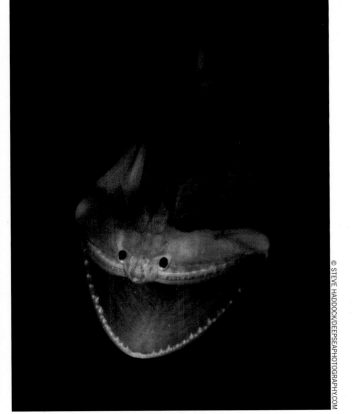

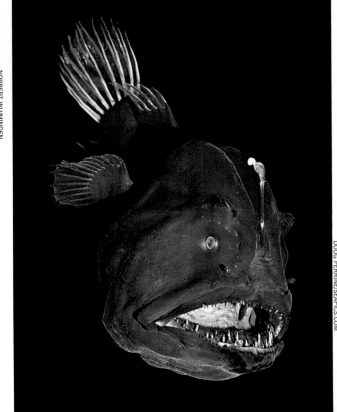

(up to eight inches in length), have round bodies and relatively enormous mouths and, again, fanglike teeth. They don't swim fast; they don't do anything very well except angle for other fish, and eat. The females are particularly adept in this regard: dangling that irresistible, luminescent lure (seen here), then employing an expandable stomach to ingest prey twice their size. They store any excess for when the pickings far down below get slim—which they often do.

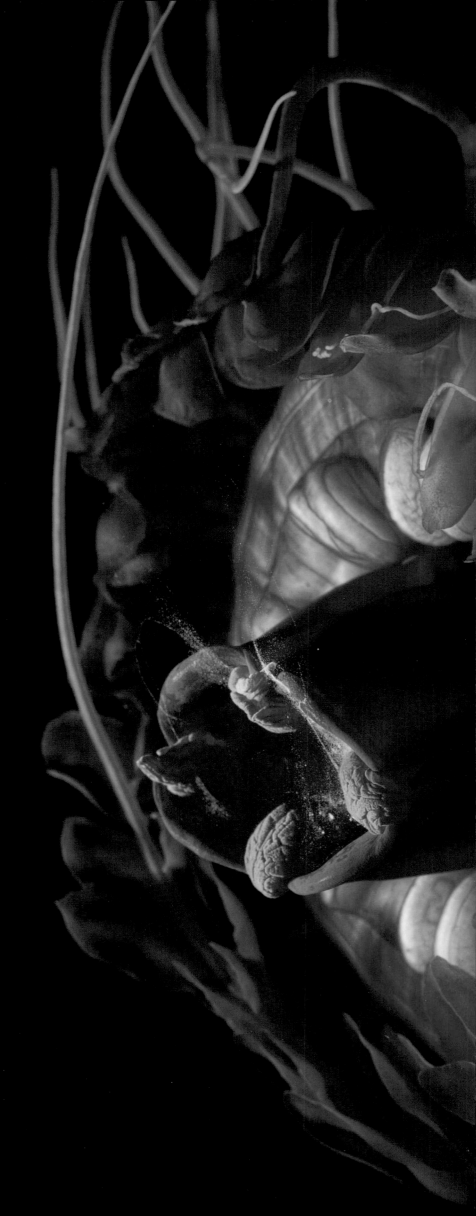

A Crown Jewel of a Jelly

Distributed throughout the world's oceans at depths as far down as one mile are six known species of Atolla jellyfish. Ruby red–brown in color, the Atolla is a crown jelly-fish, an order of jellies distinguished by the grooved, crownlike appearance of their umbrellas. From this umbrella—which reaches about six inches in diameter—the Atolla grows upward of 20 ten-tacles and, as is the case with most jellyfish, these tentacles sting. Because they are skittish and live at such depths, the Atolla jellyfish still poses mysteries to sci-entists. One thing the lab folks do know: The Atolla is a truly magnificent organism if judged by its biolumines-cence. In its signature dark red, the Atolla is nearly invis-ible to its deep-sea predators. When threatened, though, this jellyfish fights back with what is known as a "burglar response": It literally calls for help by sending out a bio-luminescent distress signal. This signal, which resembles a moving pinwheel of blue light, can be seen as far away as 300 feet. The theory is that when under attack, the Atolla jellyfish starts its fireworks display in the hopes of attracting another larger creature, which will then, in turn, scare off or eat the thing that is trying to eat it. With the ability to turn in a bravura performance like this, it's hard to believe the Atolla jellyfish, like its many billow-ing relat has no brain. No brain, no blood, no heart. Ninety-eight percent water, jellyfish aren't even fish. They are actually zooplankton. Zooplankton with sound instincts and innate if unfathomable "intelligence."

Adapters

At right we have a close-up of the face of a rough skate, and below, from left, we have a sea butterfly, a tube-eye fish (also called a thread-tail fish) and a barreleye. These are all deep-sea species and further illustrate how animals must adapt to extreme conditions or find a different way forward (relocation, if possible—extinction being the destination they're trying to avoid). The rough skate ranges from depths of 30 feet from the surface to more than a mile below it. It is a voracious eater of benthic invertebrates, and grows larger than most skates that cruise the reef. The sea butterfly is actually a shell-less snail that swims by propelling itself with its muscular wings (which are actually modified feet, the same appendages upon which conventional snails crawl). Just about an inch long, and disarmingly named after the butterfly, this delicate creature is a surprisingly fearsome predator, feeding upon other pelagic gastropods. The tube-eye, whose eyes resemble binoculars, is swimming in its characteristic vertical position in the Arabian Sea. This is another fish that makes nightly migrations from the deep toward the surface, in the tube-eye's case to feed on plankton. The barreleye, for its part, keeps its specialized peepers pointed up to detect the faint shadows of predators or prey. The deep sea is filled with specialized species floating about, ever watchful, desperate to eat and not be eaten.

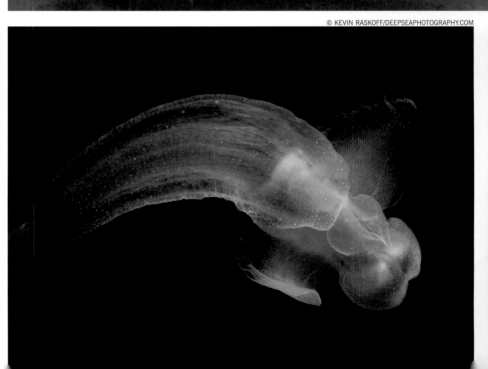

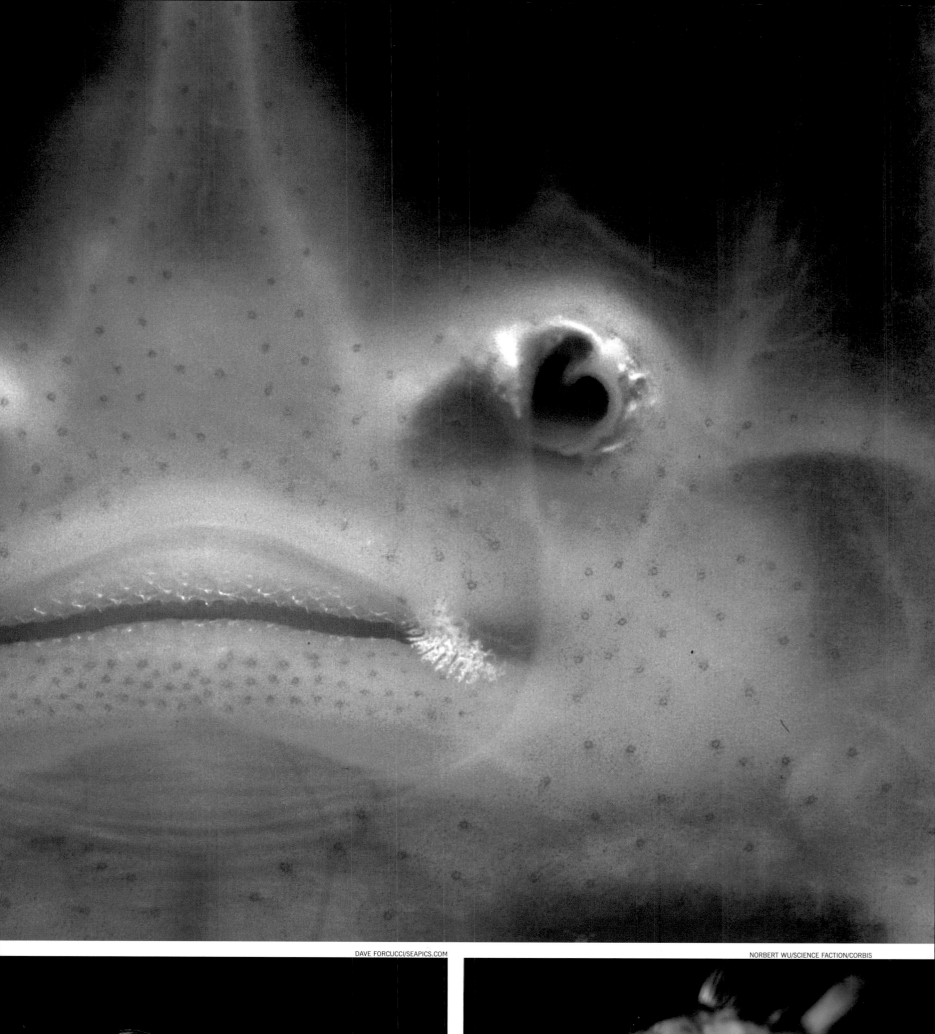

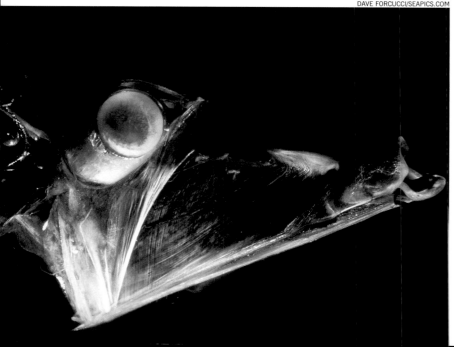

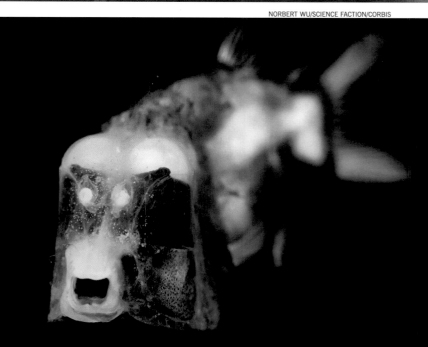

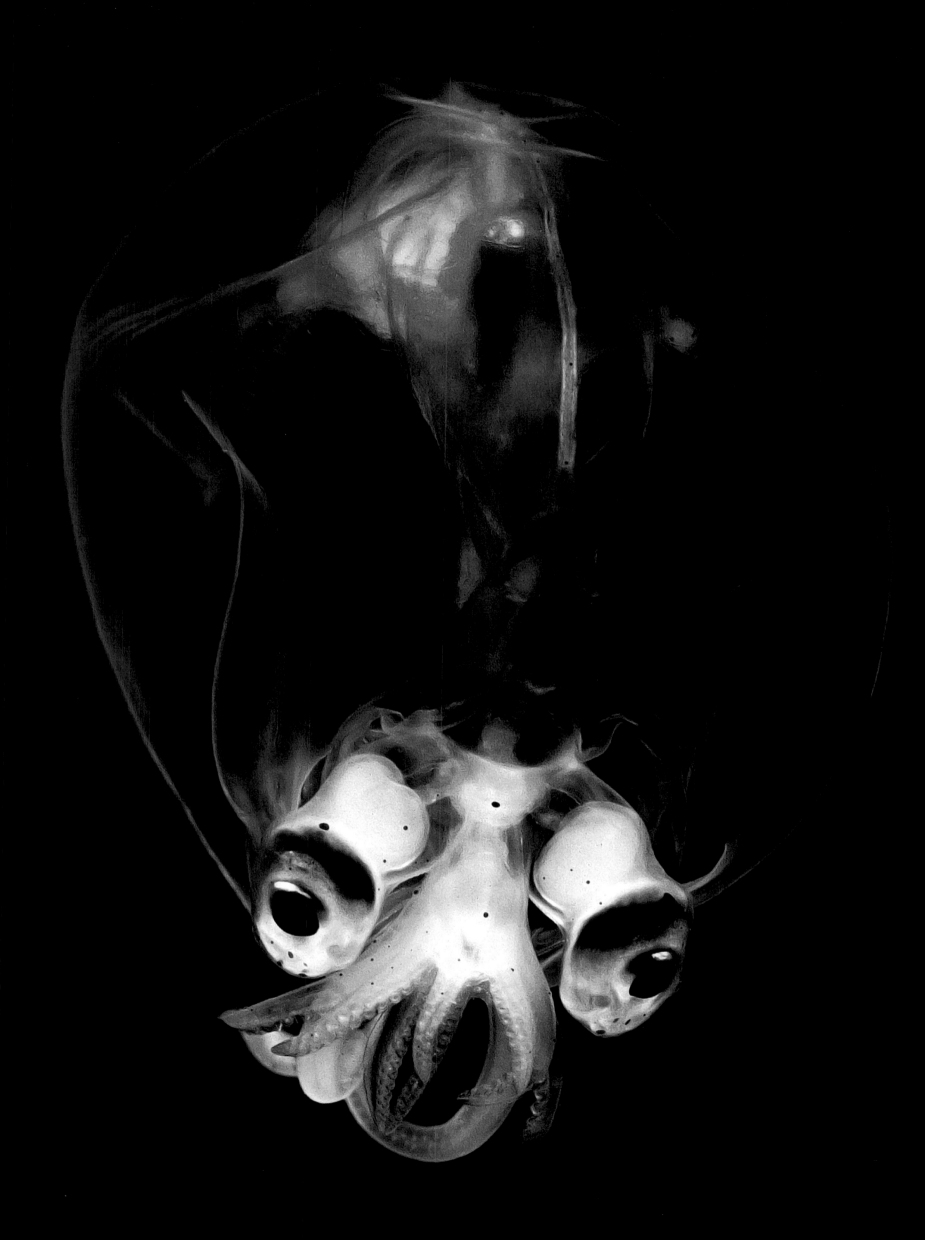

Distant Relations

O n the opposite page is a photograph of the glass squid, a deep-sea citizen of the Southern Hemisphere. This species has light organs on its eyes but is otherwise transparent and possesses the ability to roll into a ball, like an aquatic hedgehog, in an attempt to elude its foes, which include goblin sharks and whales. The Dumbo octopus, seen in two photographs on this page descending to the ocean's floor to feed, gets its name from Disney, or rather: scientists amused by Disney. The fins protruding from the top of its body, which basically looks like one big head, reminded them of Dumbo the flying elephant's prominent ears. The seagoing Dumbo, one of the rarest of octopi, lives at depths exceeding, in unusual instances, four miles. They grow to a few feet in length and, in a hefty individual, a dozen pounds in weight, and have taken on characteristics of their fellow denizens of the very deep that are differentiated from those of their own family. For instance, the Dumbo, perhaps savvy that food at extreme depths is scarce and to be treasured, swallows its prey whole in one gulp; no other octopus does so. They use everything they have, including those earlike fins, to move about in their black-as-night world. In short, they make it all work.

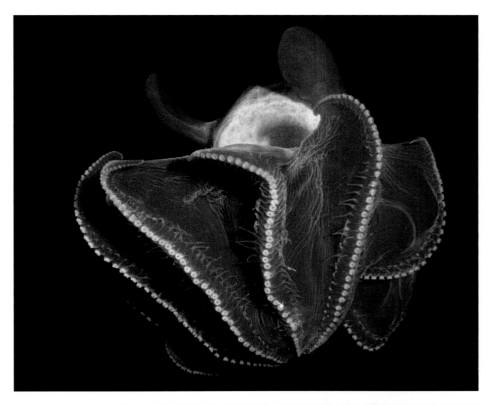

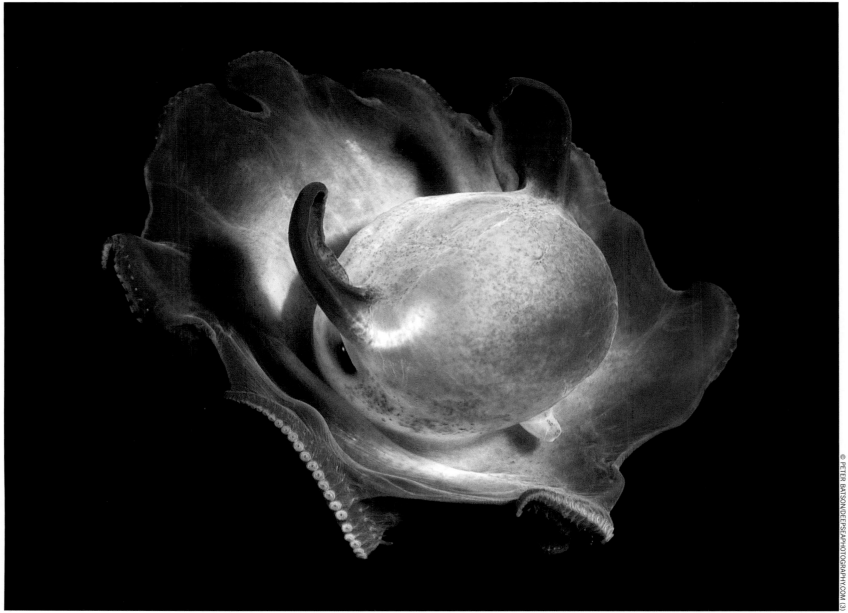

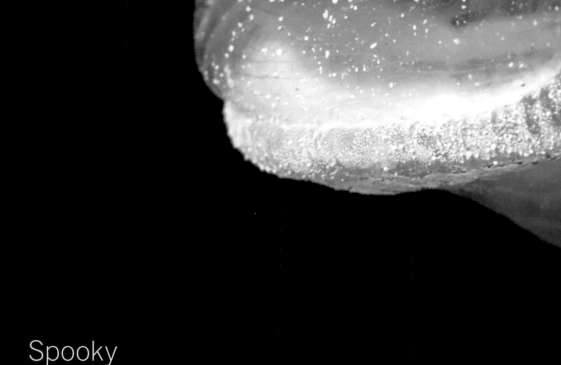

Spooky

Thousands of feet below the surface, anchored to the deep-sea walls and ocean floor of Monterey Canyon, off Monterey, California, sits the predatory tunicate. Prehistoric not only in appearance, the predatory tunicate dates back to the Cambrian period of about 540 million years ago. Like most tunicates, it is a filter feeder. But unlike the others, it captures its prey by snapping its large oral hood shut and trapping inside any passing zooplankton or tiny animal. Predatory tunicates are also simultaneous hermaphrodites: Each animal can produce both eggs and sperm, allowing it to reproduce by itself if need be. Opposite, another deep-sea dweller, a newly classified spookfish, is pictured here off the Cape Verde islands in the North Atlantic. Existing more than 3,000 feet down, where very little light penetrates, Spooky has found a way to make do with what's available. Recently, it was discovered that the brownsnout spookfish is the only vertebrate ever found to use mirrors, as well as lenses, to focus light in its eyes. How does it do this? While the brownsnout spookfish appears to have four eyes, it really has only two, but each is split into dual parts. One half points upward, catching light from the surface far above; the other points downward. Within these downward-looking parts are mirrors made of tiny plates of guanine crystals. These mirrors help to reflect the bioluminescent light emitted by other creatures, providing the spookfish with imagistic warnings from its surroundings. Thousands upon thousands of years of evolution have gone into this modern, creepy-looking animal.

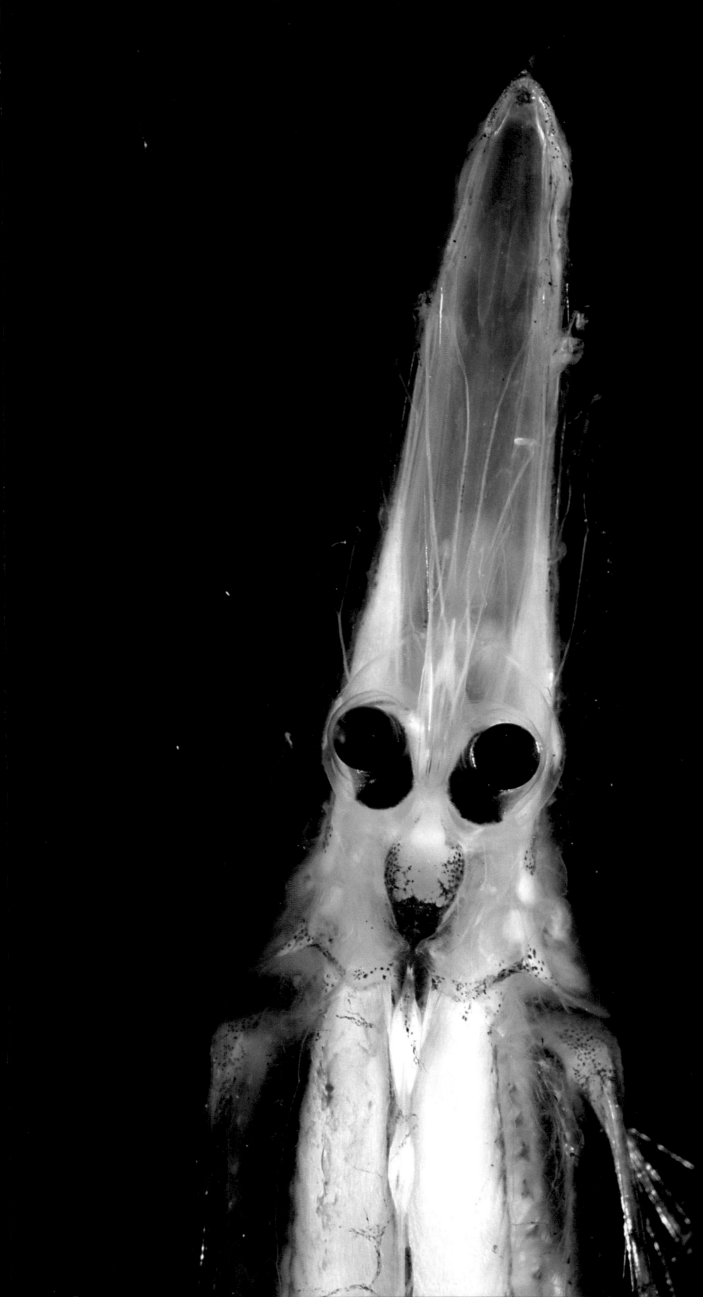

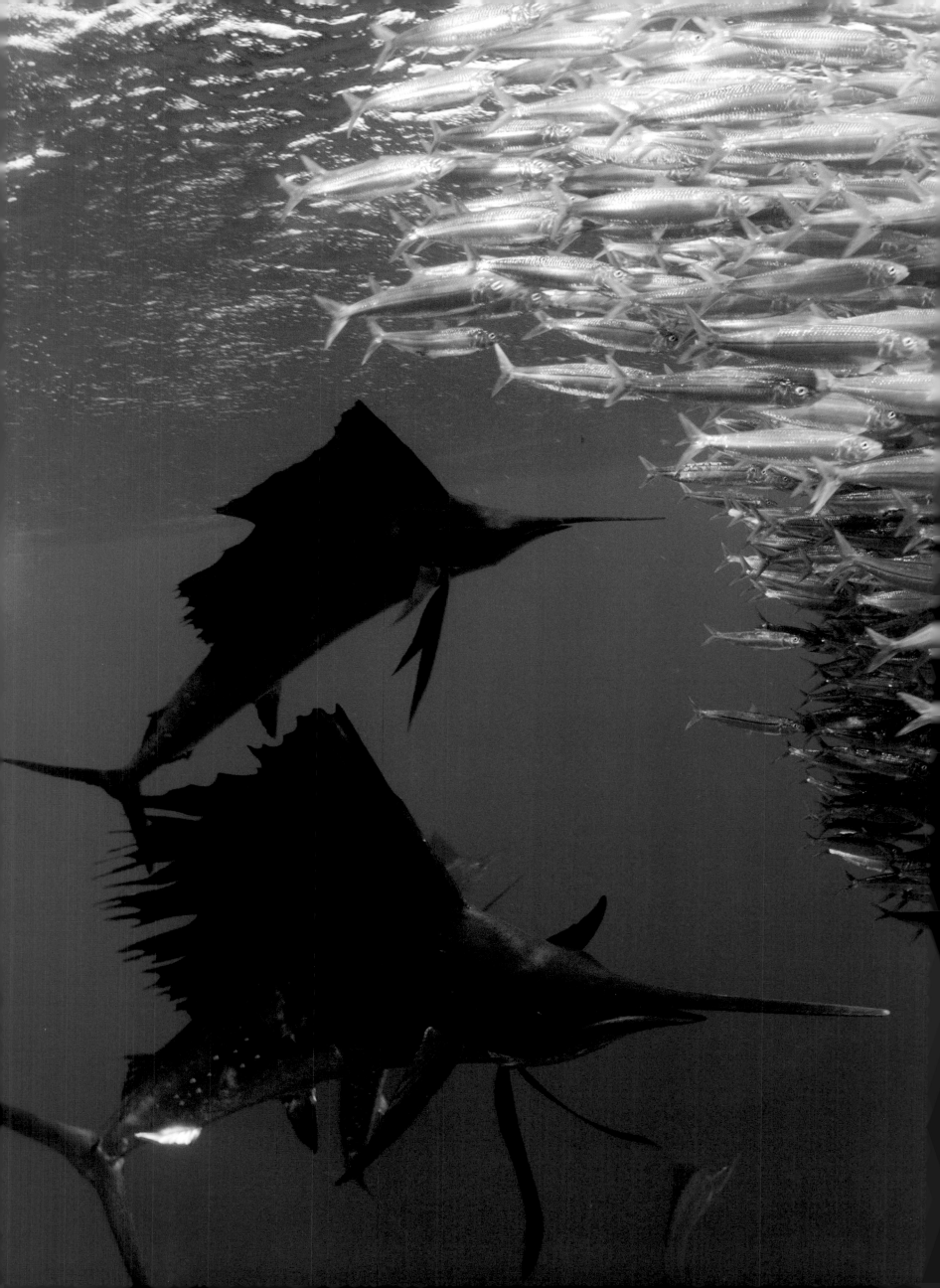

Here Come
THE
BIG GUYS

Come Sail Away

Or should we say: Come *speed* away? Named for its exceptional dorsal fin, which runs nearly the length of its body and can be raised and lowered like the sails of a ship, the sailfish can swim at speeds of up to 68 miles per hour—earning it the title of fastest fish in the sea. As agile as it is fast, the sailfish, seen here off Isla Mujeres, Mexico, is an expert hunter. Angling in groups of 20 or more, it darts in calculated circles, manipulating schools of anchovies or sardines by pumping its sail and changing color from blue to stripes to black, a tactic that confuses prey while communicating with its fellow hunters so as to avoid collision. Amazing. Once the prey are corralled, a sailfish uses its spear-shaped bill to stab through the school, separating out a single fish before gobbling it up. And speaking of bills, the sailfish—like the marlin and swordfish—is a member of the billfish family, a brood of apex predators distinguished not only by their distinctive swordlike upper jaws and hunting skills but also by the spirited fight they exert when hooked. Because of this ferocity and its large size—a sailfish can grow to 11 feet and can weigh 200-plus pounds—it is highly sought as a trophy fish. But unlike its brethren swordfish and marlin, the sailfish doesn't taste as good as it looks, and so there are today abundant populations continuing to slice, surf and sail through the waves and currents of the world's warmest oceans.

A Blues Ballad

This beautiful fish, with its streamlined body and crescent-shaped tail, is, as much as any other, a poster child for a food chain that begins with plankton and ends with man. A powerful swimmer able to reach speeds of more than 40 miles per hour, the bluefin tuna fuels its considerable energy with near-constant eating of smaller fish, crustaceans, squid, eel, plankton and even kelp. The constant buffet of fatty foods causes the bluefin's signature buttery belly to expand to enormous widths; the largest Atlantic bluefin tuna ever caught weighed 1,496 pounds. If the bluefin likes to eat, we like to eat the bluefin. The rising popularity of sushi and sashimi in recent decades has only made the fish more prized than ever, and in January of 2012, a 593-pound bluefin set a world record when it sold in Tokyo for $736,000. With such money in the mix, the hunting of tuna has taken on extraordinary—some would say dastardly—aspects. Today, there are spotter planes scouting the seas for schools of bluefins, and some fish, once netted, are dragged to offshore "sea cages" where they are fattened further before slaughter. Historically, there were millions of Atlantic, Pacific and southern bluefins roaming the oceans. No longer, and in 2011 the National Oceanic and Atmospheric Administration listed the bluefin a "species of concern" after debating whether to protect it more stringently under the federal Endangered Species Act. NOAA will revisit its decision in early 2013.

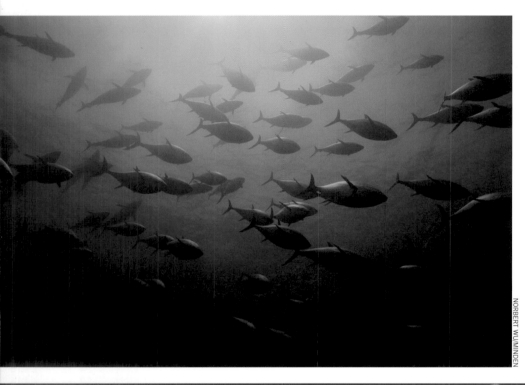

NORBERT WU/MINDEN

ROBERT THOMAS/NATIONAL GEOGRAPHIC/GETTY

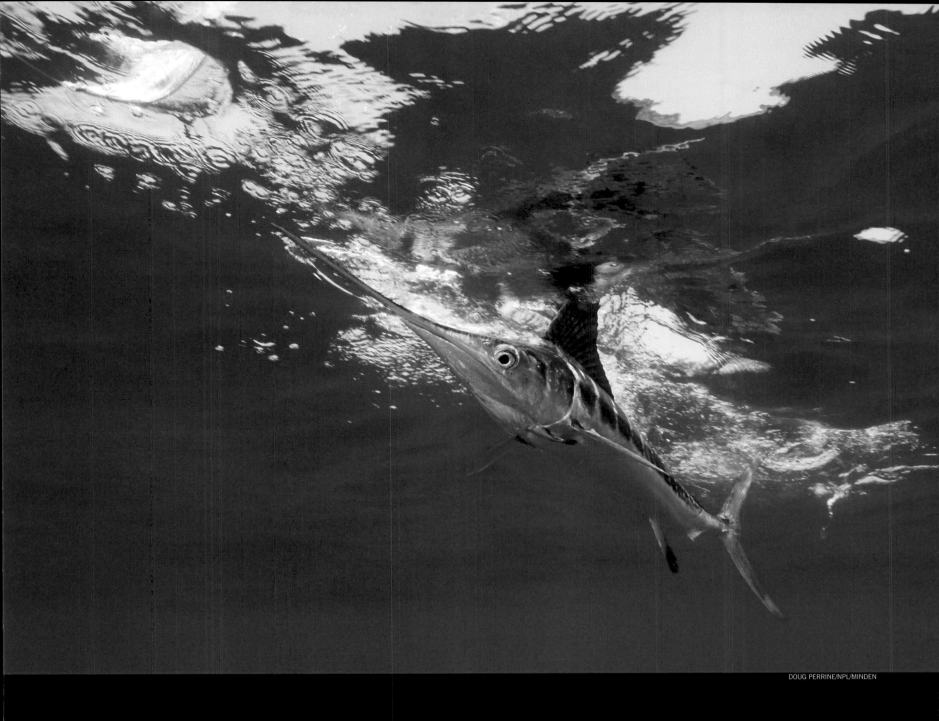

Papa's Heroic Fish

I n September 1952, LIFE magazine printed the ultimate fishing
tale, Ernest Hemingway's *The Old Man and the Sea,* and we
printed it in its entirety. The novella, which earned Hemingway
a Pulitzer and cemented his Nobel Prize in Literature, chron-
icled in print what fishermen have been yarning about for
decades if not centuries: the dramatic battle between man
and marlin. Known for being tremendous fighters when hooked,
and garnering the largest cash prizes when caught, marlin (black,
blue, striped and white) are some of the most sought-after fish
in the sea. Their character—their ferocity, their beauty—have
made them an ultimate prize and have gotten them in trouble.
Consider: A female Atlantic blue marlin can reach nearly 2,000
pounds, and in 2006, Bisbee's Black & Blue Marlin Tournament in
Cabo San Lucas, Mexico, awarded sport-fishing's greatest overall
cash payout of more than $4 million to anglers who caught (then
released) several big blues. Other fishermen in nontournament
settings do not give their marlins back to the sea, and in 2011,
the International Union for Conservation of Nature's Red List of
Threatened Species called the blue and white marlin "vulnerable,"
and the striped marlin as "near threatened." (Seen here is a lovely
example of an Atlantic white marlin, the even more elegant little
sister of the blue, maxing out at 200 pounds.) "Then the fish came
alive," wrote Hemingway, "with his death in him, and rose high
out of the water showing all his great length and width and all his
power and his beauty. Then he fell into the water with a crash . . .'
Poetry, surely. Perhaps prescience?

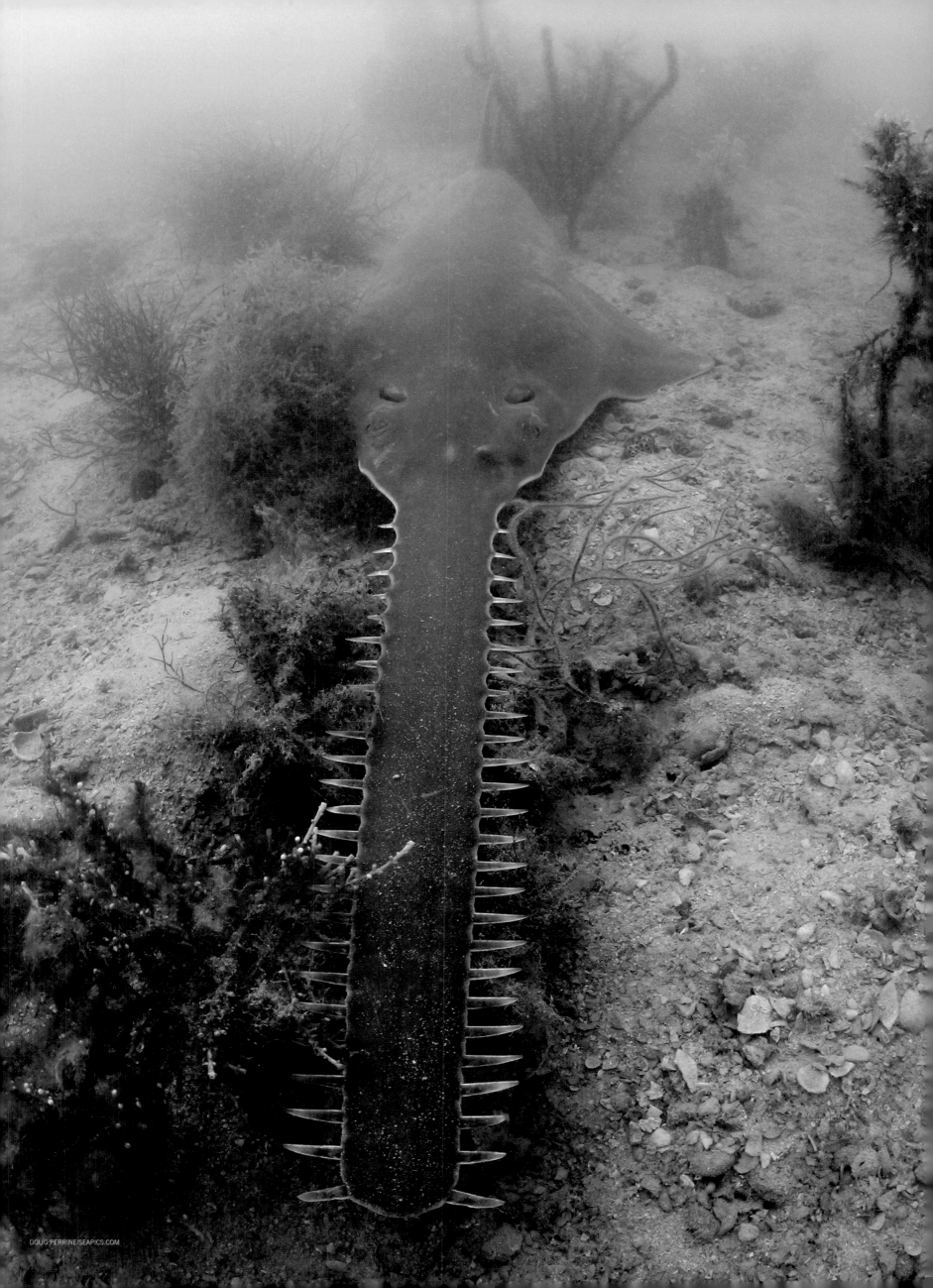

Toothsome

Cruising the muddy bottoms of tropical and subtropical Atlantic shorelines is the smalltooth sawfish (seen opposite in Everglades National Park at the southern tip of Florida). Easily recognizable by its rostral saw, the smalltooth is hardly small, growing to an average of 18 feet in length. It can exist in both fresh- and saltwater. The sawfish uses its tooth-lined snout not only to rake through sand for crustaceans but also as a sword to swipe through schools of fish. Once its prey is plucked, the sawfish employs a mouth with 10 to 12 more rows of teeth. Unfortunately, all this stabbing and serrating often gets the smalltooth sawfish snared in fishing nets, and in 2003 it was placed on the federal endangered species list, making it the first U.S. marine fish species to receive protection under the Endangered Species Act. Below: A spiraling school of blackfin barracuda ready to flash their incisors in the Solomon Islands. Found primarily in the Indo-Pacific region, blackfin—or chevron—barracuda are so called for their ink-striped bodies and black-tipped caudal fins. Shimmering and streamlined, the blackfin, like other barracuda, exhibits a voracious stare and a mouth filled with long, lethal teeth. Related to the speedy sailfish, barracuda are stealth predators, often hunting in shoals and ambushing prey in torpedo attacks involving bursts of speed up to 27 miles per hour. Scuba divers visiting reef habitats often report being followed by collectives of curious barracuda. These lookie-loos usually keep their teeth to themselves. *Usually.*

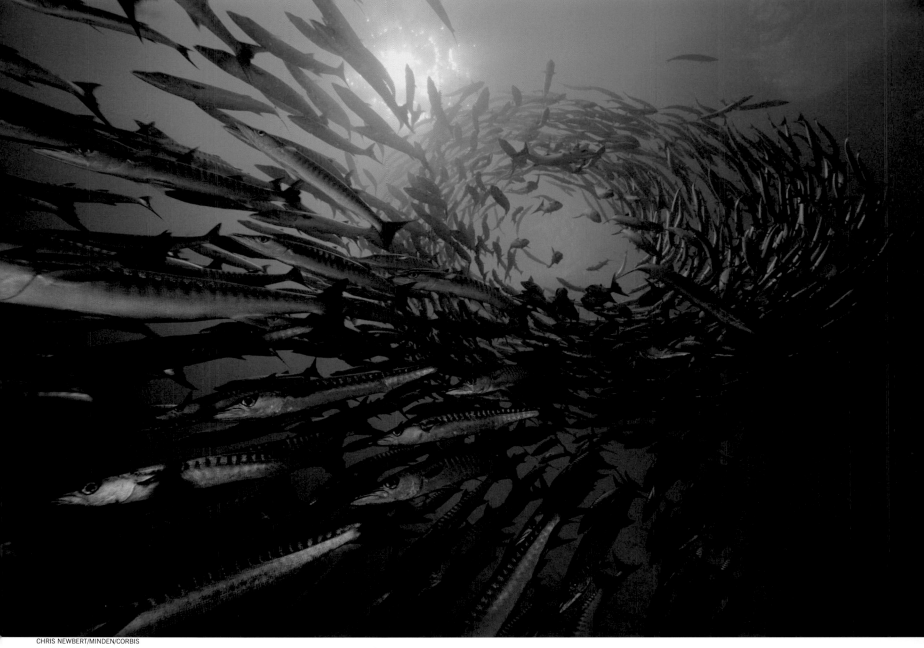

ALBERT LLEAL/MINDEN

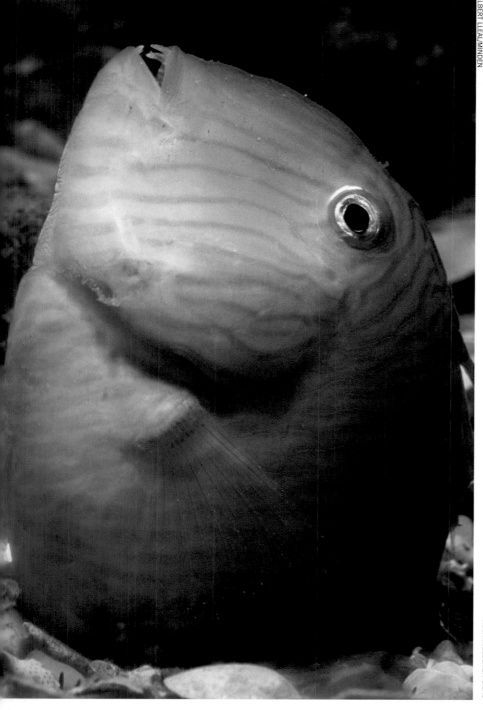

CHRIS NEWBERT/MINDEN

Sea Hags and Their Kin

There is a Welsh word you should not even try to pronounce: *gwrach.* It means "old woman" or "hag." Somehow a derivation has evolved—wrasse—which today is the name of nine tribes of fish that, in all, number some 600 species. What they share is that they are all carnivores of the Labridae family, surviving on a diet of smaller invertebrates. Where they diverge is manifold throughout the 82 different genera of wrasse. Most of them are not all that large, half a foot or less (you have already met the tiny, fascinating and helpful cleaner wrasse on pages 42

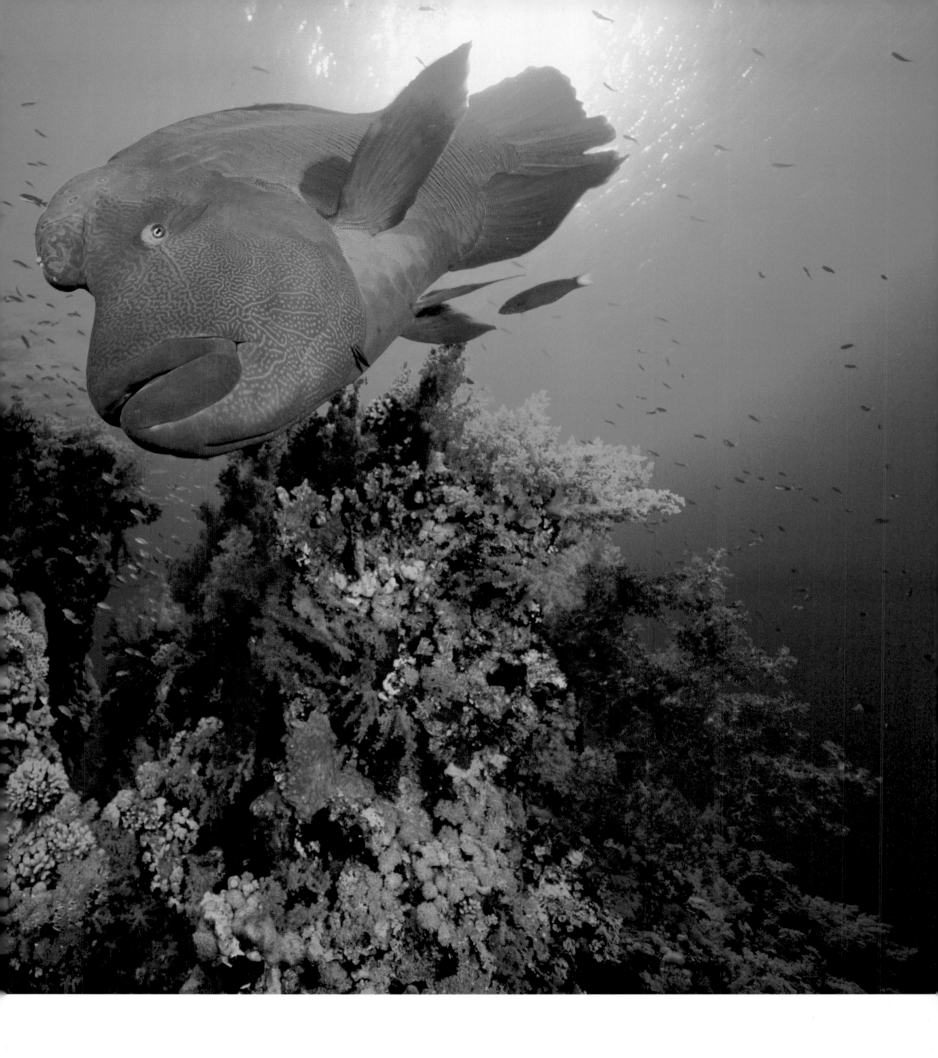

and 43), but the humphead wrasse (above)—also known as the Maori wrasse, Napoleon wrasse or Napoleon fish—can reach, in the male of the species, more than seven feet in length and hundreds of pounds in weight. He'll eat anything, including toxic sea critters such as boxfish. A fascinating fact: Humphead wrasse are hermaphroditic in their youth, and some of those who are going to become male don't do so until about nine years of age. Equally strange is its relative the cleaver wrasse (opposite). These fish, too, all start life female and then figure it out, the males turning red or greenish, females staying pinkish or brownish. Growing to a length of up to two feet, it has a head that is higher than it is long, and a small mouth filled with a dozen teeth, the front ones strong and sharp. Its habitat is the sandy or muddy bottom, sometimes 400 feet down or even deeper in winter, where it burrows for small invertebrates. It burrows more fervently—it can disappear in a second—when a predatory dolphin threatens. There are so many fish in the sea, all behaving so differently. Even in a clan like the wrasse family, the diversity of appearance, size and methodology is astonishing.

An Interesting Group

n the western Atlantic, ranging from the Carolinas to Bermuda through the Bahamas to the waters off Brazil, is a fish called the red hind (below). Growing to more than two feet in length, it feeds in the shallows of the coral reef on crabs, other fish and the occasional octopus. But it is a predator with a benign spirit, and can easily be caught by hook or by spear. It is prized by its principal hunter—man—because it tastes good, as do many of its relations in the grouper family. Far from the Atlantic—in fact, on the other side of the planet, swimming in the Pacific Ocean off the coast of Australia and in other places, including the Red Sea—is the blacktip grouper (opposite, bottom), distinguished by the dark tips of its dorsal fin and, often, the red cap above its eyes. It, too, is delicious. It is a great and unfortunate irony for groupers that they look so ghastly and yet are so yummy. Their own eating habits make the story more interesting

still. Groupers don't have many teeth, and as they are plump, they aren't the best swimmers. They prowl with that big mouth agape, and engulf their prey, sometimes sucking in fish that were, only a moment ago, a good ways away. Opposite, top, we have a giant grouper, also called a potato cod, with yellow pilot fish hunkering beneath it, swimming on the Great Barrier Reef off northeastern Australia. This fish can reach a length of more than seven feet and a weight of hundreds of pounds; it's the largest bony fish found on the reef. There are all sorts of king-size groupers—the Malabar grouper, the goliath grouper—all closely related. They feed on reef fishes, crabs and spiny lobsters, and are vigorous not only in dining but when confronting an enemy. Man of course is one, and giant groupers can present a danger to an inexperienced fisherman. Still, the odds are stacked, and this behemoth is vulnerable to the spear fishery.

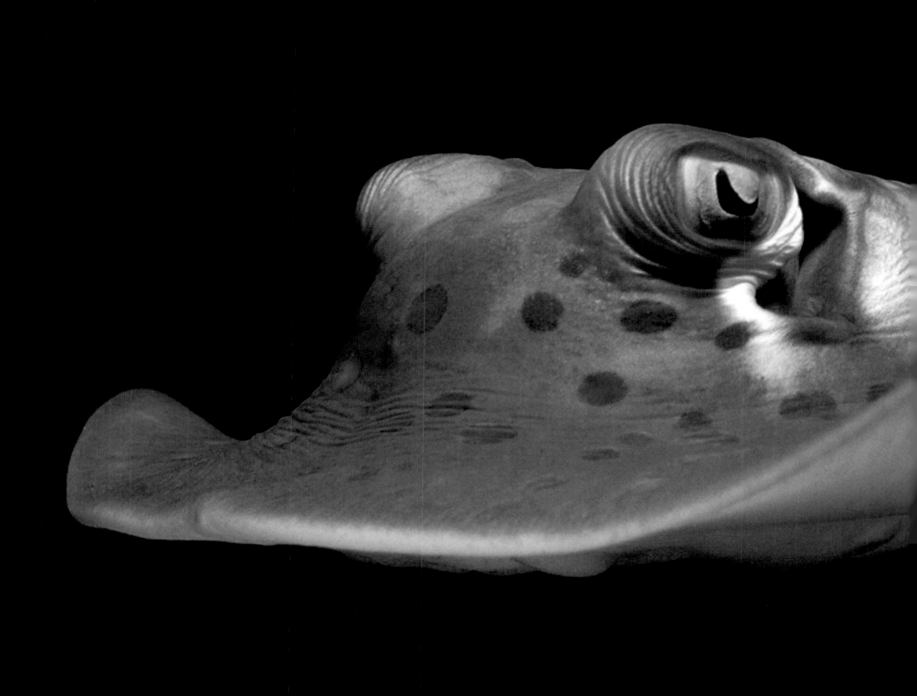

Ray's the Name

The American modernist photographer Man Ray was famous for strange, haunting images rendered in black and white. And in the world's tropical and subtropical oceans we have a school of manta rays in an image (below) the artist might have appreciated. Flapping an expansive 20-foot-plus wingspan, this largest ray in the sea, and cousin to the shark, effortlessly swims—soars—through the water. When it is feeding time, the manta opens the bladelike projections on either side of its gaping mouth to help steer in plankton, the manta's main food source. Though a member of the Mobulidae—or devil ray—family, mantas are gentle creatures devoid of the characteristic stinger so often associated with the ray species. At left is one of those stingers, the bluespotted stingray. It has a long tail with two stinging spines on the base. This fish, a bottom-dwelling species, is found near coral reefs and in the sandy shallows of the Red Sea and off the coasts of East Africa, Japan and Australia. Mostly solitary, the bluespotted stingray uses its large winglike fins to overpower its prey of shrimp, crab, mollusks and small fish. Interesting to note: Both the manta ray and bluespotted stingray are, like most sharks and rays, ovoviviparous, meaning they produce eggs that instead of being laid, develop and hatch within the mother's body.

LOGAN MOCK-BUNTING/AURORA

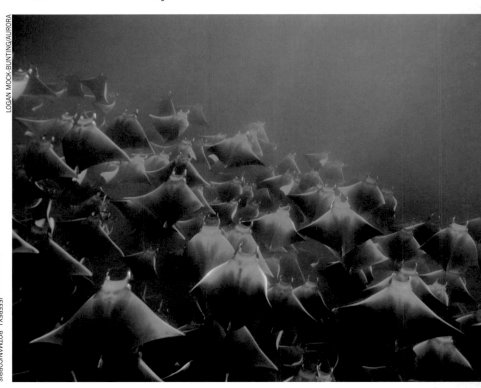

JEFFREY L. ROTMAN/CORBIS

Drawn to the Deep

These are the men and women that go down to the sea in ships, that do business in great waters. If they do not trace their heritage to the fishermen of the 107th Psalm, they travel at least as far back, psychically and spiritually, as Jules Verne's fictitious Captain Nemo, the tormented scientific genius who sailed the seven seas in the *Nautilus,* the submarine he built on a desert island. Such a wondrous figure captured the imaginations of kids who, thus inspired, grew into real-world oceangoers—just as the early American and Russian rocketeers had been spurred by Verne's all-but-unbelievable voyage to the moon. Perhaps the most famous disciple of Nemo is Verne's fellow Frenchman Captain Cousteau, but such as explorer Robert Ballard and filmmaker James Cameron are members of the fraternity as well. It is certain that tomorrow a new generation will go down to the sea in ships, and do business in great waters. The allure of what the Bible called God's "wonders in the deep" is simply too strong.

"I hate danger," Jacques-Yves Cousteau once said. How to credit such a remark from a man who plunged below the ocean's surface more than 30,000 times, free-diving to depths of 300 feet. Fifty fathoms down: an unlikely spot to find a man who suffered chronic anemia as a child and remained thin and wiry for 87 years. But as much as he might have hated danger, he loved the sea—particularly the undersea. "From birth," Cousteau wrote, "man carries the weight of gravity on his shoulders . . . But man has only to sink beneath the surface and he is free. Buoyed by water, he can fly in any direction—up, down, sideways—by merely flipping his hand. Underwater, man becomes an archangel."

Cousteau was many things: adventurer, inventor (the Aqua-Lung, among other devices and vehicles), documentarian and something of a poet. In more than 150 filmed accounts and through dozens of books, he communicated his abiding love of science as well as his sense of wonder. He continuously flirted with danger despite himself. He tested the impact of underwater explosions for the French navy, and he swam among the sharks. In his trademark red cap and high-tech research vessel, *Calypso,* Cousteau led 55 expeditions—from Alaska to Antarctica. He even went in search of the lost continent of Atlantis in the Aegean sea. When he died in 1997, the world mourned. We had lost our Pied Piper of the seven seas.

The two images at left are from *The Silent World,* the 1956 film codirected with Louis Malle, that helped launch Cousteau's fame. Below: In 1954, the adventurer descends off Abu Dhabi in a shark-proof cage. Bottom: By taking his movie camera to the depths, an oceanographer became world famous.

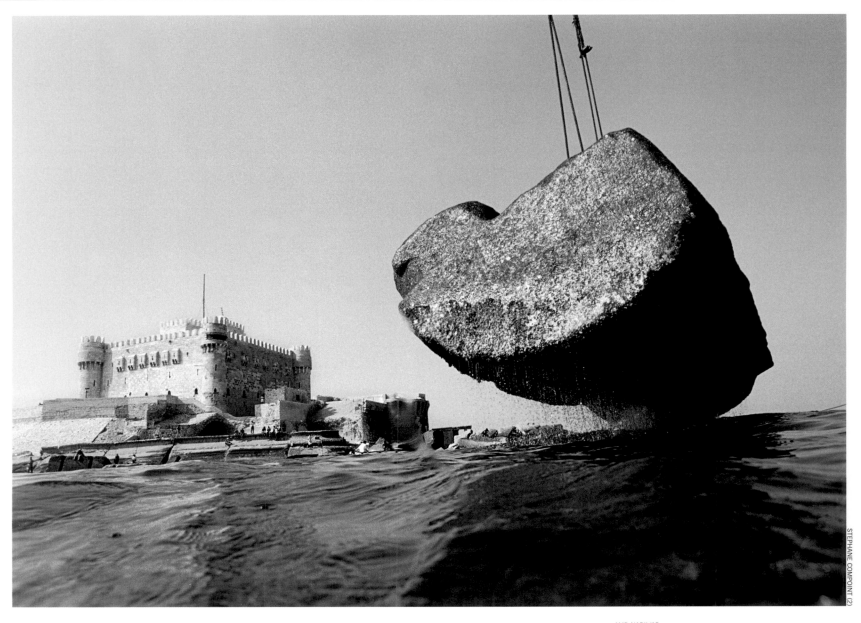

STEPHANE COMPOINT (2)

AMR NABIL/AP

There are oceanographers and researchers and just plain adventurers, and then there are the oceanic archaeologists. Excavations in the seas are quite as exciting as any digs on terra firma, and just as the Indiana Joneses of the world who work the mountains and deserts have their special grails—ancient Troy, the Egyptian emperor Tut's tomb and the like—so do those who investigate beneath the waves. On these and the following two pages, we drop in as ultimate prizes are found.

The Pharos of Alexandria was, along with the Great Pyramid, the Hanging Gardens of Babylon and others, one of the original Seven Wonders of the World. What was it, where was it, when was it? And how did it come to reside in the sea? Good questions all. First, an island lent its name to a strange building, then the building gave the world a word meaning "lighthouse." The island in Alexandria's harbor was Pharos, and after two Egyptian rulers, Ptolemy I and Ptolemy II, oversaw construction of a skyscraper with a fire at its summit, the phrase *Sailing in by Pharos*

circulated among mariners. Soon the island and its beacon were synonymous, and today *faro* means lighthouse in Italian and Spanish, while *phare* is the word in French.

Ptolemy I was Alexander the Great's successor and enjoyed a four-decade reign, during which Alexandria grew to be a golden city. The bustle in its port was increasing daily when, in 290 B.C., Ptolemy ordered a lighthouse built—one larger and more effective than any other. The project was seven years old when Ptolemy died circa 283 B.C. His son and successor watched as

perhaps another 15 years of work went into the lighthouse. Limestone and granite blocks of up to 75 tons were quarried and dragged to the site; newly devised hoisting systems, which might have involved early cranes, lifted the blocks into place. The 400-plus-foot lighthouse, which finally came online circa 270 B.C., became the world's second tallest building after the Great Pyramid, a status it would retain for nearly 17 centuries. Even today, it would stand proudly, if curiously, alongside 40-story office towers.

In the 14th century, the lighthouse was finally felled by an earthquake, and its remnants tumbled into the harbor, where they rested for more than half a millennium. In the 1990s, as seen on these pages, excavations in and around Alexandria recovered parts of the Pharos and other stoneworks from the sunken ancient city of Heracleion. A final note on the picture opposite: The diver is having an inscrutable encounter with a sphinx that predates even the lighthouse: a two-ton sculpture found to have been dedicated to Pharaoh Ramses II.

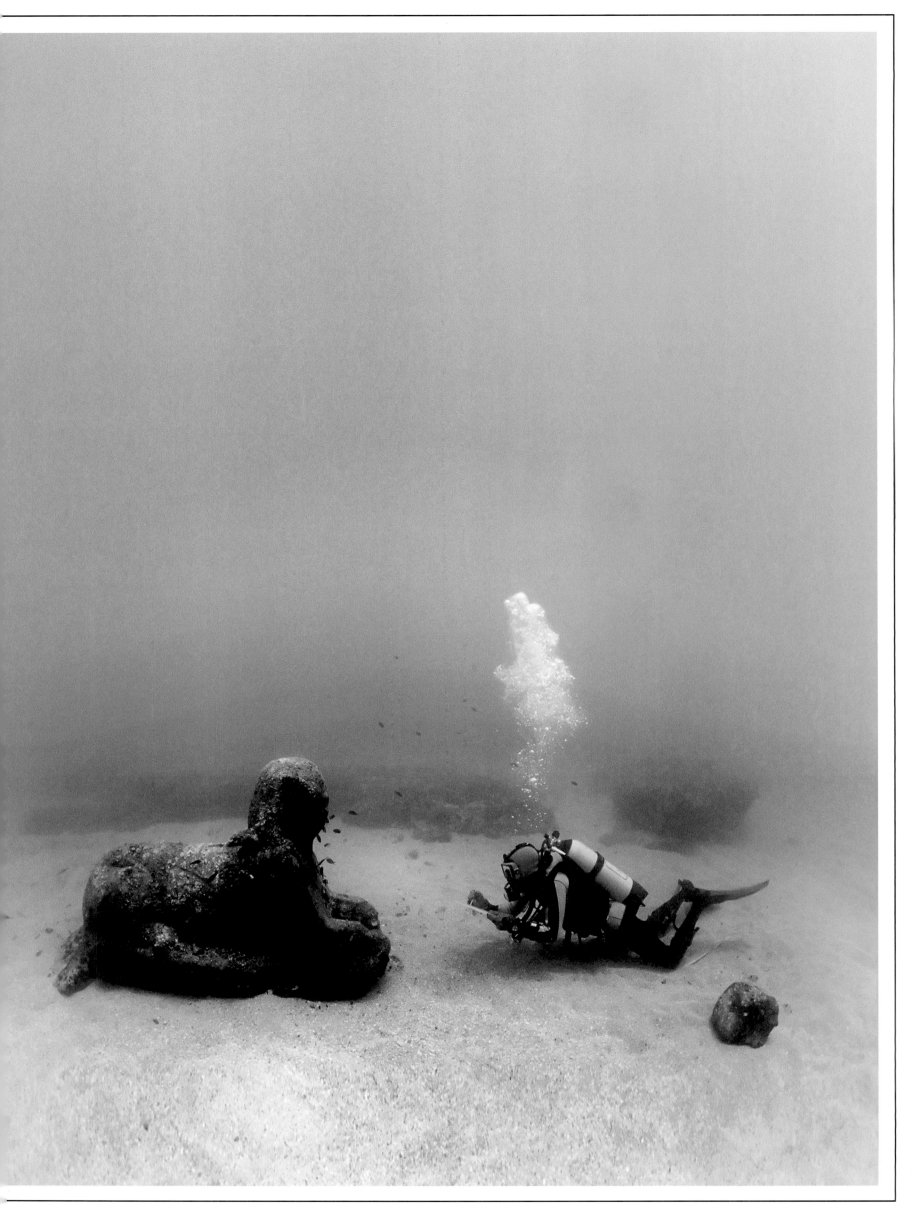

On the previous pages we visited the recovery of the ruined Pharos of Alexandria. This was quite a project, certainly. But one point to be added: If you look at these expeditions as hunter-gathering, it was more gathering than hunting. For centuries folks knew exactly where the lighthouse ruins were: They were right down there, many of the pieces less than 100 feet below the surface. By contrast, other excavations have represented true finds, using radar, sonar and such as Bob Ballard's jet-propelled diving saucer (hovering over the sea floor, below) to locate wrecks and debris that they are certain are . . . somewhere around here in the inky depths.

At bottom is the wreck of the USS *Yorktown*, three miles down on the Pacific Ocean floor. The World War II aircraft carrier was sunk by Japanese torpedoes in the battle of Midway on June 7, 1942, and its wreck was discovered on May 19, 1998, by the National Geographic Midway Expedition, led by deep-sea explorer Ballard. He is unquestionably our generation's most famous undersea finder, not least since it was he who landed the big one, the long-sought grail of shipwreck seekers: *Titanic.*

At 1 a.m. on September 1, 1985, Bob—or, rather, Robert Ballard, Ph.D.—a marine geologist who had spent 19 years at the Woods Hole Oceanographic Institution on Cape Cod, Massachusetts, and a dozen years obsessing about the doomed ship *Titanic,* was reading in bed three decks above the control center of the ship *Knorr.* Unbeknownst to him, the *Knorr* was rolling on the ocean's surface 12,460 watery feet above the rusted hull of *Titanic.* There came a knock on his door. Ballard had been ready for lights-out—but suddenly he was wide awake. He pulled on a jumpsuit and bounded below to the control room just in time to see the first identifiable remnant of the ship, one of its massive boilers, slide across the screen. (Below is a railing of the ship's bow, photographed on a Ballard-led expedition.) Ballard got no sleep that night, nor during the next four days. The *Knorr*'s 20 days of round-the-clock searching had paid off, and suddenly sleep was the furthest thing from Bob Ballard's mind. *Knorr*'s crew had just found the prize.

For the world at large, the discovery of the long-lost liner, sunk after its fateful collision with an iceberg, rekindled notions of a glamorous, bygone era. For Ballard, the

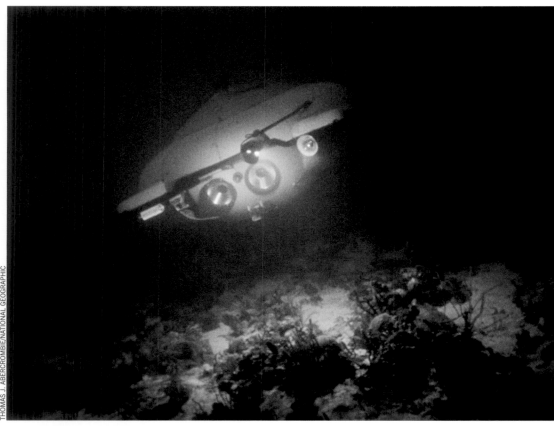

THOMAS J. ABERCROMBIE/NATIONAL GEOGRAPHIC

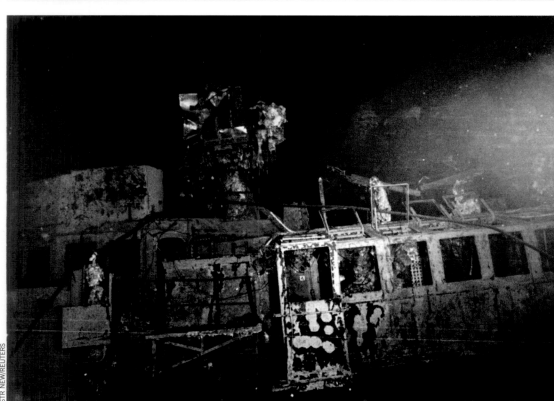

STR NEW/REUTERS

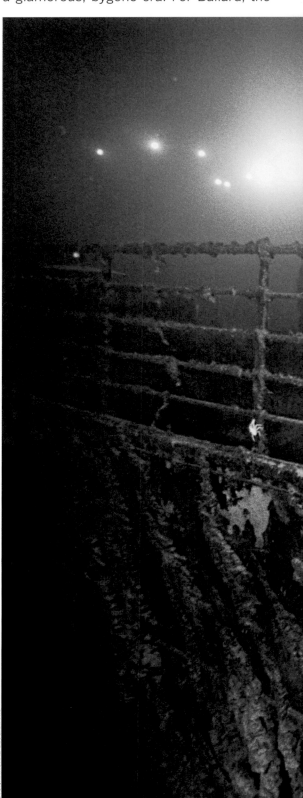

EMORY KRISTOF/NATIONAL GEOGRAPHIC

find proved the value of using newly available technology for undersea research. In the early 1970s, the U.S. research submersible *Alvin*, which was based at Woods Hole, had been overhauled to dive as deep as 12,000 feet. Ballard realized immediately that this put *Titanic* "within our reach." His quest was begun, and even as he worked on other projects, including developing various technologies that would help him find the ship, he kept a wary eye on rival American scientists who had started searching the waters of the North Atlantic. In the end, his joint French-American effort made the discovery, and Ballard has returned to the site several times since. At right, in 2012, Ballard uses a large-scale picture of the upper deck during a presentation in Mystic, Connecticut, explaining how he found the wreck.

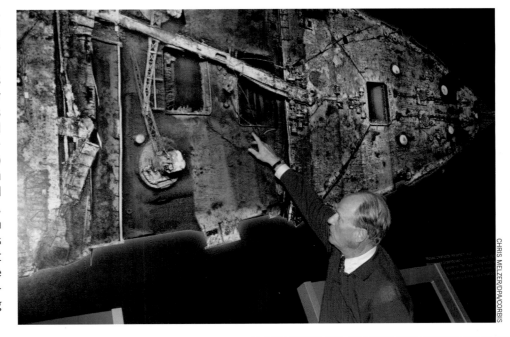

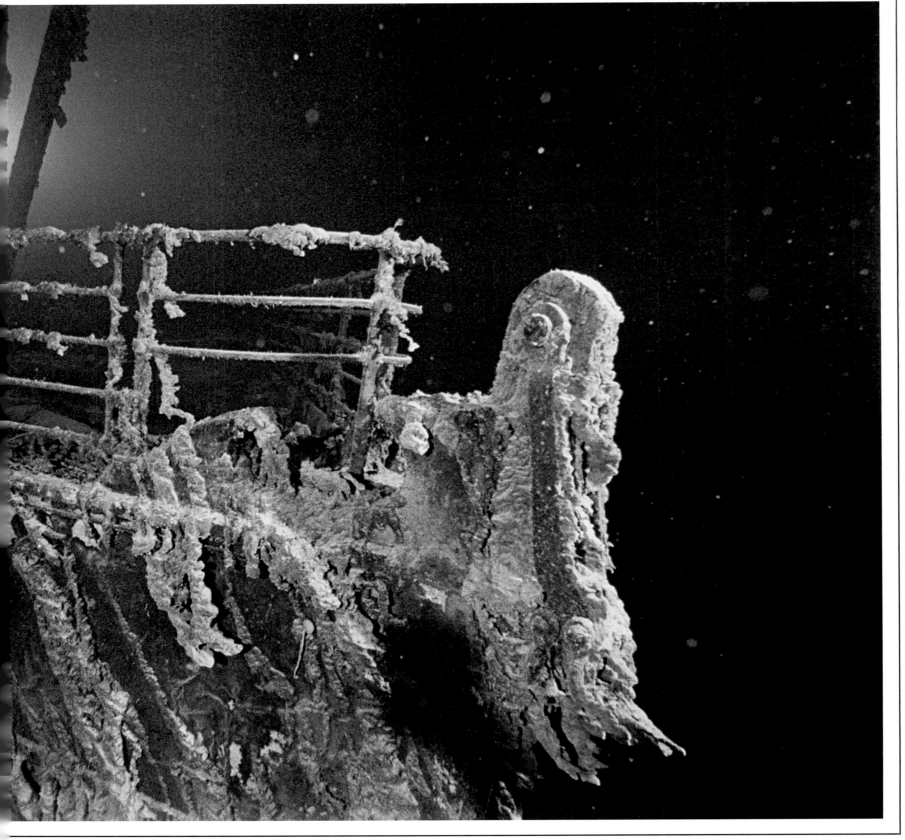

In 1960, seven years after Edmund Hillary and Tenzing Norgay had climbed Mount Everest to the world's highest point, man had yet to visit its lowest. The Marianas Trench, a deep-sea depression nearly 1,600 miles long and more than 36,000 feet down in the western Pacific Ocean, was alluring—in a creepy sort of way. What was down there, so far beneath the waves off Guam? For anyone to find out, a vessel would be required that could withstand eight tons per square inch of water pressure.

The French-built, U.S. Navy–operated bathyscaphe *Trieste* (opposite, top and left, after a successful 1959 test dive in the Trench with that mission's copilots Andreas B. Rechnitzer, one of the pioneers of deep-sea diving, and Jacques Piccard, who passed away in 2008, posing) was a 150-ton craft with a six-foot-diameter steel sphere and a 58-foot-long gas tank. Naval Lieutenant Don Walsh (opposite, right photograph, foreground) believed in it, and obviously so did Swiss engineer Piccard (at rear), whose father had designed the thing. On January 23, 1960, the two men climbed in and closed the hatch.

They descended at the rate of four feet per second for five hours, eventually bottoming out at a record 35,797 feet below sea level. "And as we were settling into this final fathom," wrote Piccard in his memoir *Seven Miles Down,* "I saw a wonderful thing." It was a weird fish, he said, flat and with two round eyes on top of its head. "Here, in an instant, was the answer," he wrote. "Could life exist in the greatest depths of the ocean? It could!"

Though scientists would later surmise that Piccard's subject was more likely a sea cucumber—indeed a marine animal, but not a fish, as we learn elsewhere in our pages—no one would argue that Piccard and Walsh's dive hadn't answered another question conclusively: Human beings could survive not only at the planet's highest elevation but also at its greatest depth.

We have continued to go low. Two thousand and twelve has been a particularly active year in the Marianas Trench. In March, the film director of the movie *Titanic,* Bob Ballard's pal James Cameron, traveling solo, reached a record-breaking 35,756 feet below the waves in a privately financed sub, and three months later the Chinese craft *Jiaolong,* seen on this page emerging at the surface (top) after probing the sea floor (bottom), transported three Chinese aquanauts to the depths even as three Chinese astronauts were preparing to manually dock their *Shenzhou-9* spacecraft with the orbiting *Tiangong-1* lab module: All sorts of new players in the twinned games of extreme adventure and extreme research. Jules Verne would doubtless be very proud indeed.

NON-FISH, FAUX FISH AND SECRET FISH

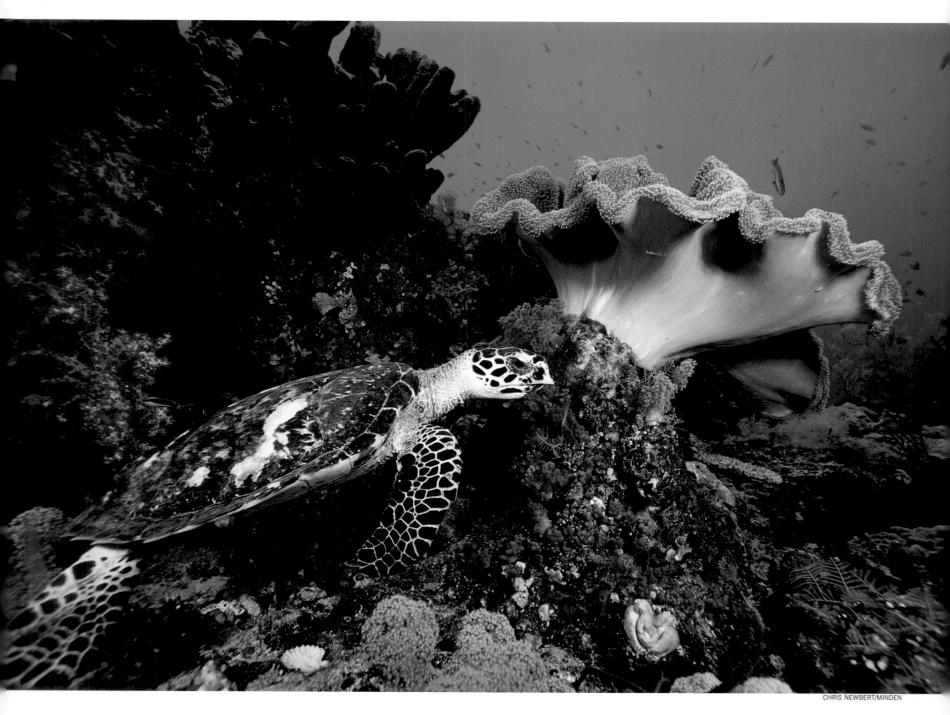

CHRIS NEWBERT/MINDEN

Endangered, Endangering

We meet, on these first pages of our new chapter, a few of the kinds of animals we will learn much more about as we proceed: a bit of coral, a reptile and an echinoderm. This hawksbill sea turtle (above) is passing before so-called leather coral on a reef in Indonesia. We will begin dealing with corals on the pages immediately following, but as for the hawksbill: A remnant species within its genus, it is itself critically endangered and under the protection of the U.S. Endangered Species Act and other conservation plans worldwide. The problem, besides a slow-going reproductive cycle, is not so much its culinary desirability, but its acute beauty, seen on display here. Hawksbill shells are prized for decorative uses. The turtle's different subspecies swim in both the Atlantic and Indo-Pacific oceans, where they grow to average lengths of more than two feet and weights of 100

to 150 pounds. The hawksbill is migratory by nature, and when it hunkers down it does so on a coral reef, dining principally on sponges (of which we will also learn much more, shortly), with a supplemental diet of algae, jellyfish and sea urchins. Clearly its body is well-armored, and so is its head; in aspect, the reptile seems indestructible. But as we have mentioned, this is hardly the case. On the opposite page is a fire sea urchin, an echinoderm, like a starfish or a sea cucumber. (We will talk about this animal phylum beginning on page 112.) The fire sea urchin comes in various colors, grows to nearly a foot and moves around its Indo-Pacific habitat slowly and stealthily on tubed feet, sometimes bumming a ride on the back of a crab. It dines on invertebrates, dead fish and sponges, and is, like its brethren urchins, highly venomous (this and its bright colorations have given it its name). In other words, it is a quiet but lethal beauty.

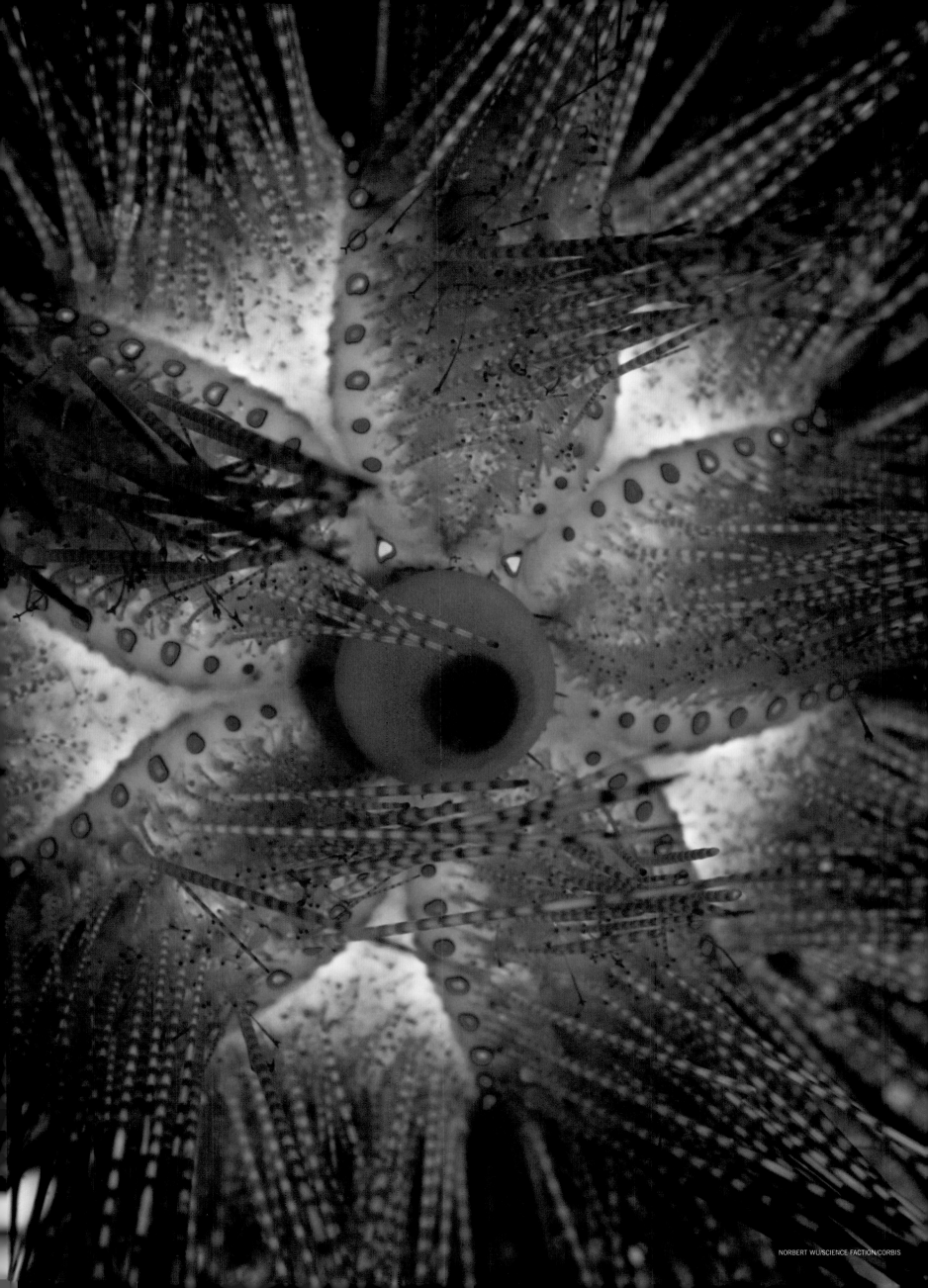

Animal, Vegetable, Mineral?

The correct answer, believe it or not, is animal. That's right: The tiny, colorful specimens that make up all the earth's coral reefs—including the famous 1,250-mile-long, 135,000-square-mile Great Barrier Reef off northeastern Australia—are not plants but animals. Coral polyps and hydrocorals are smaller relations of jellyfish and sea anemones, crowned with colorful tentacles. They exist in colonies and become fixed by remnant algae, sponges and other decayed creatures. White coral indicates polyps that have died; the brilliant pastels that are a reef's hallmark show vibrant life. Below: Soft coral in a cluster off Indonesia (a note here: The soft corals do not produce calcium carbonate skeletons, and therefore do not help to build a reef. They feed on what passes by,

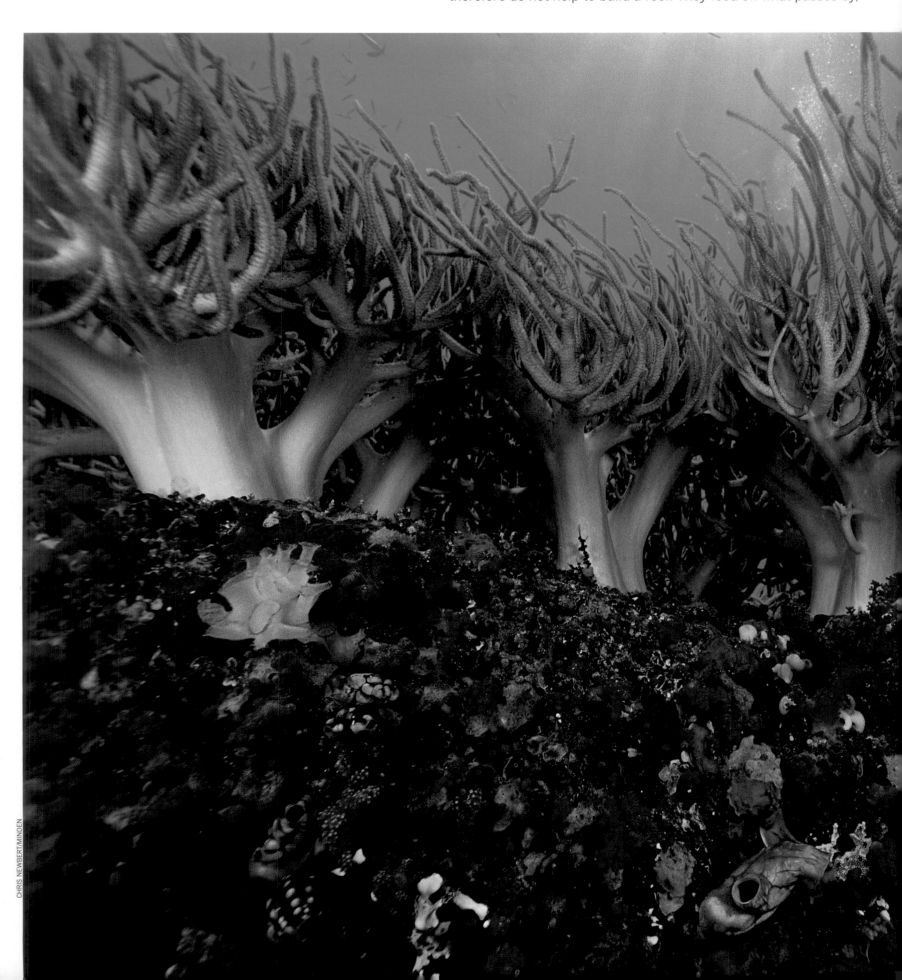

CHRIS NEWBERT/MINDEN

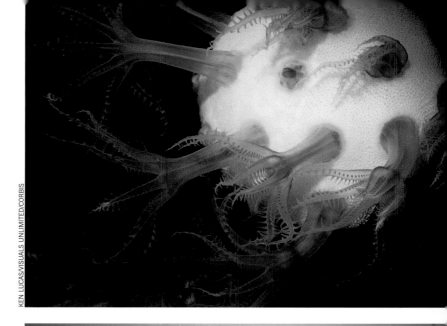

grabbing nutrients from plankton and brine shrimp). Right, from top: Mushroom soft coral near the central California coast; grooved brain coral in the Caribbean; and then a sponge—the azure vase sponge—in an example from Cuba's Jardines de la Reina National Park. As was true with corals, for centuries people—scientists most definitely included—were not at all sure what sponges were. Many considered them plants, which isn't surprising if you judge them by their looks. In 1765 a linen merchant and amateur naturalist named John Ellis proved that because sponges could eject water, they must therefore be animals. He was right. The sponge, of which there are 15,000 different kinds, has been around some 500 million years, longer than any other living animal, and we will tell more about it on the next page.

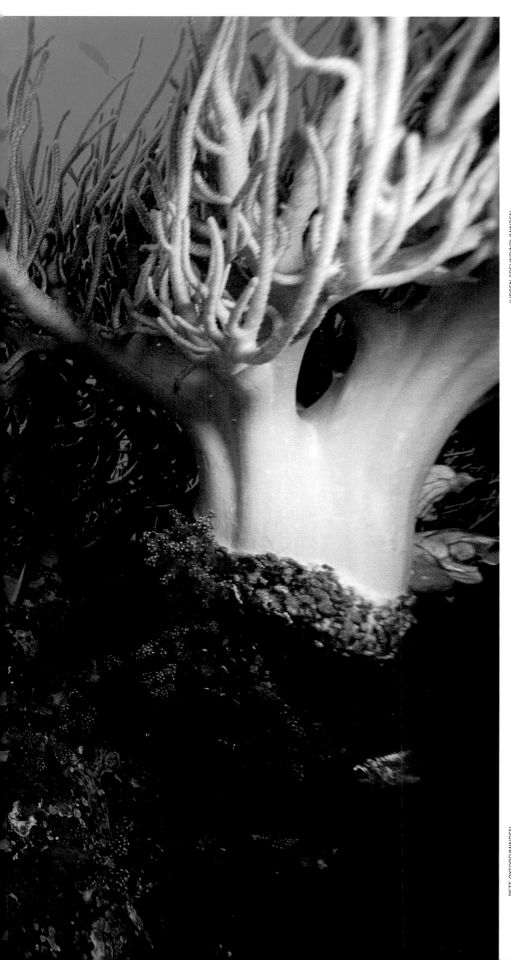

Sponging, Good and Bad

Above is a barrel sponge spawning by releasing sperm in the ocean off Bali, Indonesia—and this gives us an opportunity to talk further about this altogether fascinating animal. As was just mentioned, it has been part of the planet's life cycle for half a billion years. And because sponges—the vast majority of which are incapable of moving about and so rely on water flowing through them for sustenance and oxygen—are, as scientists say, "morphologically conservative" (which means they don't change much), what we have now closely resembles what existed all those years ago. It has even

been posited that the precursor to all animals closely resembled the sponge. On a given day, liquid equal to 20,000 times its volume may be filtered by a sponge; some sponges can retain 90 percent of the bacteria that pass through. Living in this sedentary way, sponges have varying and some would say enviable life spans. One species, the living fossil sclerosponge, may reach 5,000 years of age, which would make it the oldest living creature on the planet. But can its habitat prove as endurable? Your villain is the undeniably handsome crown-of-thorns starfish, seen in the center photograph, opposite, with an Atlantic trumpet triton near Hawaii. Able

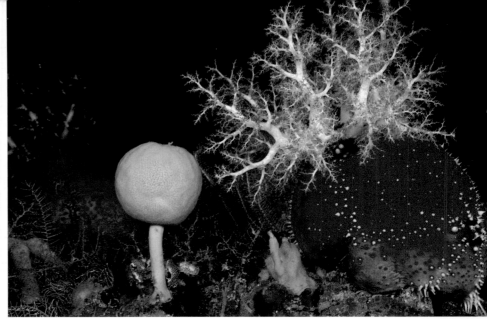

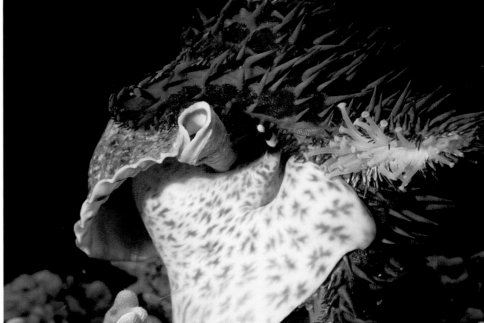

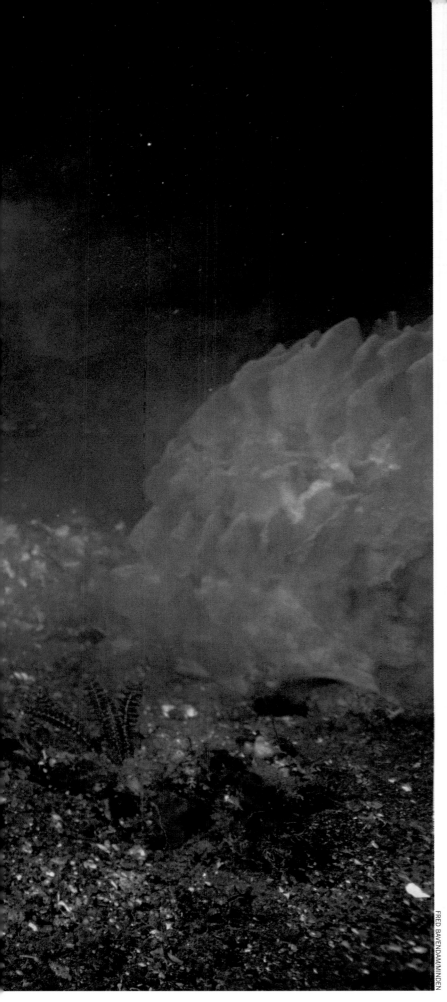

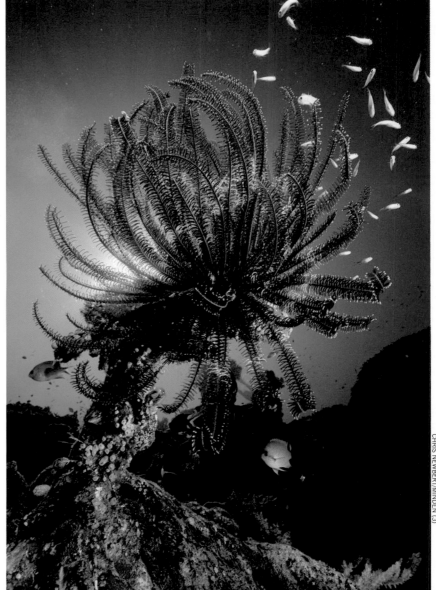

to grow to nearly two feet in diameter, it has been, since the 1960s, eating away at parts of the Great Barrier Reef and other aquatic havens. Sponges and corals are hardly the only reef dwellers threatened by the crown-of-thorns. At top we have a sea apple (with tentacles extended for feeding) off Indonesia; and at bottom is a crinoid on a reef off Pohnpei. All three animals are echinoderms, like other sea stars or sea urchins or sand dollars (yes, the sand dollar, too, is an animal). We will learn more about this fascinating phylum of some 70,000 living species, Echinodermata, upon turning the page once more.

A Strange and Stirring Scene

This diver has come upon an ethereal vision in an ice cave in Antarctica's Weddell Sea: a galaxy of starfish, drawn to this place by seal feces, on which they feed. A more accurate name for the animal is sea star, since it is not a fish at all. As an echinoderm, it is a multicelled exclusively marine invertebrate (meaning no backbone), characterized by a symmetrical aspect; it has several arms (usually five, though the crinoid on the previous page and some species of sea star have more) and a central body, but no heart nor brain nor eyes (though some brittle stars in the depths seem to have light-sensitive units on their arms); and, in the case of most—excepting some stars, cucumbers and urchins—it has a mouth on the bottom and an anus on top. Echinoderms are found everywhere, in cold water and warm, and are a fundamental part of the foundation of life. They move very slowly, often employing a suction method on firm surfaces that is unique. Some echinoderms, including sea stars, are carnivorous, while others, such as sea cucumbers, feed on detritus or plankton. To talk briefly and specifically about the startling sea star: Like most of its mates in the phylum, it can regenerate a missing limb or other body part—it can rise from near death. Some of the 2,000 species can reproduce asexually by purposely splitting their bodies in half, and many will initiate self-amputation of an appendage if under attack by an enemy. The top of a sea star, with its protective calcium carbonate armor, is often colorful and beautiful—and so as children we gather a collection of stars in our pails at low tide—and the underside is routinely remarkable in its construction. Some sea stars, like the bad guy crown-of-thorns we met earlier, are specialty feeders (the crown-of-thorns, as we know, likes live coral polyps), but most have a diet ranging from sponges to mollusks and small crustaceans. However, the sea star has no hard mouth, so how does it take on such prey? It extrudes its stomach over the soft, meaty parts of its victims and begins secreting digestive fluids even while the stomach is still outside its body. Then the stomach and digested meal is sucked back in, and the sea star goes—slowly—on its way.

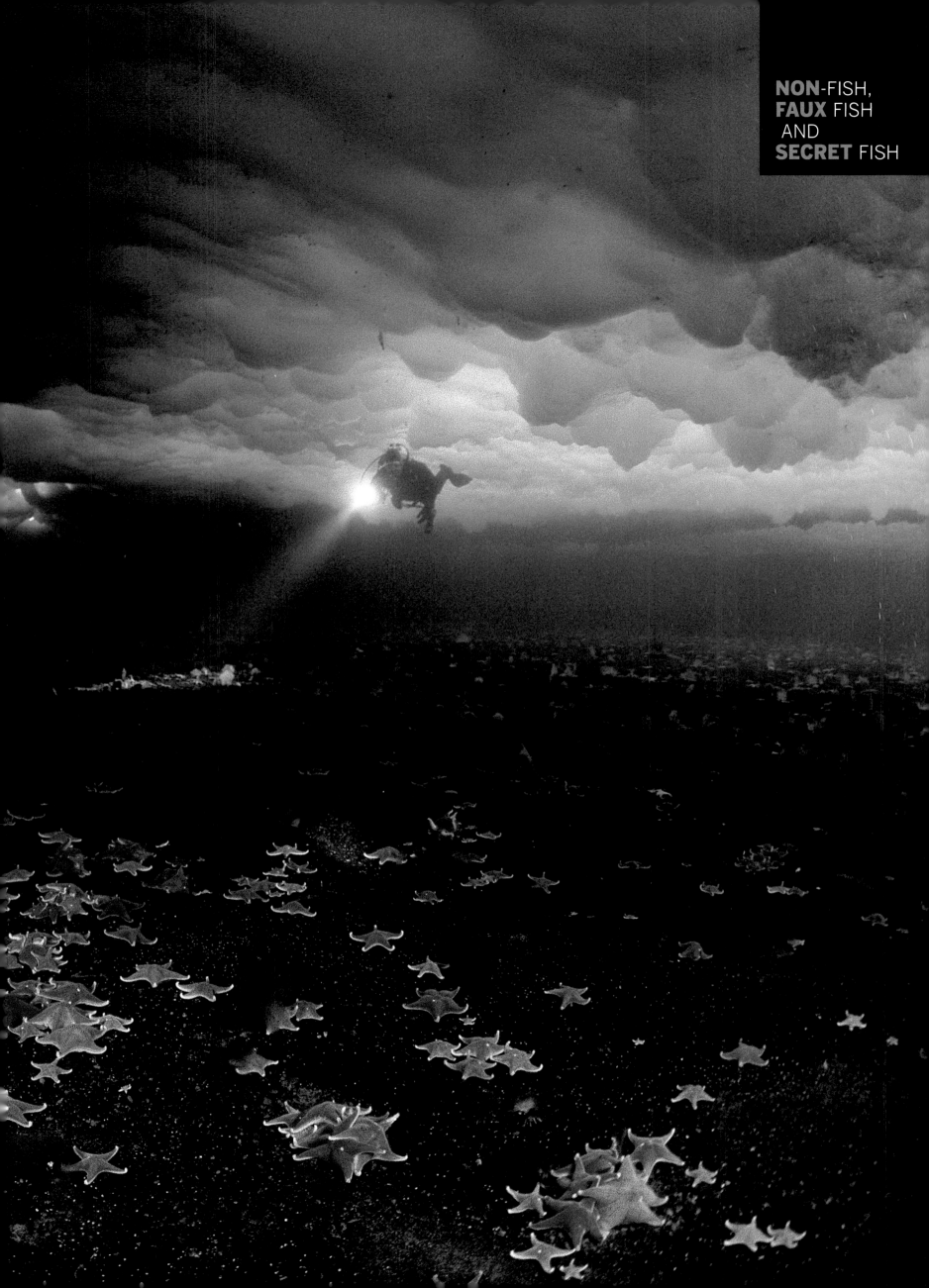

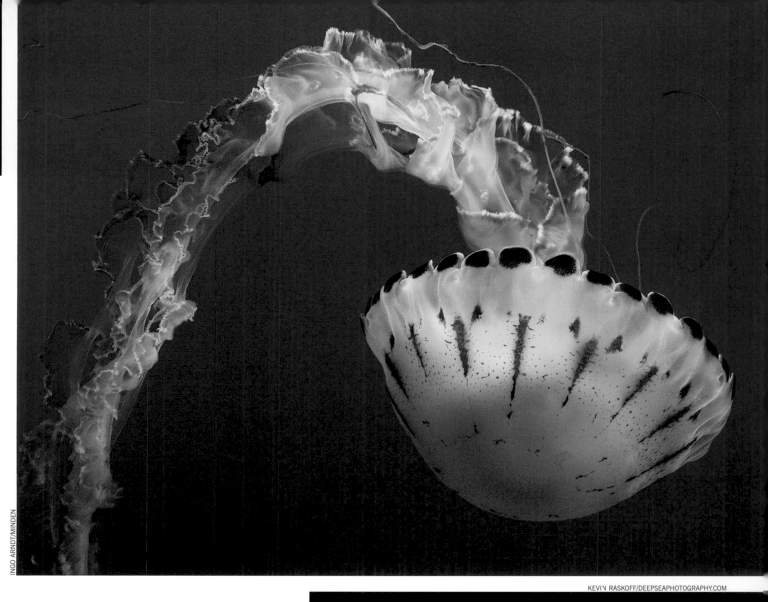

INGO ARNDT/MINDEN

KEVIN RASKOFF/DEEPSEAPHOTOGRAPHY.COM

Heartless, Literally and Otherwise

These three species are assembled together to make a point about the interrelatedness of diverse animals, and to illustrate linkage: how there exist weird hybrids that bridge one world to another. All three—a jellyfish, a type of coral and something in between—are of the phylum Cnidaria, and as cnidarian citizens they have a symmetrical body, a saclike internal cavity, stinging cells, a simple nervous system and no circulatory system. Yet they do exist, as we know—in great profusion around the globe. Clockwise from above are a purple-striped jellyfish, a red harp gorgonian on a coral reef off Thailand's Similan Islands, and a species of siphonophore, which is in a class of Cnidaria called Hydrozoa. Siphonophores often resemble jellyfish, but a crucial difference is that when you're looking at a jelly, you're seeing a single organism; when you behold a siphonophore, you're actually looking at a whole colony of siphonophora, individually called zooids, that have teamed up for the greater good. Because of this communal involvement and tentacles that can extend for great distances, siphonophores can grow very large, and one species, the deep-sea organism *Praya dubia* (or giant siphonophore), is one of the longest animals in the world, with a body length equivalent to half a football field. *Praya dubia* is a terrific example of the adage, "It takes a village . . ." Each of its many connected zooids has a specific task: to feed, to attack or to defend. As awesome as *Praya dubia* is, it is hardly the most famous member of its order. That would be the Portuguese man of war, a siphonopore with a venomous sting that can paralyze prey and inflict great pain on a diver or swimmer. In Australian waters, there are an estimated 10,000 man of war stings every year.

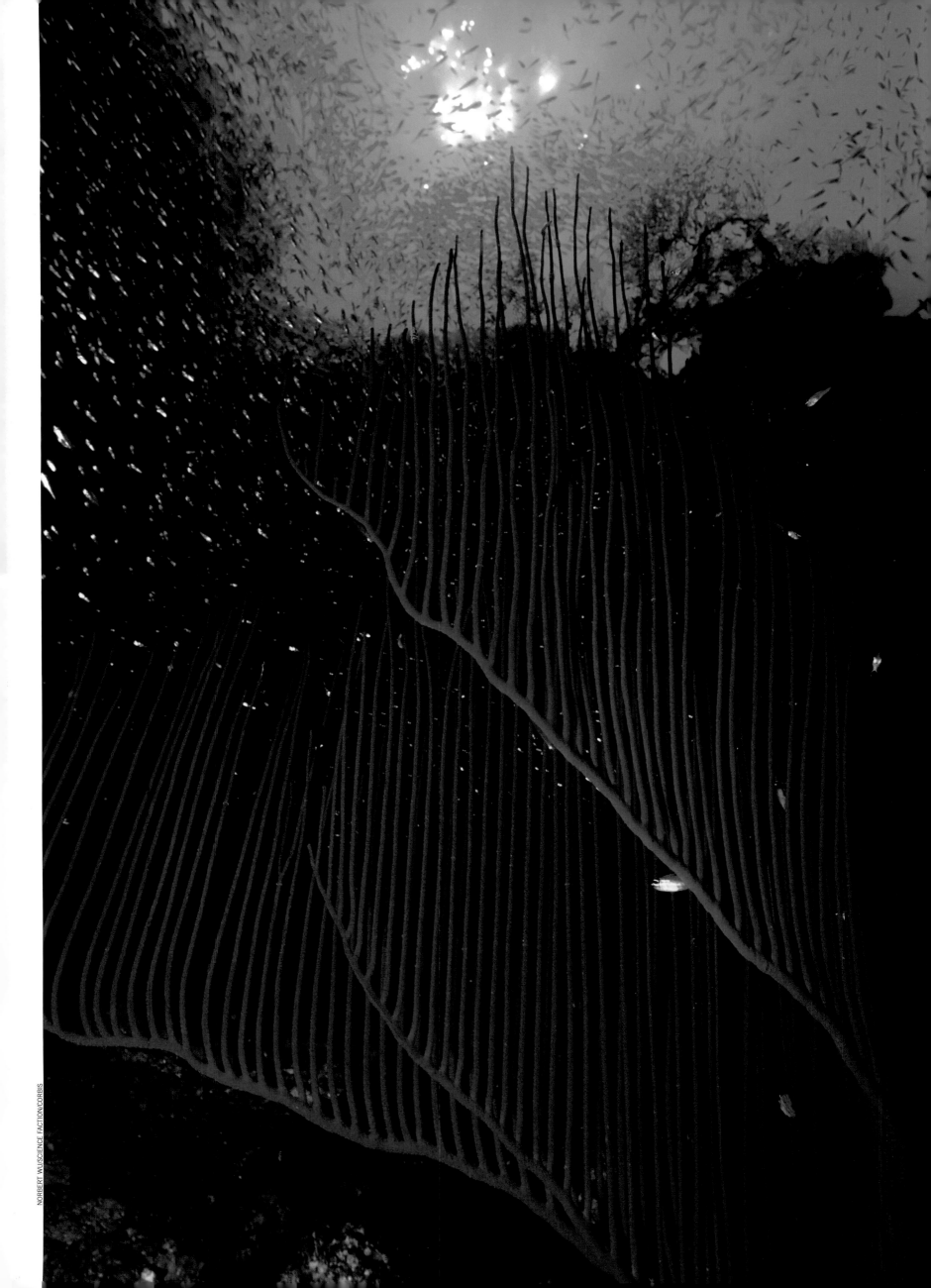

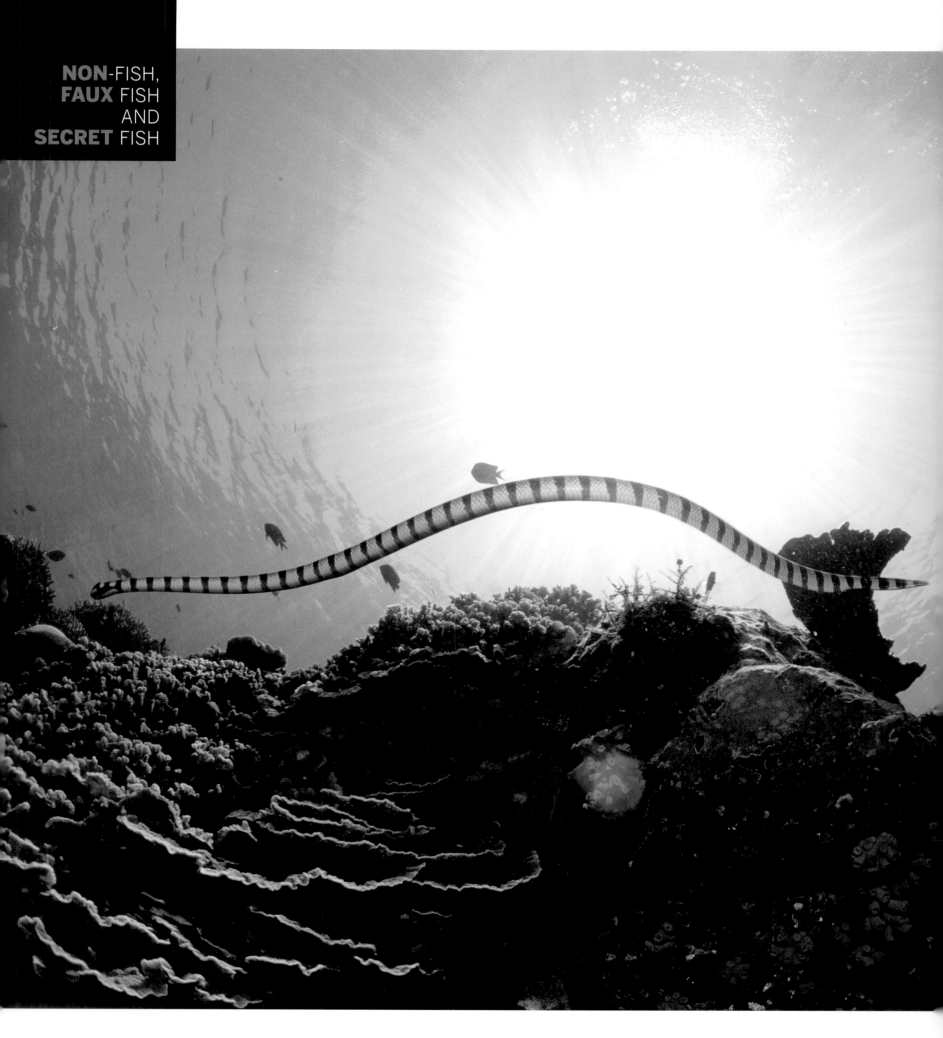

Sea Serpents and Dragons (Sort of)

Above is a dangerous sea krait swimming openly in the warm waters of the Indo-Pacific—its domain—and opposite is an oceanic master of disguise, the leafy sea dragon, nonchalantly afloat in the colder southern Australian waters of Rapid Bay. We'll start with our serpent. There are more than 60 species of sea snakes, all of them venomous reptiles; unlike fish, they have to surface to breathe, because they lack gills. Many of them rank among the most thoroughly aquatic of air-breathing vertebrates, and some can stay submerged for as long as several

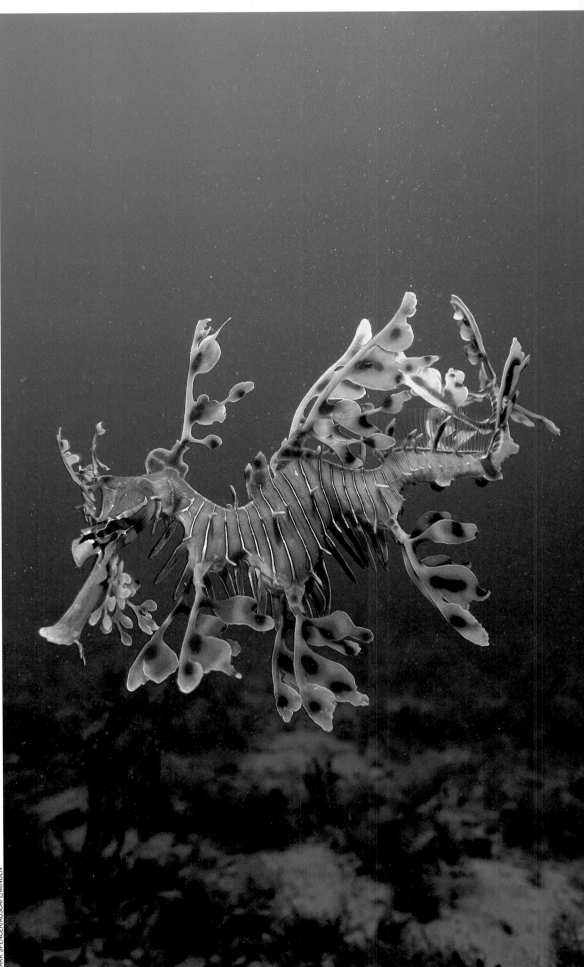

hours if not engaged in heavy action. But the six species of kraits, seen as primitives in relation to their slithery brethren, have retained the large, low-friction ventral scales on their undersides that are common to terrestrial snakes. Kraits are therefore able to spend much of their time ashore, and do: They are snakes of two worlds. A sea snake's right lung has evolved into a dominant organ, extending nearly the whole of its body length (and that length, in kraits, can reach five feet or more). The animal has fangs and a dozen teeth. Most sea snakes will not attack unless feeding or provoked, but some are aggressive. It is wise to give them a wide berth, as one might steer clear of a rattler in the desert. No need to swim away from a leafy sea dragon, however, if you chance upon one off the southern or western coast of Australia. It grows to a maximum length of 13 inches and has leaflike protrusions that are for one purpose only: camouflage. All it asks is to be mistaken for a piece of seaweed and be left alone. Pretty and imperiled, this fish—which is in fact a fish and is related to the sea horse—has many fans, and biennially in South Australia there is a Leafy Sea Dragon Festival. There is not yet a pageant for the sea krait.

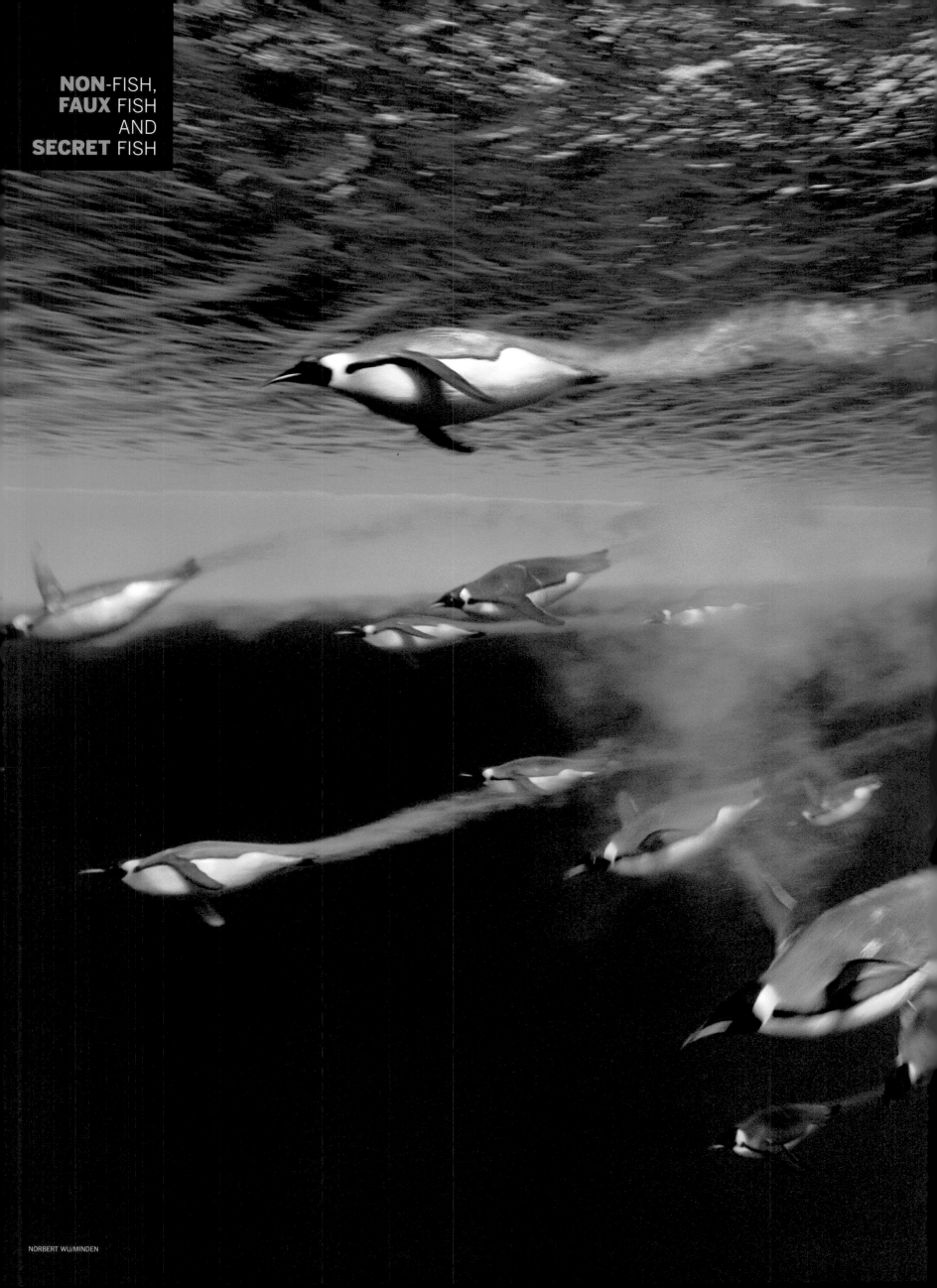

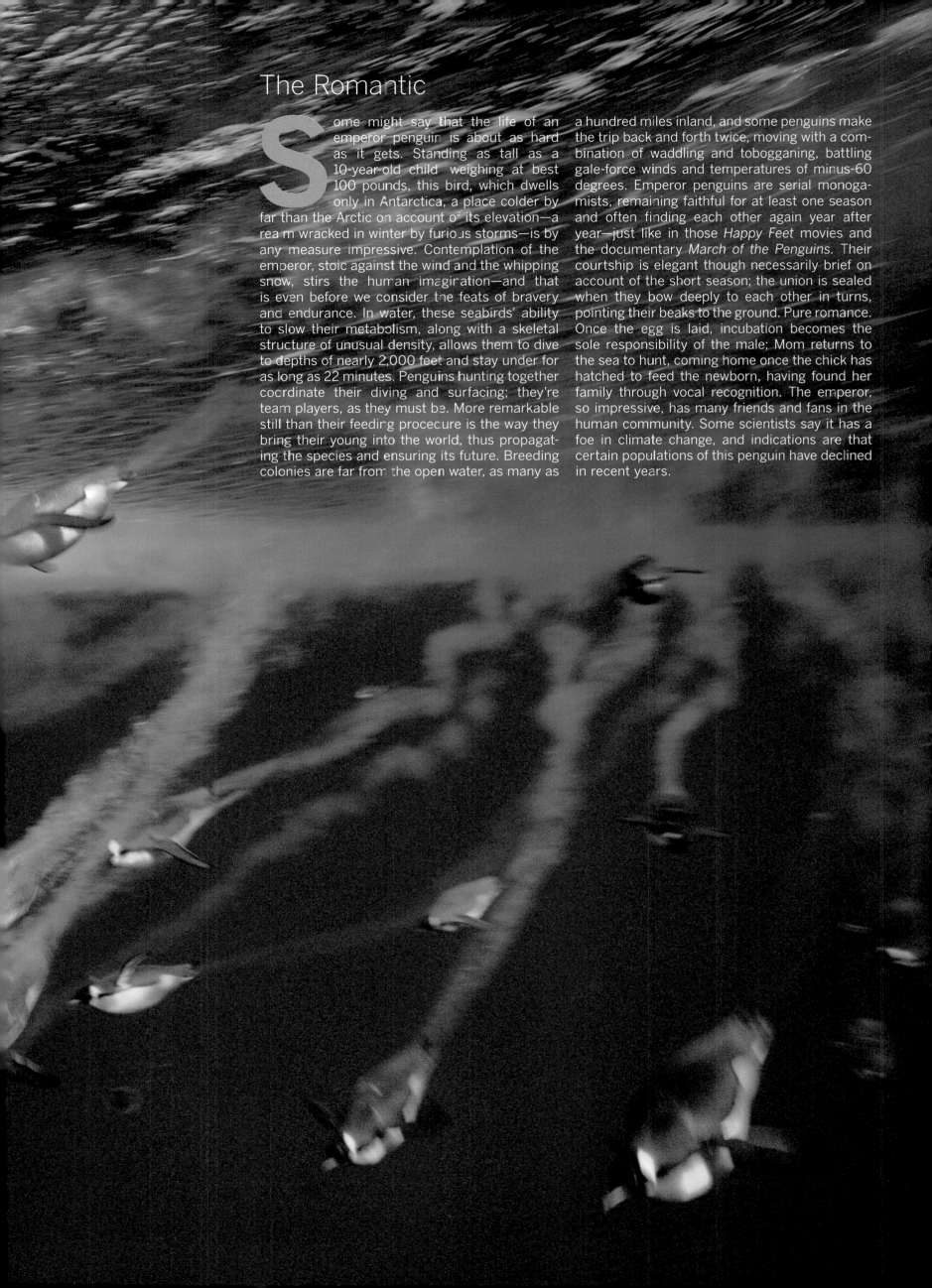

The Romantic

Some might say that the life of an emperor penguin is about as hard as it gets. Standing as tall as a 10-year-old child weighing at best 100 pounds, this bird, which dwells only in Antarctica, a place colder by far than the Arctic on account of its elevation—a realm wracked in winter by furious storms—is by any measure impressive. Contemplation of the emperor, stoic against the wind and the whipping snow, stirs the human imagination—and that is even before we consider the feats of bravery and endurance. In water, these seabirds' ability to slow their metabolism, along with a skeletal structure of unusual density, allows them to dive to depths of nearly 2,000 feet and stay under for as long as 22 minutes. Penguins hunting together coordinate their diving and surfacing; they're team players, as they must be. More remarkable still than their feeding procedure is the way they bring their young into the world, thus propagating the species and ensuring its future. Breeding colonies are far from the open water, as many as a hundred miles inland, and some penguins make the trip back and forth twice, moving with a combination of waddling and tobogganing, battling gale-force winds and temperatures of minus-60 degrees. Emperor penguins are serial monogamists, remaining faithful for at least one season and often finding each other again year after year—just like in those *Happy Feet* movies and the documentary *March of the Penguins*. Their courtship is elegant though necessarily brief on account of the short season; the union is sealed when they bow deeply to each other in turns, pointing their beaks to the ground. Pure romance. Once the egg is laid, incubation becomes the sole responsibility of the male; Mom returns to the sea to hunt, coming home once the chick has hatched to feed the newborn, having found her family through vocal recognition. The emperor, so impressive, has many friends and fans in the human community. Some scientists say it has a foe in climate change, and indications are that certain populations of this penguin have declined in recent years.

THE REALM
in Which They Roam

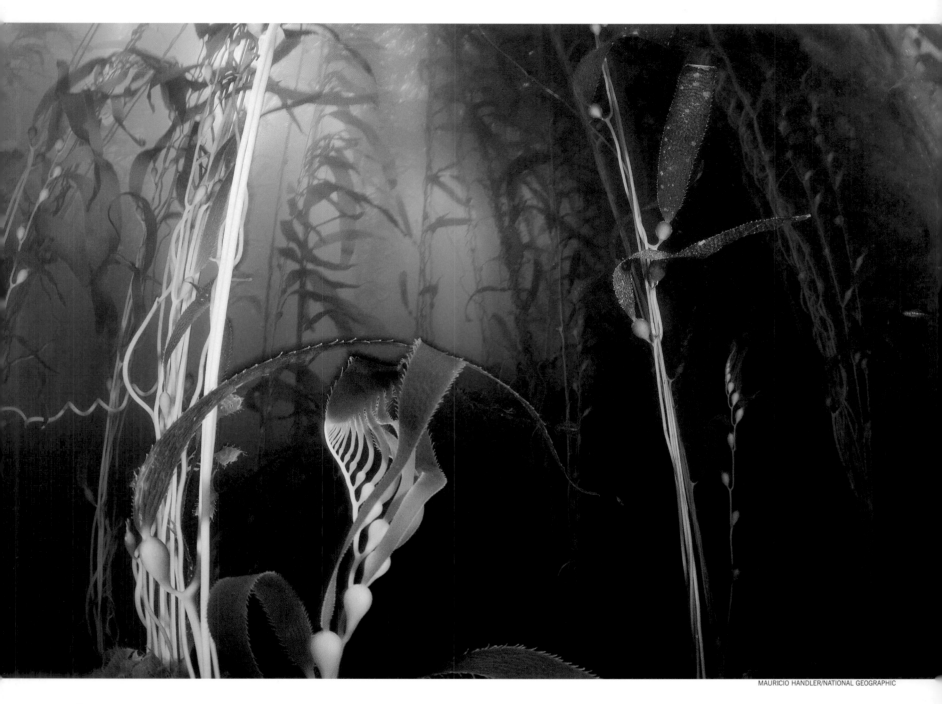

"Seaweed" Seems an Unfair Term

Animals do not have a monopoly on life in the sea, not hardly. Flora as well as fauna is plentiful, splendiferous and sometimes not to be believed. One of the world's great and most often photographed kelp forests is off the Southern California coast in Channel Islands National Park, where these two images were made. What is kelp? It is, to use the common though ignoble name, seaweed that employs rootlike holdfasts to cling to rocky subaquatic surfaces. Its tangled tendrils, which can reach 100 feet in length, create a cool, dark microenvironment—a fertile, nurturing, sheltering undersea jungle—for a food chain that stretches from plankton to crabs to octopi to blue sharks, along with oodles

and oodles of fish. There is kelp (some 300 genera) and then there is giant kelp (*Macrocystis pyrifera*), the world's largest seaweed. (That insulting word again!) Along the Pacific coasts of North and South America, this species of brown algae can grow to more than 200 feet, two-thirds the lengths of a football field (if well below the top height of the tallest terrestrial redwood tree, also a Californian: 379 feet and still climbing). In a forest of giant kelp, the plants are anchored to a rocky bottom, and floating canopies not unlike the roof of a rainforest extend mightily near the ocean's surface, fueled by photosynthesis. As one of the fastest growing organisms on earth, a giant kelp plant can extend its reach at the astonishing rate of up to two feet per day.

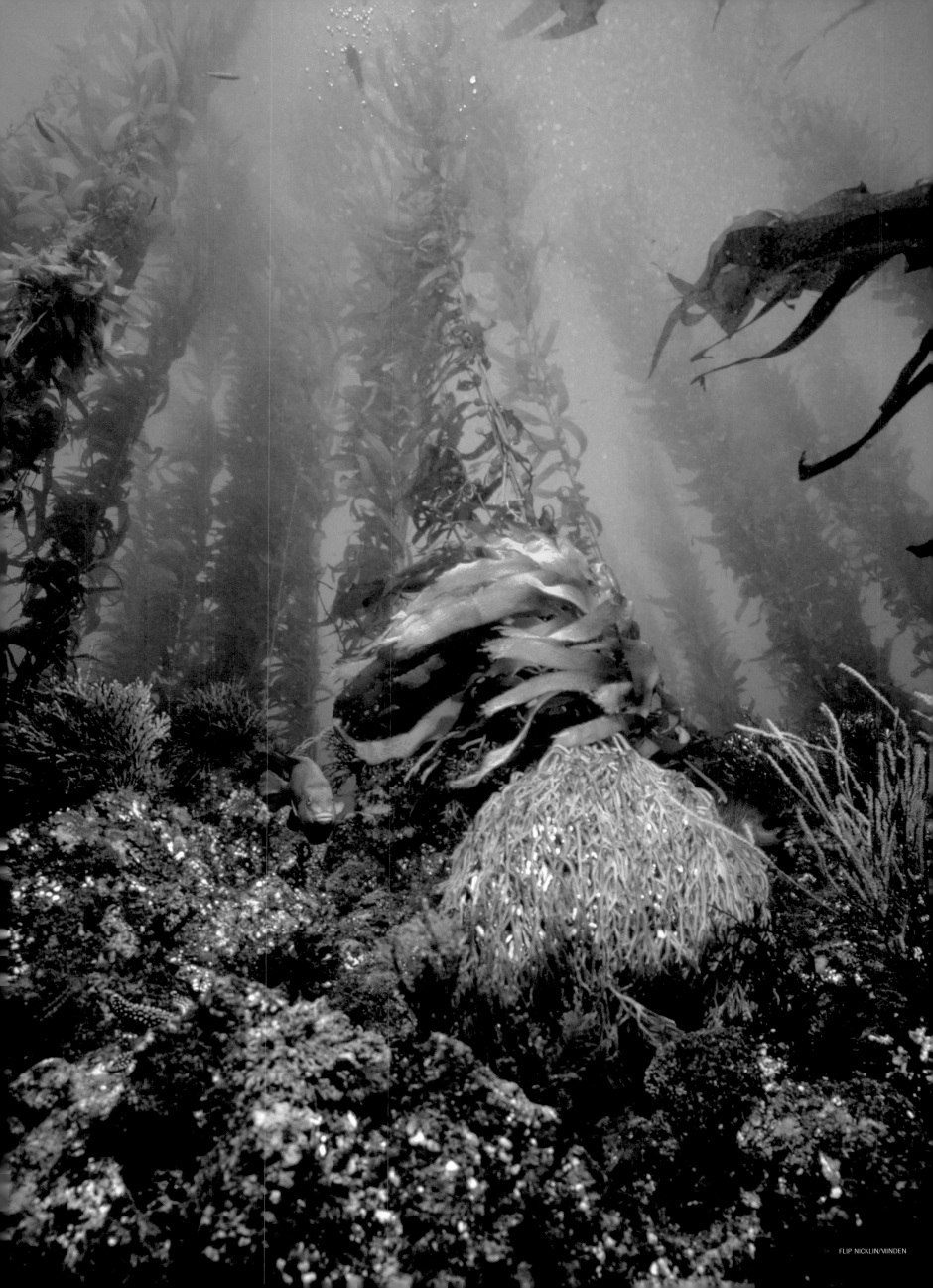

How Kelp Helps

I n Greek mythology Medusa is a Gorgon whose hair is a tangle of living snakes, and so the name of the plant in this kelp bed in South Georgia Island's Hercules Bay at the southern end of South America—Medusa kelp—makes perfect sense. What was ethereal when adrift in the ocean current looks rather messy ashore. But kelp keeps on giving, and is one of the products of the sea that has great current and future potential. Both below and above the waves, certain animals rely on kelp, including some named for it that seek sustenance or shelter in kelp forests, such as the northern kelp crab and the kelpfish, a species of blenny, both of which are found off the Pacific coast of North America. In the high latitudes of the Southern Hemisphere, the kelp goose relies on seaweed for nutrients. And so does another bipedal animal: man. Harvested—which is easily done, since kelp's surface canopy fairly shouts: "I'm here for the taking"— kelp provides a vitamin-rich source of food and fertilizer. Kelp, rich in iodine, has long been used to help with digestion and weight control and, since the Middle Ages, to treat enlargement of the thyroid gland. Kelp ash is used in soap and glass manufacture, and other derivatives are used to thicken daily staples like salad dressing, toothpaste and ice cream. Some pricey dog foods incorporate kelp by-products, as do—and this is a theme in this book—various menu items in Asian cuisines. The good news is: The use of kelp in Chinese, Japanese and Korean cooking is hardly a contentious issue, in contrast to the whale or shark harvesting done in service to haute cuisine. Whether to flavor stews or decoratively wrap rice, kelp use is politically correct. And when employed to reduce flatulence, it is more than welcome.

D.P. WILSON/FLPA/MINDEN

A Bedrock of Life

Plankton may possibly be most famous these days as a principal character on *SpongeBob SquarePants*. Secondarily, it is known to be the principal food source for baleen whales and other denizens of the deep (and not so deep), who sweep it up and filter it through their digestive systems as they swim happily along. But what, in fact, is plankton? It can be broadly, and then more narrowly, defined. Plankton comprises any number of organisms—floral, faunal, bacterial—that drift in salt- or freshwater: cellar dwellers in the food chain, aimless in their wanderings (the name derives from a Greek adjective meaning "errant") but crucial in their contributions. Zooplankton consists of very small animals—protozoans, crustaceans, the eggs and larvae of larger fish. What we see on these two pages is an example of phytoplankton, *phyto* deriving from the Greek for "plant." Phytoplankton is an alga that blooms near the water's surface, where light fuels photosynthesis. The microscopic diatoms, dinoflagellates and other bits and pieces of vegetation in phytoplankton represent essential and abundant bounty for many of our planet's water-going species. Nothing can better illustrate the magnificence of the oceanic cycle of life than a quick contemplation of these beautiful and terribly small geometric shapes, seen as they must be through a 'scope, and then the blue whale, a behemoth that depends on them as well as krill. Nature's genius.

The Miracle of
THE SALMON

As we have already seen in these pages, certain species' abilities and behavior patterns—not to mention uncanny instincts and bottomless willpower—are altogether astonishing. Nowhere is this in such tight focus as when we look at the legendary migrations within the animal kingdom. Loggerhead sea turtles leave the beach of their birth, travel through the ocean thousands of miles to a feeding ground, then return to the same nesting beach to make a family. The monarch butterfly, which weighs barely more than a hundredth of an ounce and features a wingspan of just four inches, accomplishes a 2,000-mile north-to-south trip down the breadth of the United States to its ancestral wintering ground in Mexico; best guesses as to how the butterflies find their way suggest they use the sun as a compass. Among mammals, more than a million wildebeests and

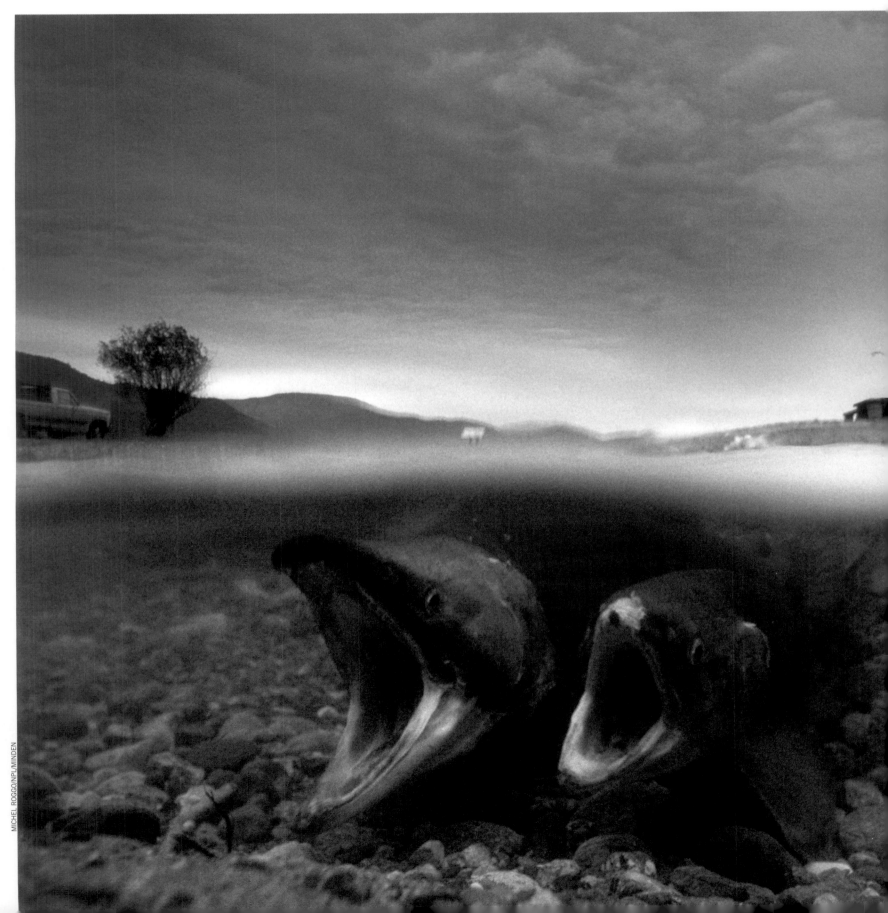

200,000 zebras are on the move each October in Africa's Serengeti, venturing from the hills of the north to the plains of the south for the short rains of the coming season. In April they are spurred by heavier rains to head back west, then back north; 250,000 wildebeests and tens of thousands of other herbivores will succumb to predation, exhaustion or other causes during this annual Circular Migration. Reptiles migrate, insects migrate, mammals migrate and of course birds migrate with colder or warmer weather. Among fish, there is, preeminently in terms of drama if not record-holding in terms of distance, the salmon. (We should say, there are various species of the salmon; some are exclusively freshwater fish.) Born in an inland river environment, becoming for a goodly time an ocean species, then returning home to yield the next generation and to end its days, the salmon of which we speak seems a miracle of a fish. On

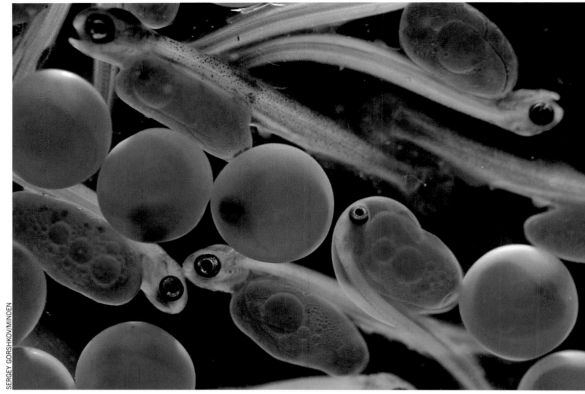

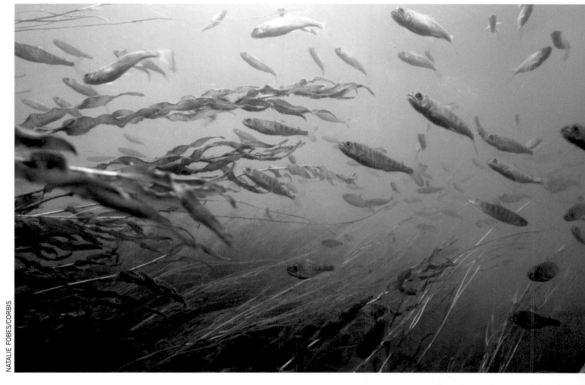

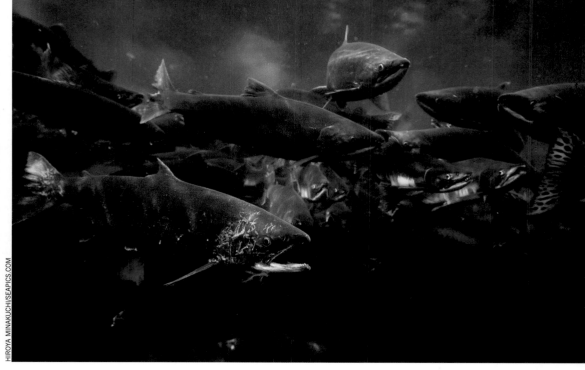

four pages, pictures describe the story, and we will subsequently elucidate further. On page 128 is a pair of sockeye salmon spawning on gravel ground in the Adams River in British Columbia, and then, from top to bottom on page 129, are sockeye salmon eggs and alevins (young fish, a term usually reserved for salmon or its relative trout); salmon smolts (as they are called at about two years of age) swimming in a river's estuary; and a school of sockeye swimming in the Pacific Ocean not too far from the North American coast. After many miles and adventures at sea, the sockeye return to the Adams River and swim upstream (below). Sometimes, depending on which river they are negotiating (the one opposite is in Alaska's Brooks mountain range), the fish are required to navigate obstacles such as waterfalls, bears and fishermen during their uphill battle to reach their goal. Now then, here's what has happened in this altogether extraordinary life cycle: The salmon were born, as we saw, upstream. When they reached their juvenile stage, after a year or more, they developed characteristics that would allow them to thrive in the ocean, and they moved downriver to the estuary—a fresh- and saltwater mix—where they doubled or tripled in size before heading out to sea. The world's oceans were their domain for up to five years, depending on the species. They traveled huge distances and they grew strong. Then they headed home to spawn. When we say "home" we really do mean home: They headed back to the precise place they came from, as if they had the address and a GPS. This was their fervent hope and diehard intention—to get back home. It has been hypothesized that a salmon may use the sun and stars to navigate—and it can actually detect the odor of its native stream—but whatever: Each one is astonishingly accurate in ascending to the very spot where it was born, there to give life to its own offspring. This is so thoroughly incredible, it is thought in some corners to be a myth—but it has been proved and documented. For our salmon seen here, they fought the good fight. They succeeded, many of them. They spawned. And then they died. They were, in their individual lifetimes, a wonder of the shallows, then a wonder of the deep, then a wonder of the shallows again. They are, as salmon, an eternal wonder of life itself.

YVA MOMATIUK & JOHN EASTCOTT/MINDEN

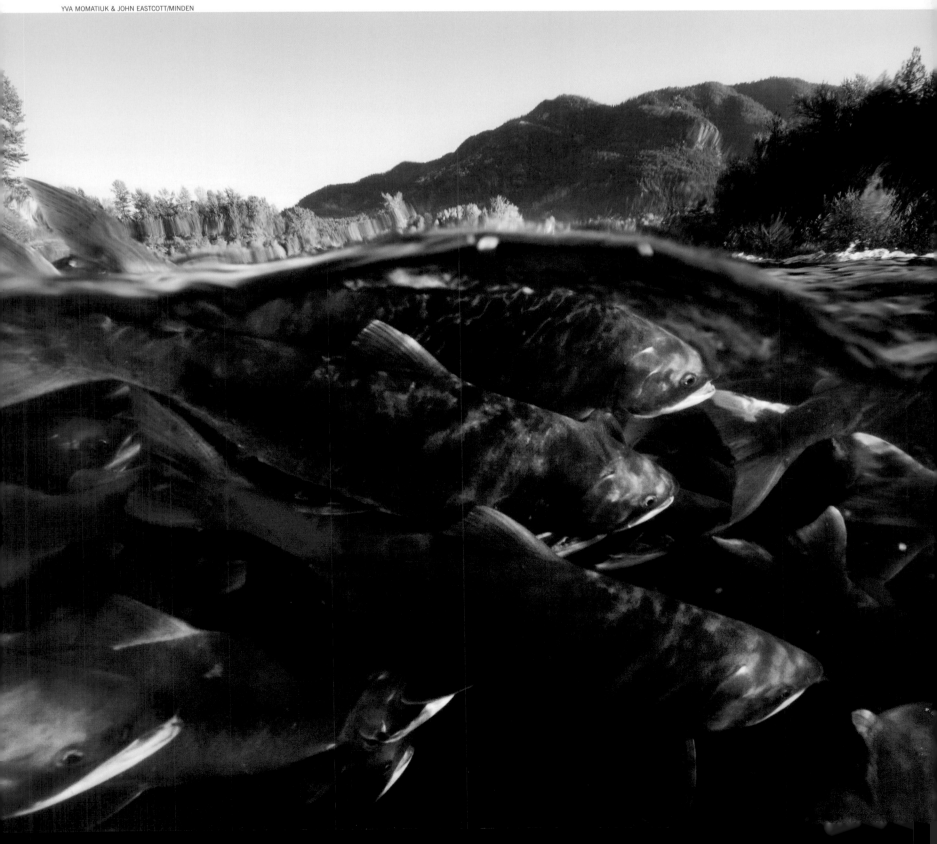

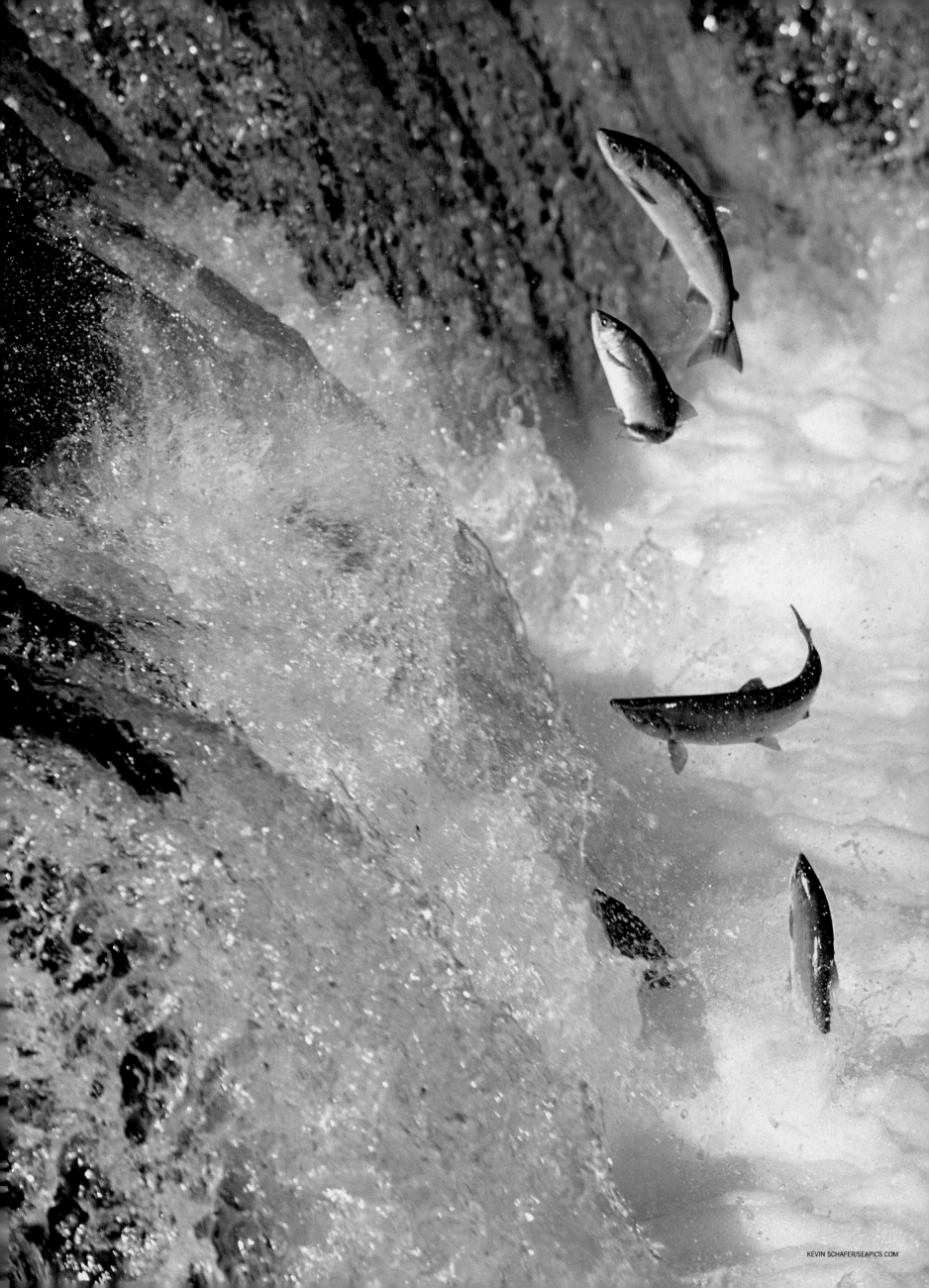

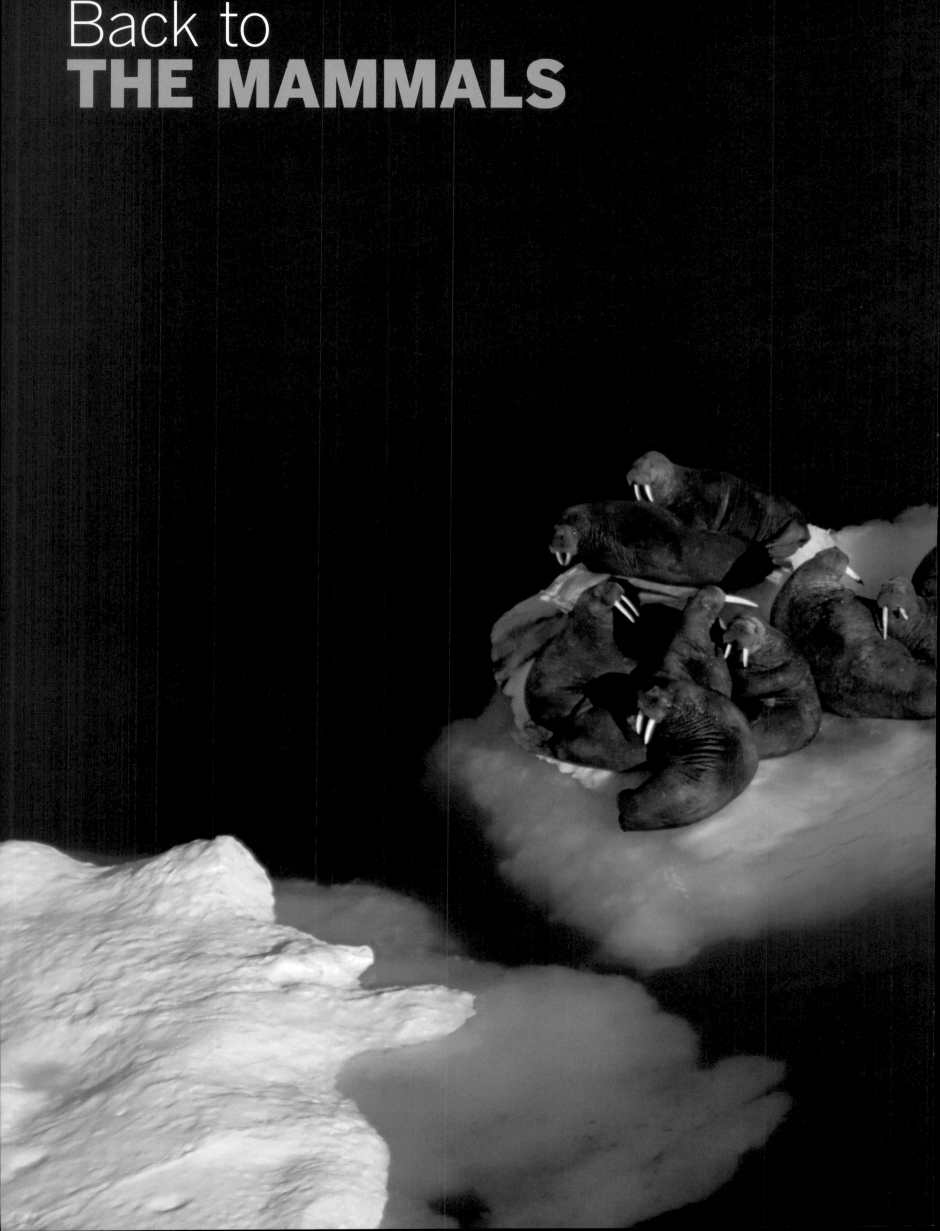

Back to
THE MAMMALS

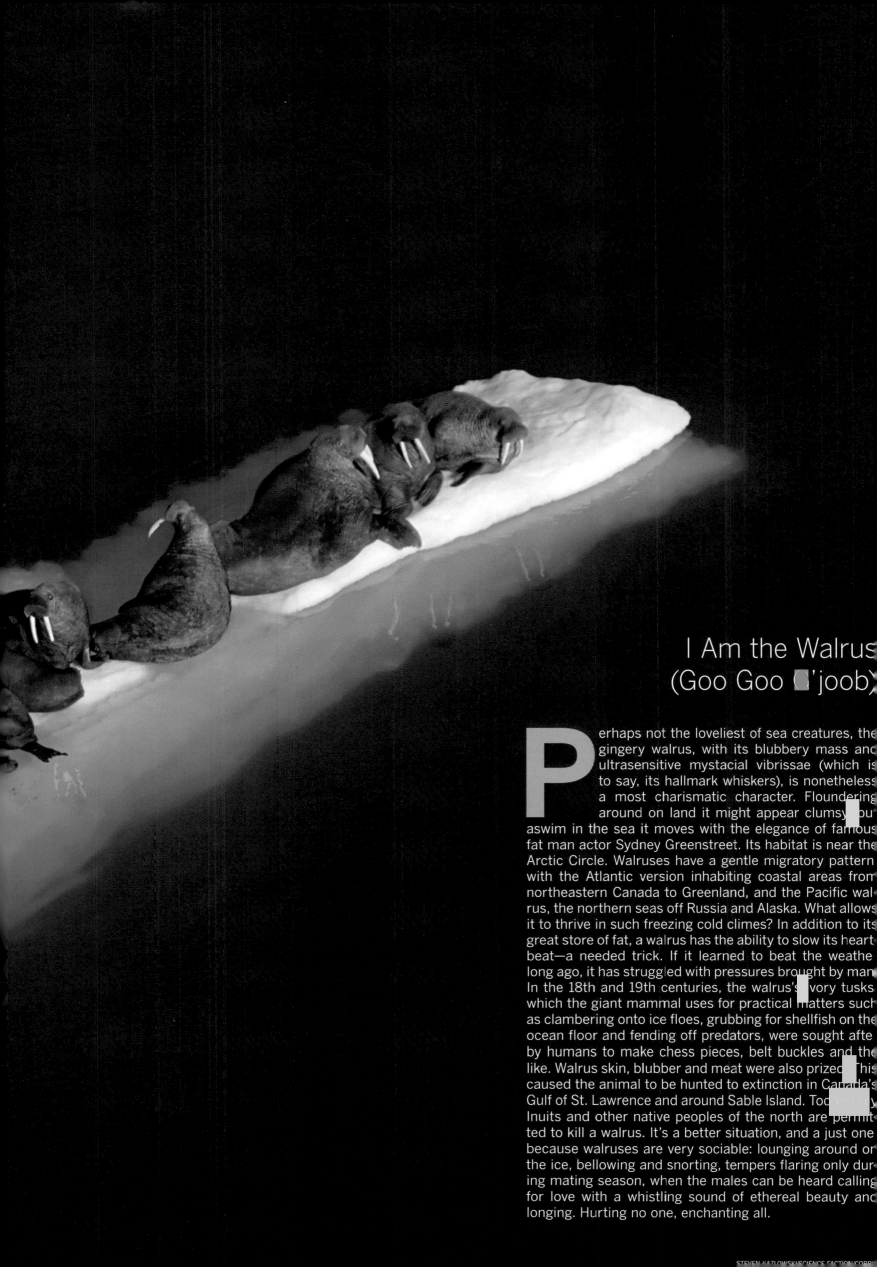

I Am the Walrus
(Goo Goo G'joob)

Perhaps not the loveliest of sea creatures, the gingery walrus, with its blubbery mass and ultrasensitive mystacial vibrissae (which is to say, its hallmark whiskers), is nonetheless a most charismatic character. Floundering around on land it might appear clumsy, but aswim in the sea it moves with the elegance of famous fat man actor Sydney Greenstreet. Its habitat is near the Arctic Circle. Walruses have a gentle migratory pattern, with the Atlantic version inhabiting coastal areas from northeastern Canada to Greenland, and the Pacific walrus, the northern seas off Russia and Alaska. What allows it to thrive in such freezing cold climes? In addition to its great store of fat, a walrus has the ability to slow its heartbeat—a needed trick. If it learned to beat the weather long ago, it has struggled with pressures brought by man. In the 18th and 19th centuries, the walrus's ivory tusks, which the giant mammal uses for practical matters such as clambering onto ice floes, grubbing for shellfish on the ocean floor and fending off predators, were sought after by humans to make chess pieces, belt buckles and the like. Walrus skin, blubber and meat were also prized. This caused the animal to be hunted to extinction in Canada's Gulf of St. Lawrence and around Sable Island. Today only Inuits and other native peoples of the north are permitted to kill a walrus. It's a better situation, and a just one, because walruses are very sociable: lounging around on the ice, bellowing and snorting, tempers flaring only during mating season, when the males can be heard calling for love with a whistling sound of ethereal beauty and longing. Hurting no one, enchanting all.

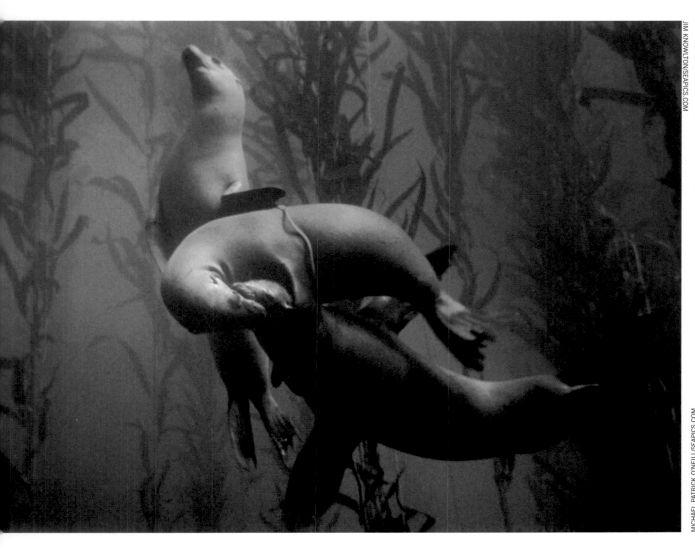

JIM KNOWLTONSEAPICS.COM

MICHAEL PATRICK O'NEILL/SEAPICS.COM

Often in the Spotlight, Happier in the Sea

Above, left: Frolicking amidst the giant kelp at San Miguel Island off the Pacific coast of North America are three California sea lions. With the largest of the species reaching eight feet in length and weighing upward of 800 pounds, the California sea lion is the classic circus "seal." In captivity, it will obligingly balance a ball on its nose when instructed to do so. Of course its element is not a swimming pool but the wild ocean, where this eared pinniped prefers to race, reaching

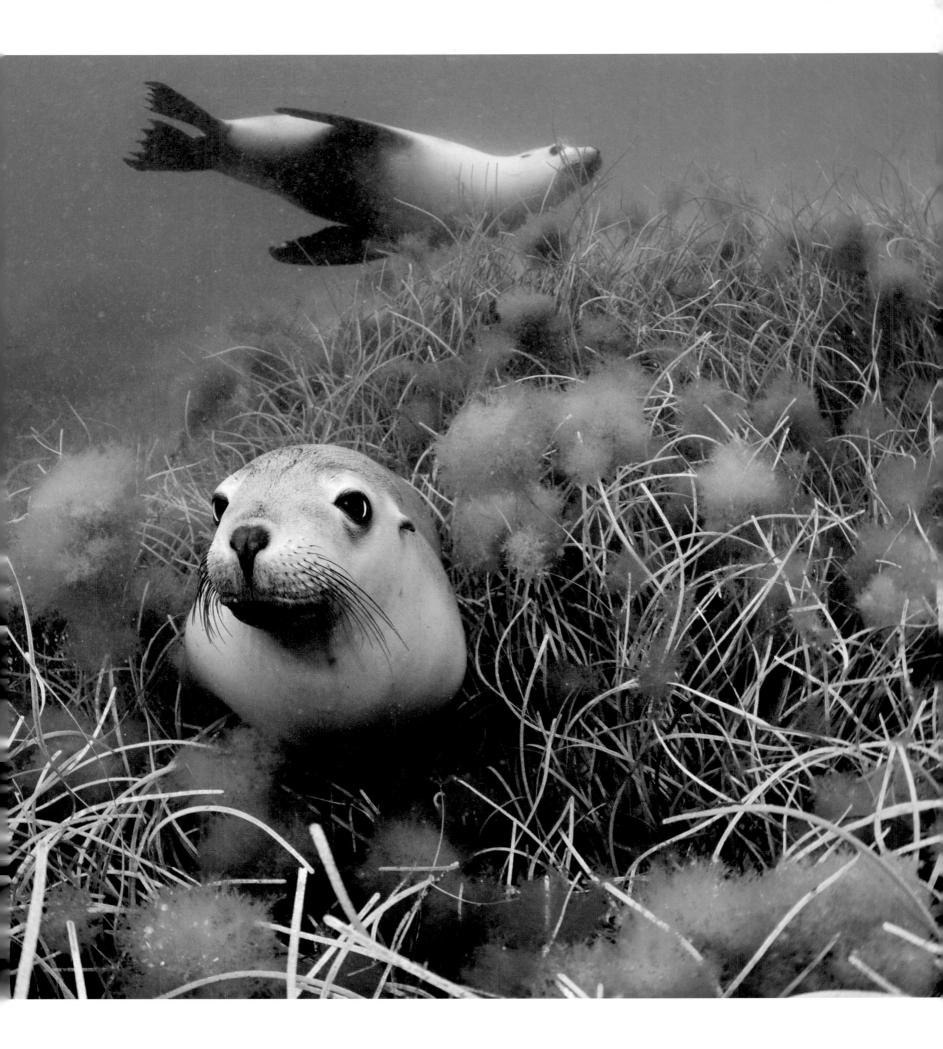

speeds of 25 miles an hour, making it faster than any other seal or sea lion. The California sea lion is an expert deep-diver, able to slow its heart rate and stay underwater for nearly 10 minutes before coming up for air. This ability gives it the upper hand when chasing fish and squid along the western coastline of North America. Though populations of California sea lion are abundant, the same cannot be said for those of its relation Down Under, the Australian sea lion. Shown above in the shallows off Hopkins Island, populations of this animal are still trying to recover from decimations visited upon them by sealers in the 1700s and 1800s. The Australian sea lion's unique breeding habits—colonies breed only every 17 months, coming together in summer one year, winter the next, and different colonies breed on different schedules—have not helped. Today it is estimated that only 10,000 to 12,000 Aussie sea lions remain, but these are now under the protection of the Australian government. They swim without hazard of human harm, and without having to balance balls on their noses.

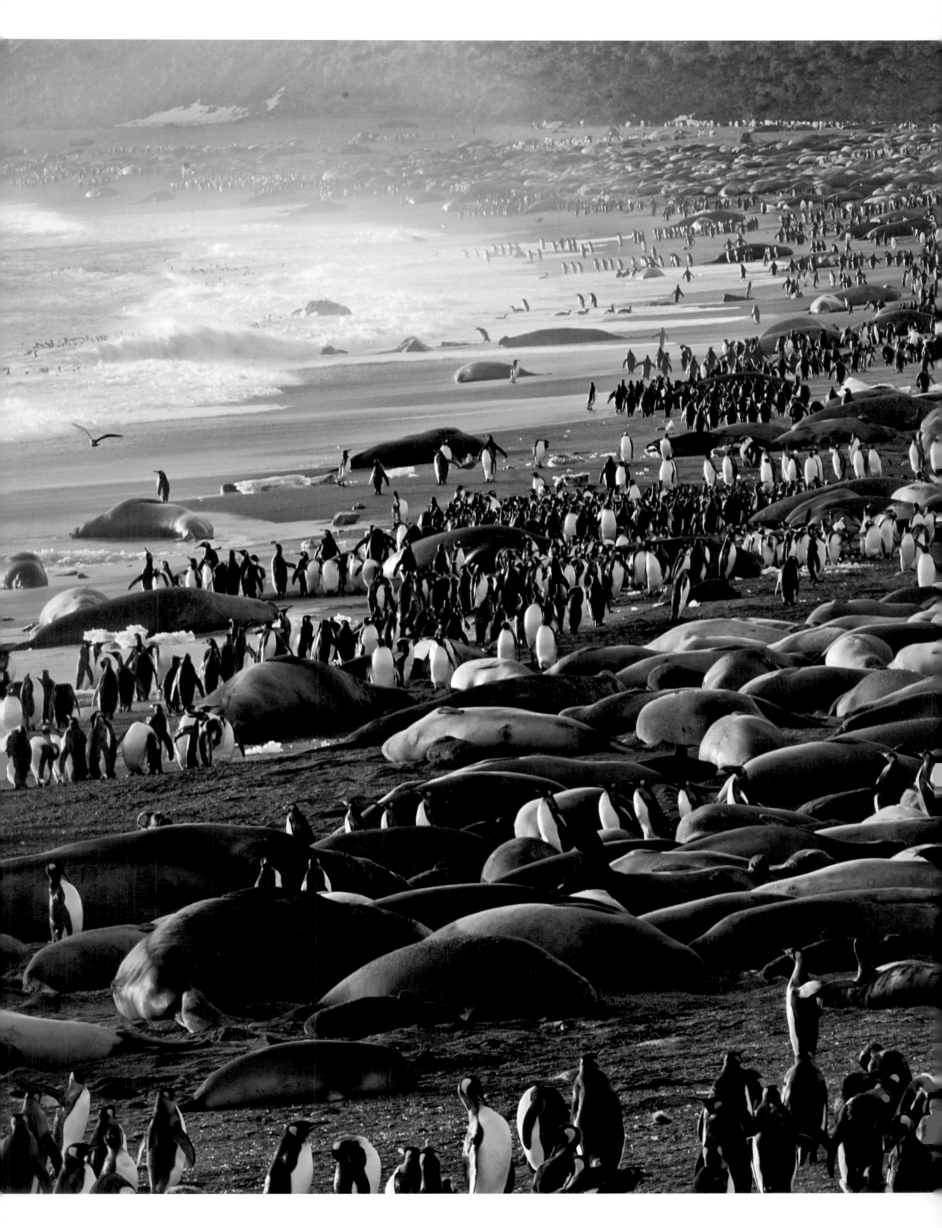

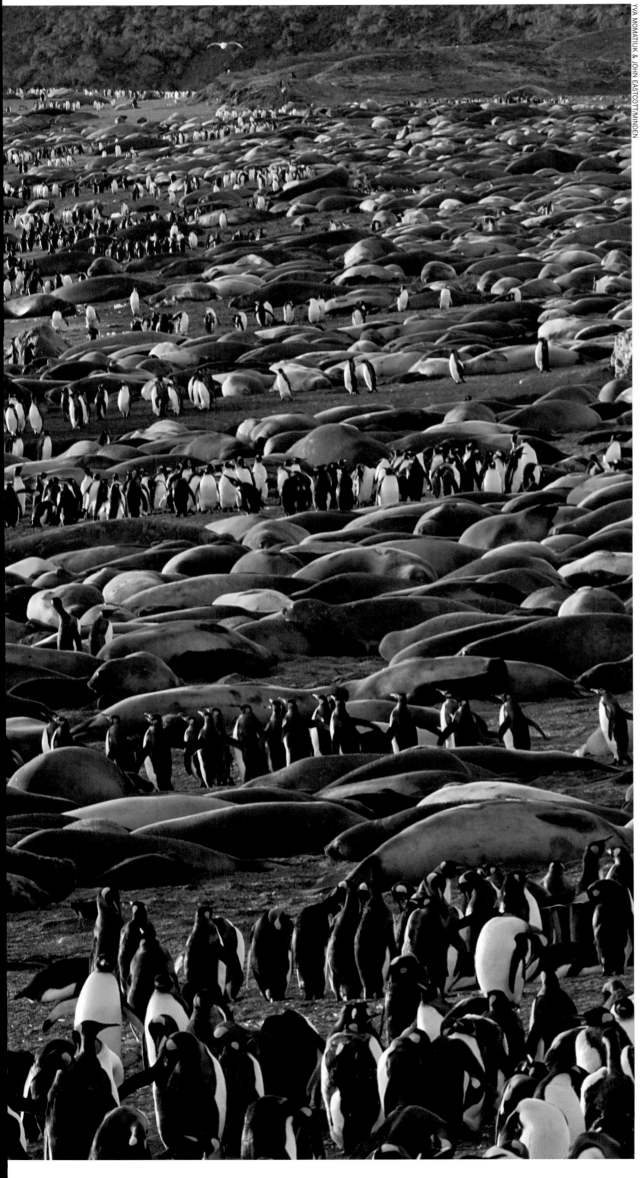

All Kinds of Royalty

I n this extraordinary picture, taken at St. Andrews Bay on the island of South Georgia, off the southernmost tip of South America, a large flock of king penguins shuffle amidst a vast collective of equally regal animals: elephant seals, resting during their breeding season (August to November). The southern elephant seal is the larger manifestation of this super-beast, which is, pound for pound, one of the most impressive mammals to be found anywhere on the planet. Bull elephant seals can attain a weight upwards of three tons (cows weigh in at a mere ton), and the largest ever recorded was more than 22 feet long and weighed—get this!—11,000 pounds, the biggest carnivore on earth. As does the walrus, the elephant seal plays a dual game: It's seemingly sloppy ashore, awe-inspiring in the sea. This seal can dive a mile down and, with its enormous quantity of oxygen-bearing blood, hold its breath for up to two hours while it forages for skates, squid, eels and, yes—when not otherwise distracted or tuckered out—penguins. What you can't sense in this photograph is the soundtrack: The bull's prodigious proboscis produces a horrendous roar during mating season. As for the king penguin: He sidles into this chapter on mammals by special invitation. He is, like his larger cousin the emperor (please see page 120), a bird. Just by the way, Antarctic Circle penguins and seals have gained fresh renown in recent years for their star turns in the terrific *Happy Feet* movies. But no: The birds don't dance like Savion Glover, and the seals don't jibber-jabber with Aussie accents.

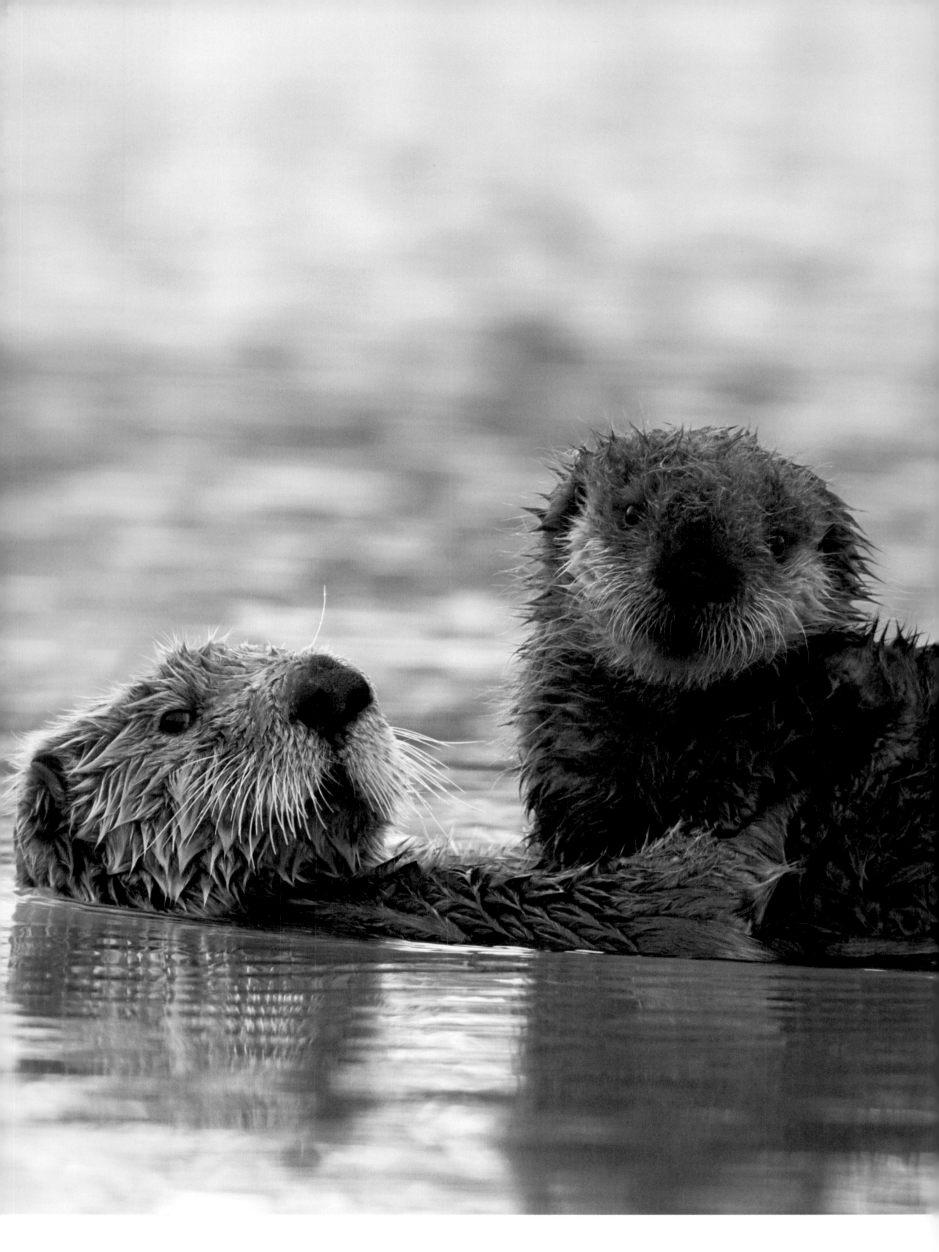

Otters Like
the Ocean, Too

Floating here on the Prince William Sound in Alaska, a mother sea otter, with pup in tow, looks to the camera. Usually giving birth to a single offspring at a time, the female sea otter is quite the doting mother. Acting as her child's crib, she will carry her baby on her chest for three to six months, meticulously grooming it to ensure its fur remains buoyant and insulated, leaving its side only to dive for food. An aquatic member of the weasel family, sea otters are found along the Pacific Coasts of North America and Asia, hanging near the surface in large, same-sex groups known as "rafts." Within these rafts, sea otters, when not in the deep, are often seen sleeping or dining: using their chests as tables as they ingest caught sea urchins, crabs and other invertebrates. Sometimes using rocks to smash open a tough shell, sea otters are one of the only mammals—aside from primates—known to use tools. When they aren't eating, hunting or sleeping, sea otters are fastidiously cleaning themselves by rubbing, rolling or blowing air into their fur. This last exercise is key: Because sea otters have no insulating body fat, constant maintenance is their key to staying warm in chilly waters, and in this procedure the air gets trapped in the otter's thick underfur, where it is then warmed by the body. These are heady days for the sea otter: The commercial fur trade reduced the population to perhaps one to two thousand individuals by the early 1900s. These days, protected by law, sea otters now number perhaps as many as 150,000.

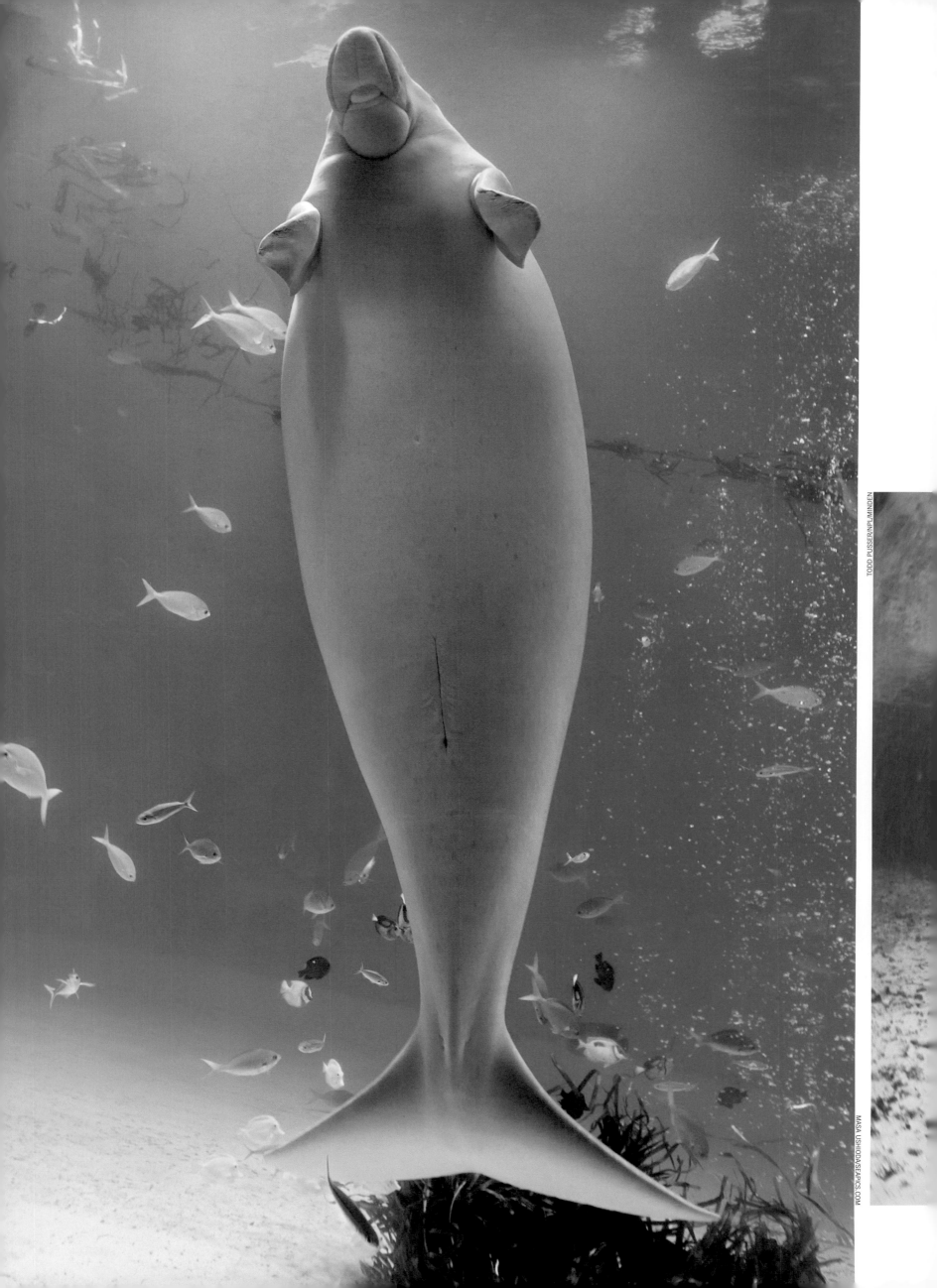

Gentle Giants

Legend has it that the manatee, found along tropical and subtropical Atlantic coasts and in nearby lagoons and estuaries, and its close relative the dugong, which swims the warm coastal waters of the western Pacific and Indian oceans from Australia to Japan, hold the secret to the myth of the mermaid. Certainly a sailor would have been a very long time at sea—or deep into the rum—to mistake one of these gentle giants for a woman; in fact, scientists now surmise that manatees and dugongs share a common ancestor not with man but with the elephant, all of them large, air-breathing herbivores with a fondness for delicate grasses—of which they eat stupendous amounts. The West Indian manatee, seen below with her nursing calf feeding from a teat under the flipper, can grow to more than 10 feet and lives into its seventies. It travels along gracefully, despite its bulk, at about five miles an hour, though is capable of bursts of speed up to three times that rate. We say it can live to 70 or more, but that would represent a long and occasionally hazardous journey. The species is under threat, and many manatees are injured or killed when crashed into by motorboats. It is suspected that, despite having excellent hearing in the upper ranges (their own sounds are a combination of high-pitched squawks, barks and whistles), this mammal cannot detect the low tones made by boat engines. The dugong (opposite: a female in the Indo-Pacific region) is also endangered. In an irony, while the people of Okinawa traditionally hold the dugong in reverence, the animal is particularly vulnerable in the waters near Japan.

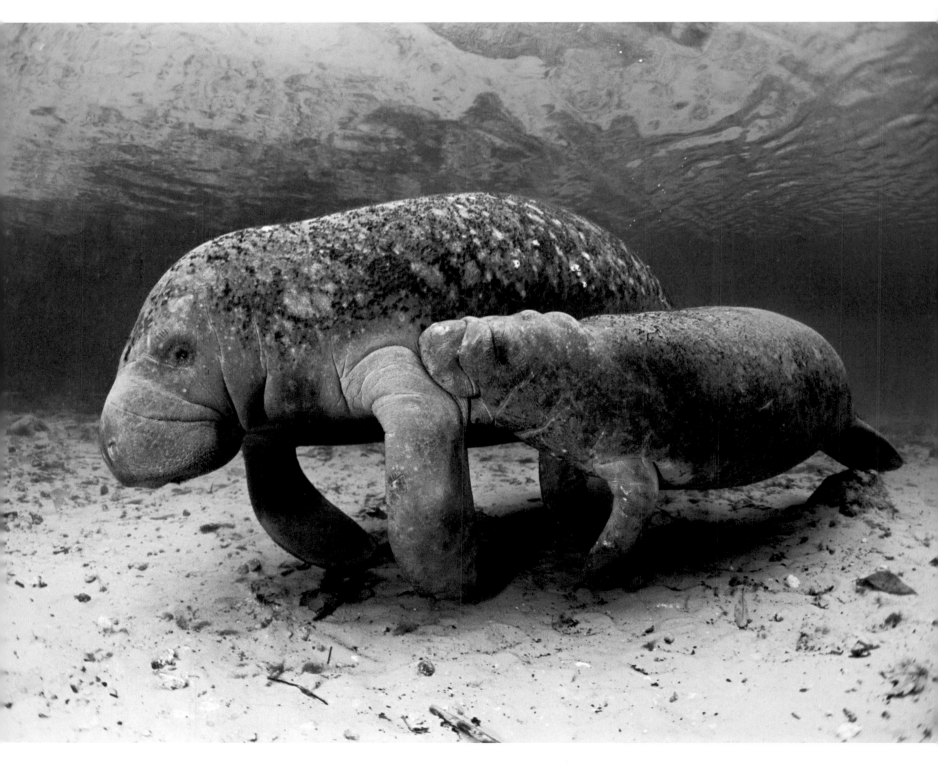

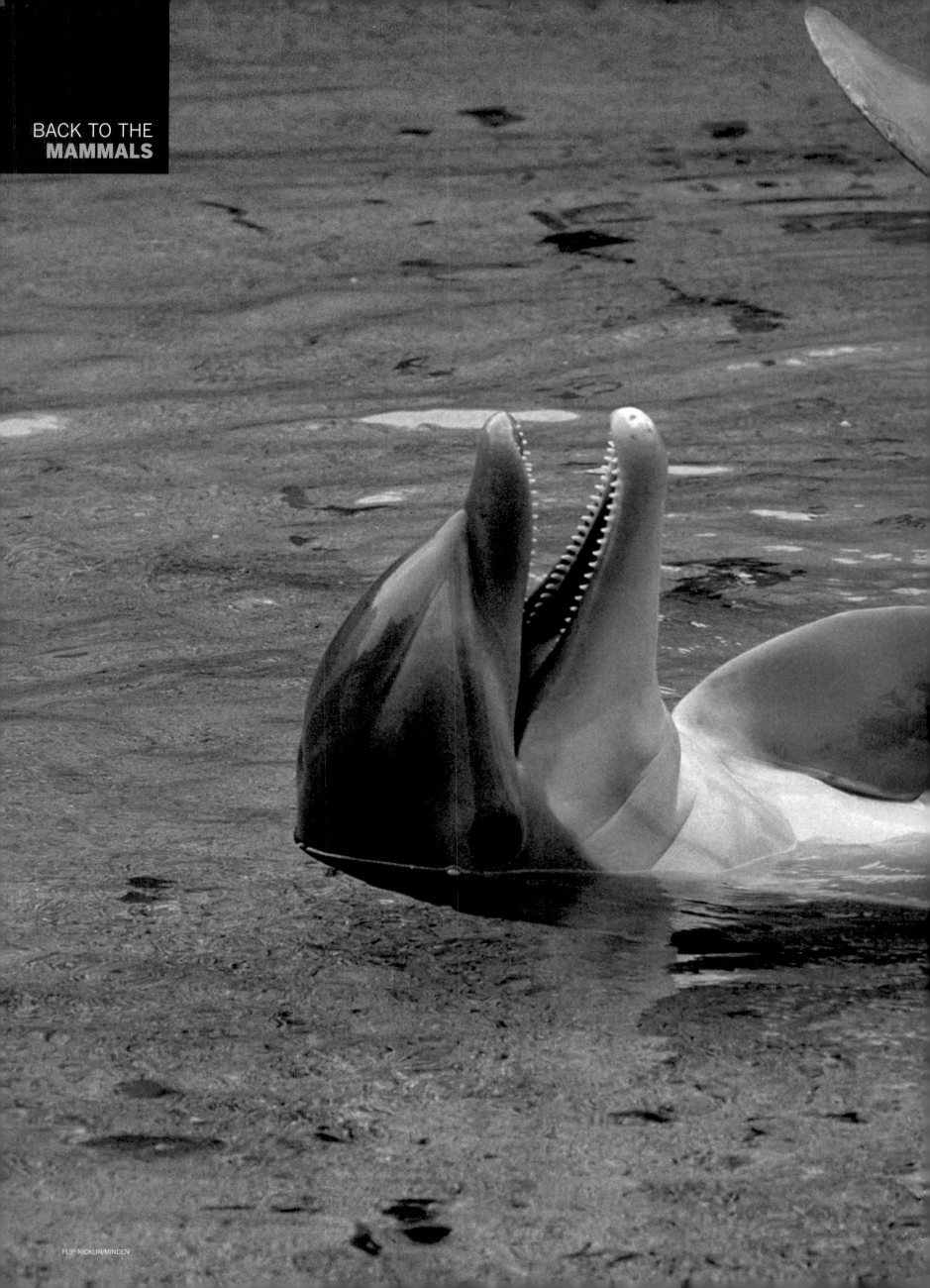

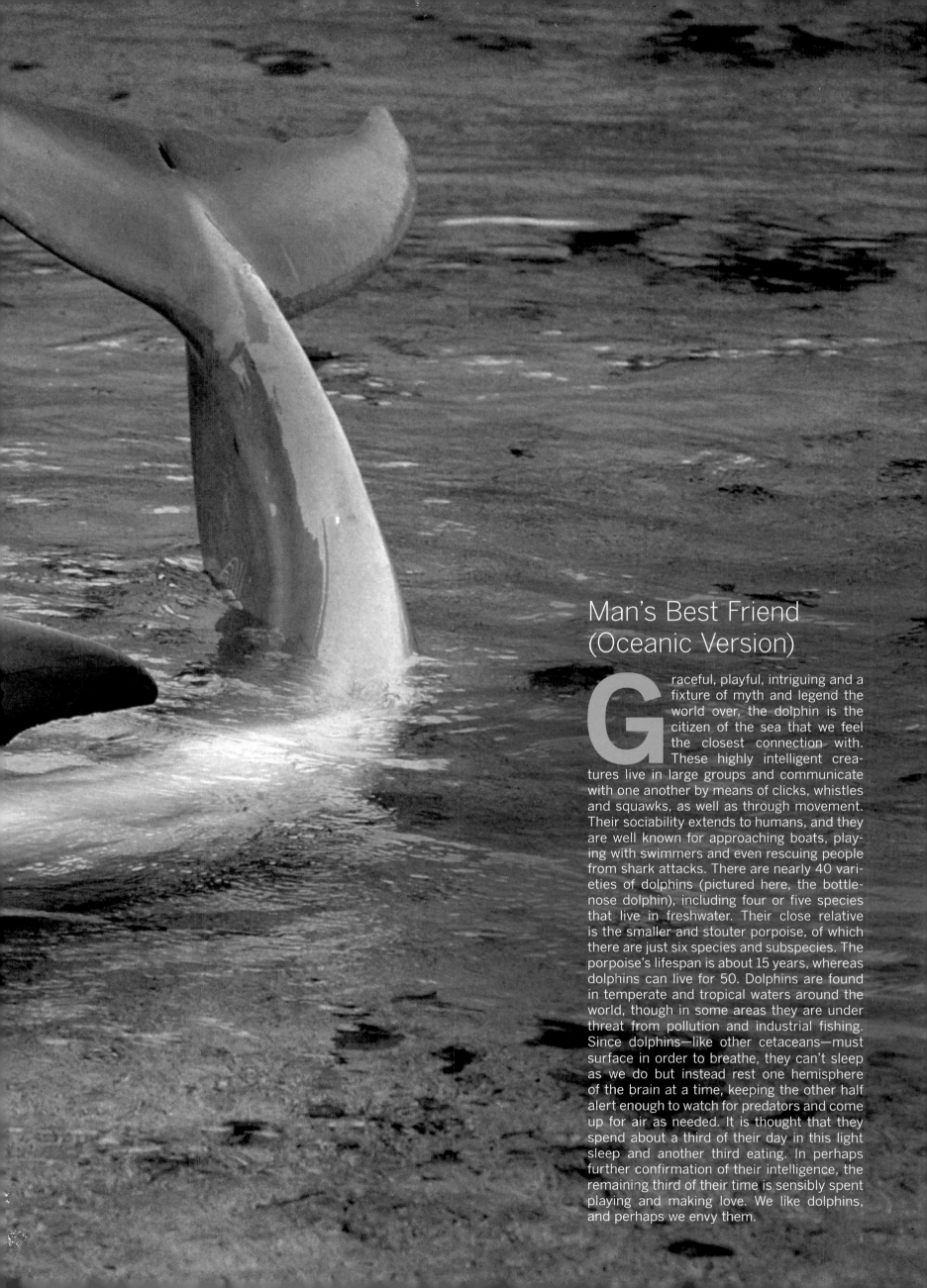

Man's Best Friend (Oceanic Version)

Graceful, playful, intriguing and a fixture of myth and legend the world over, the dolphin is the citizen of the sea that we feel the closest connection with. These highly intelligent creatures live in large groups and communicate with one another by means of clicks, whistles and squawks, as well as through movement. Their sociability extends to humans, and they are well known for approaching boats, playing with swimmers and even rescuing people from shark attacks. There are nearly 40 varieties of dolphins (pictured here, the bottlenose dolphin), including four or five species that live in freshwater. Their close relative is the smaller and stouter porpoise, of which there are just six species and subspecies. The porpoise's lifespan is about 15 years, whereas dolphins can live for 50. Dolphins are found in temperate and tropical waters around the world, though in some areas they are under threat from pollution and industrial fishing. Since dolphins—like other cetaceans—must surface in order to breathe, they can't sleep as we do but instead rest one hemisphere of the brain at a time, keeping the other half alert enough to watch for predators and come up for air as needed. It is thought that they spend about a third of their day in this light sleep and another third eating. In perhaps further confirmation of their intelligence, the remaining third of their time is sensibly spent playing and making love. We like dolphins, and perhaps we envy them.

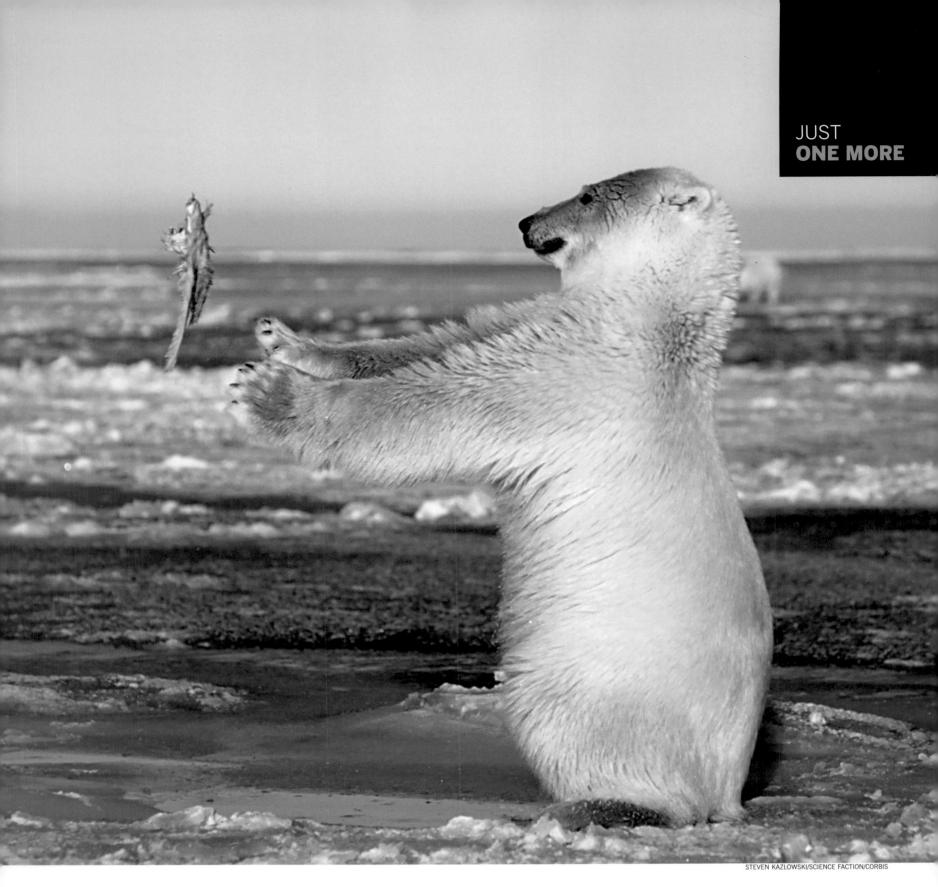

Ursus maritimus: A Bear of Two Worlds

We close here with a famous bear that seems so much a part of our terrestrial community of animals, yet is equally at home in the deep. The polar bear is the only member of the tribe *Ursus* to be considered a marine mammal, and with huge, partially webbed forepaws, and hind legs used as rudders, it is a Phelps-ian natator, able to attain speeds of six miles per hour and swim more than 60 miles without rest. (Without a hint of chagrin, it does the dog paddle.) Up to four inches of blubber keeps the animal warm in frigid Arctic seas and adds buoyancy, while its water-repellent fur further insulates and also allows the bear to shake free of water after a swim. Further advantages come with specialized eyes and nose: The polar bear can see very well under water, and its nostrils automatically close when it takes the plunge. It is such a mysterious hybrid of an animal, for the longest time it was thought to be its own genus separate from the bear, but it is now accepted as part of that family, having diverged from the brown bear perhaps as long as 600,000 years ago. White as snow, fuzzy as a bunny, nothing seems cuter—from afar—than a polar bear; in this picture we see a cub playing with a piece of baleen from a bowhead whale at sunrise on Barter Island off the north coast of Alaska. The male of the species can grow to weigh three-quarters of a ton, and you might think that fact would render this enthusiastic carnivore indomitable. Sadly, not so. In a final mention of a theme that has permeated our book, the polar bear has an enemy in man. As global warming—or *something*—seems to be melting away the borders of its icy habitat, nearly half of 19 polar bear subpopulations are in decline, and the International Union for Conservation of Nature has predicted that "[i]f climactic trends continue polar bears may be extirpated from most of their range within 100 years." Something to think about, perhaps, as we look at all the beautiful photographs on these pages, and contemplate the whales and fish and coral and now this bear . . . And perhaps wonder about our wonders of the deep: How can we help?